THE ART OF
GAME
WORLDS

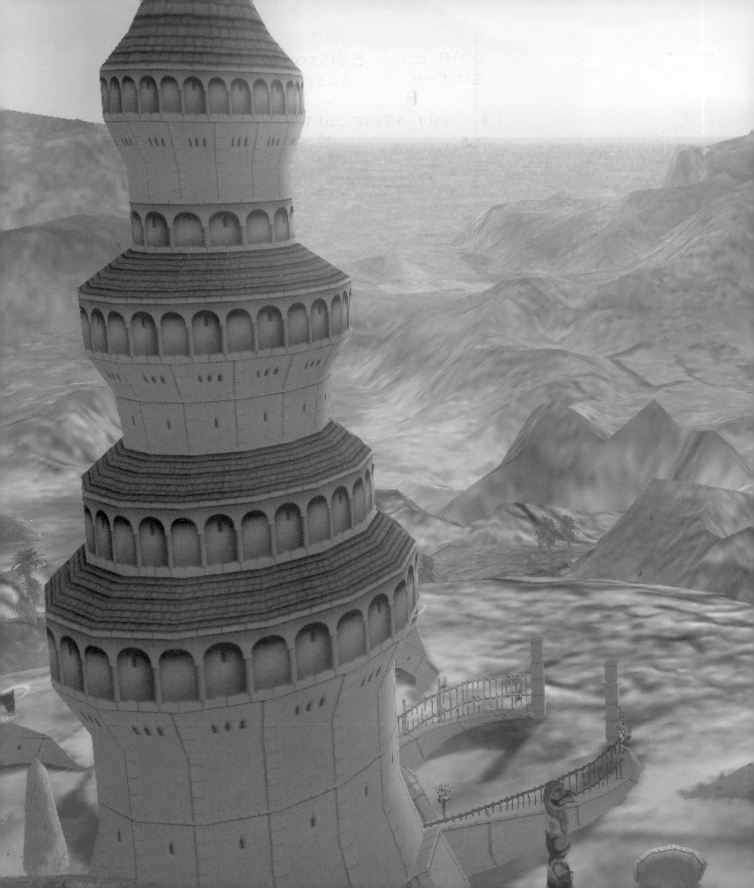

THE ART OF GAME WORLDS

DAVE MORRIS & LEO HARTAS

HDi

HARPER DESIGN international

An imprint of HarperCollinsPublishers

THE ART OF GAME WORLDS

Copyright © 2004 by The Ilex Press Limited

First published in North America and
South America in 2004 by
Harper Design International
An imprint of HarperCollins*Publishers*
10 East 53rd Street
New York, NY 10022

This book was conceived, designed, and produced by
ILEX
Cambridge
England

HarperCollins books may be purchased for
educational, business, or sales promotional use.
For information, please write: Special Markets
Department, HarperCollins*Publishers* Inc.,
10 East 53rd Street, New York, NY 10022.

First Edition

Printed in China

1 2 3 4 5 6 7 / 10 09 08 07 06 05 04

Library of Congress Control Number: 2004104866

ISBN 0-06-072430-7

For information on game worlds, see:
www.gawous.web-linked.com

CONTENTS

GAME WORLDS

INTRODUCTION

GAMES ARE ABOUT MUCH MORE THAN JUST GAMEPLAY NOWADAYS. ON THE THRESHOLD OF A NEW MEDIUM, WE HAVE THE OPPORTUNITY TO EXPLORE EXTRAORDINARY WORLDS AND STORIES INTERACTIVELY. WHETHER THE AIM IS TO PLAY OR TO WATCH OR JUST TO HANG OUT IN AN IMAGINARY PLACE, THE MODERN VIDEOGAME DELIVERS AN EXPERIENCE THAT IS ENTIRELY NEW. ENTERTAINMENT WILL NEVER BE THE SAME AGAIN.

—DAVE MORRIS & LEO HARTAS

Black & White 2 by Lionhead

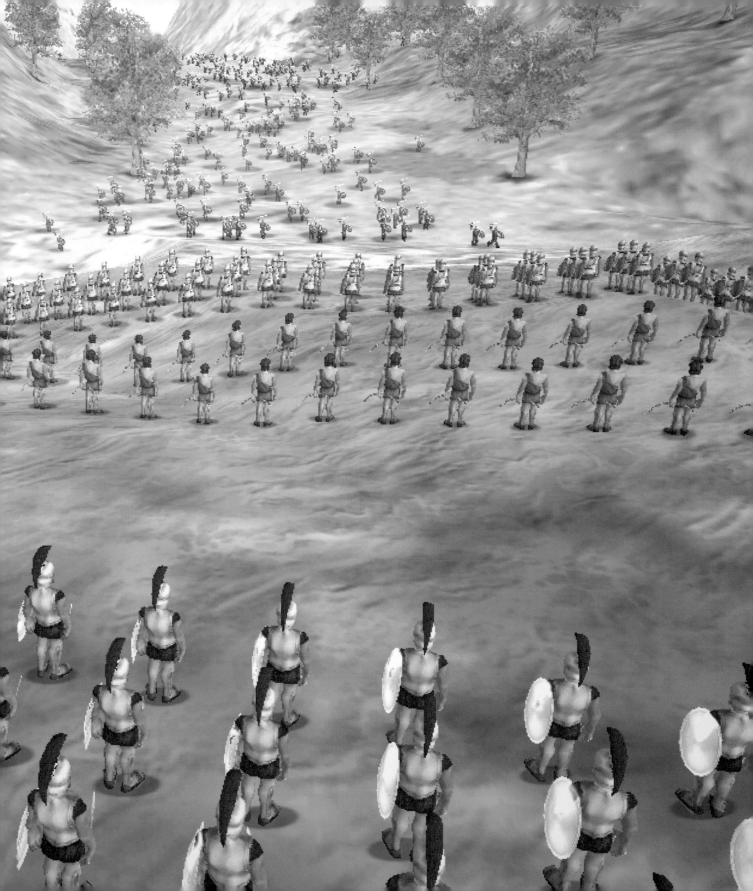

BIRTH OF A NATION

THE ESSENTIAL INGREDIENTS OF IMAGINED WORLDS

1

WHEN ALEXANDER THE GREAT SAW WHAT HE HAD ACHIEVED, WE ARE TOLD, HE WEPT, FOR THERE WERE NO NEW WORLDS TO CONQUER.

WHEN ARTISTS USED TO CREATE WORLDS IN OLDER MEDIA, THEY HAD TO CREATE ONLY THE TIP OF THE ICEBERG. WE NEVER NEEDED TO SEE THE COLOR OF THE SKY OVER MORDOR ON THE DAY OF SAURON'S BIRTH, NEVER NEEDED TO HEAR THE FIRST WORDS MACBETH SPOKE TO HIS WIFE, NEVER NEEDED TO WATCH THE LITTER BEING SWEPT UP FOLLOWING CLEOPATRA'S RIDE THROUGH ROME.

THESE DAYS, GAME ARTISTS HAVE A MUCH BIGGER TASK. THEY HAVE TO CREATE THE WHOLE ICEBERG. IN GAMES, YOU CAN WALK AROUND BEHIND THE BUILDINGS IN DODGE CITY, SO IT ISN'T ENOUGH ANYMORE JUST TO MAKE DO WITH PLYWOOD FACADES, LIKE THEY USED TO DO IN THE MOVIES.

Kameo: Elements of Power by Rare

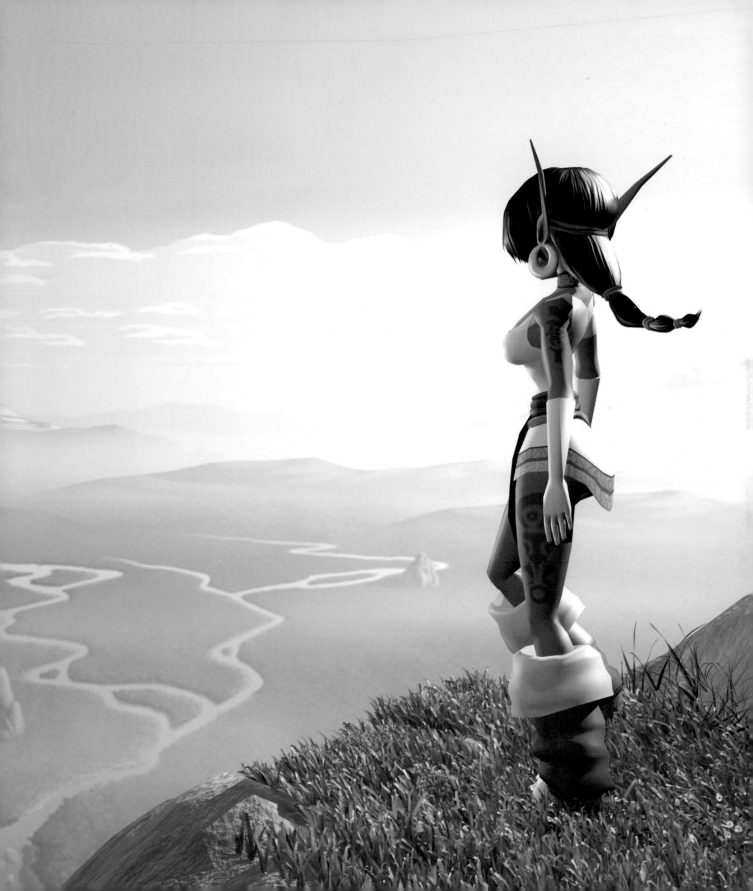

IN THE BEGINNING

IAN LOVETT, DIRECTOR OF ART AT BIG BLUE BOX STUDIOS, HAS THIS ADVICE FOR GETTING STARTED:

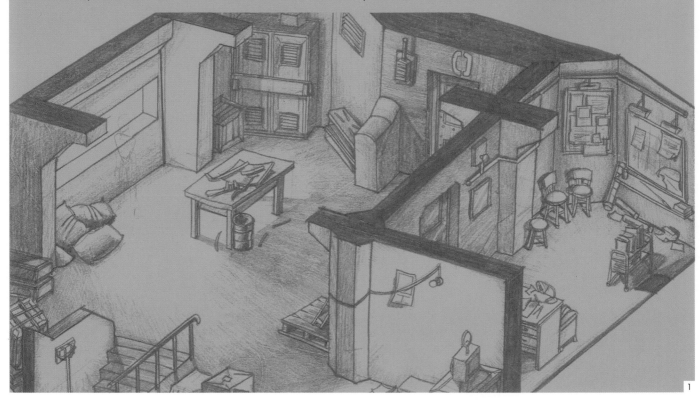

1

"Coming from a strong photographic background, I tend to start with lighting and basic colors. These alone can give you a feel and the beginnings of a setting. Everything else comes after that all-important first step.

"A game's setting is almost entirely derived from the design and game type. At Big Blue Box, we've always approached setting as a film company might, with key elements such as mood, location, lighting, and so on driven by the story and the action taking place. There will always be elements of yourself in that, though. Given a free creative brief, you tend to approach things in a more personal way that not only enriches the look of the game but makes it more of a labor of love.

"Looking outside the field of games is also hugely important. Inspiration can come from anywhere. Visual media, films, and artwork are obvious choices; however, good literature can conjure up some of the most vivid images of all. *Fable*, by Big Blue Box, is very much a creation born of Jim Henson and Tim Burton films, with Danny Elfman's music echoing throughout."

1. Pyro Studios uses a fixed view in **Commandos 3: Destination Berlin**. Note the intricate level of detail worked out at this preliminary stage of concept art.

2. **Medal of Honor: Pacific Assault** by Electronic Arts. Lush, detailed in-game foliage has only been made available to developers recently, as powerful new graphics hardware has appeared on the market.

3–6. Jungle reference and surface textures in **Medal of Honor: Rising Sun** by Electronic Arts. As game technology allows for more detail, it increases the burden on developers to study, gather, and create ever more material.

7. Wireframe of a hut amid jungle foliage in Electronic Arts' **Medal of Honor: Rising Sun**.

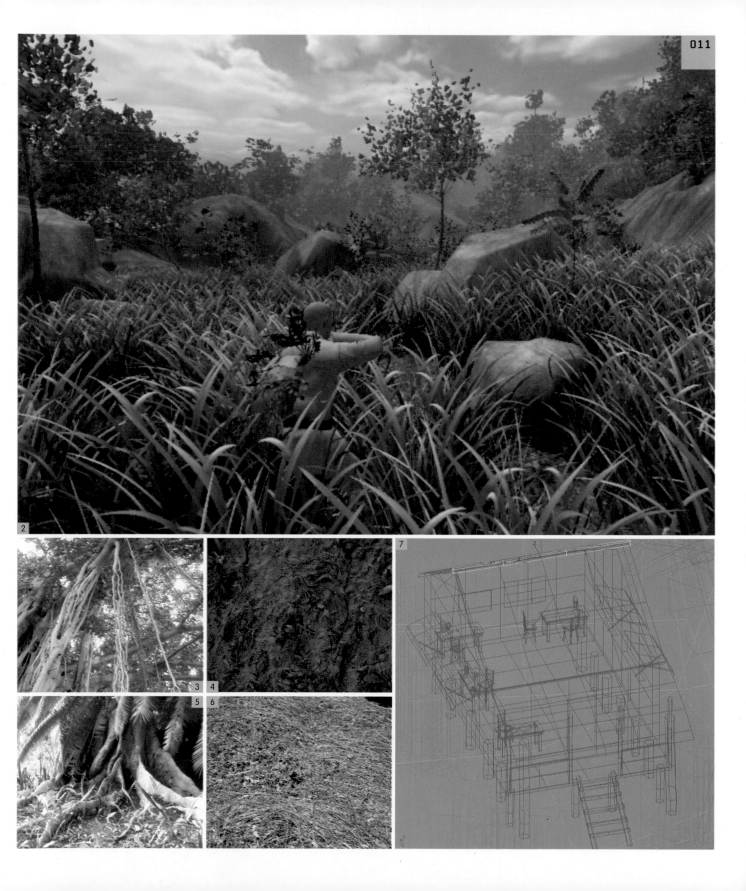

SO MANY WORLDS

ARTISTIC VISION, OR STORY AND GAME DESIGN: WHICH COMES FIRST?

1

"HEREAFTER, WHEN THEY COME TO MODEL HEAVEN AND CALCULATE THE STARS, HOW THEY WILL WIELD THE MIGHTY FRAME, HOW BUILD, UNBUILD, CONTRIVE TO SAVE APPEARANCES, HOW GIRD THE SPHERE WITH CENTRIC AND ECCENTRIC SCRIBBLED O'ER, CYCLE AND EPICYCLE, ORB IN ORB."

JOHN MILTON, *PARADISE LOST*

"A real chicken-and-egg question," says Ian Lovett, currently working on the keenly anticipated role-playing game, *Fable*. "I would say from experience that both are generally conceived at the same time. The best games have an artistic vision in mind from the beginning. Most people will discuss the setting in the same breath as the story. You might say your game was a gritty, detective, film noir game set in a *Blade Runner* environment. With those few comments, you've already painted a strong visual picture."

"In the game developers' ideal world," says Marc Holmes, production designer at Turbine Entertainment, "they have to be simultaneous. A germ of a story comes first, and generates ideas for images and gameplay that feed back and change the story—you do that loop a few times till you have something going."

1. A shot from the level editor for Pyro Studios' **Commandos 3: Destination Berlin**. All character movements are accounted for. Note the realistically uneven nature of the ground, a detail that adds subtle richness to the world.

2–4. Intrepid's **BC**. An amazing reconstruction of the past—with just a little artistic license and no sign of Raquel Welch.
5. The famous big robots return in **Transformers Armada: Prelude to Energon** by Atari.

6. Big Blue Box Studio's **Fable**. A beautiful fantasy world where care has been given to every stylistic detail.

7. In **Vega$: Make It Big** by Deep Red Games, the artists have capitalized on the excesses of the city to develop new, imaginative ideas that any casino owner would be proud of.

013

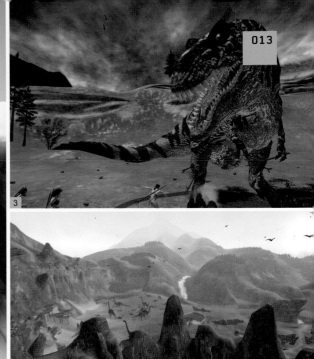

3

2 4

5 6

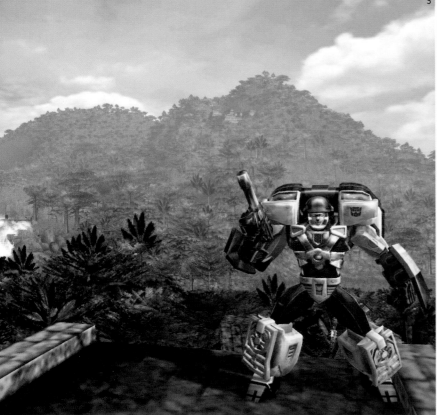

7

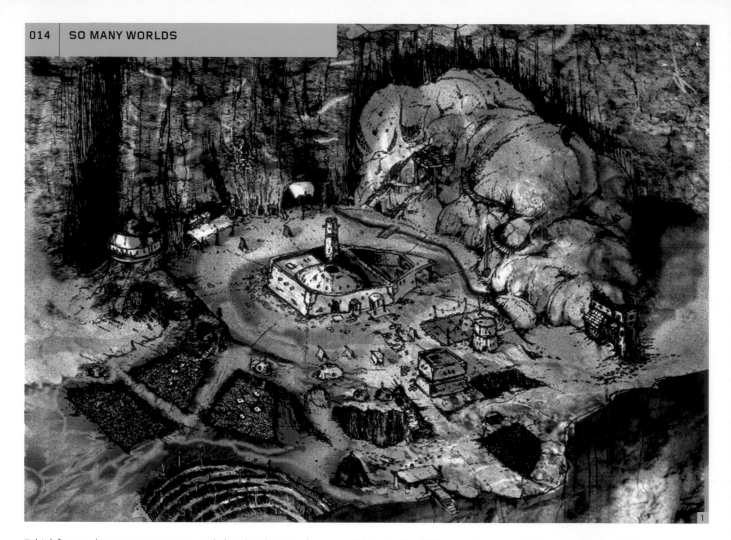

"I think first you have to come to terms with the idea that out of these three, the story is probably least important," says Tim Shymkus, producer at High Voltage Software. "First and foremost, what you are making is a game. Art draws players in, and design keeps them playing. Sometimes having a story up front can help visualize these other elements, but generally speaking, the game story is the most flexible and adaptive element. That being the case, I feel the fundamentals of the game must first be developed—and proven—before getting tied to a storyline."

"In practice, art always comes first," says Owain Bennallack, editor of the game-industry magazine, *Develop*. "In theory, game design comes first—oh yes, and they have the paperwork to prove it. Ideally, story should come first. One day."

What are the differences between building a game world for solo or small-group play as opposed to building one for massively multiplayer environments?

"The technological restraints on these different games often force different rules on the designers," says Ian Lovett. "However, from a purely visual standpoint, the same rules apply. Clear landscape features are becoming increasingly important in any world. These reference points allow us to discard clunky maps and adopt a more intuitive approach to navigating around our worlds."

1, 2. **City model and concept work from Elder Scrolls III: Morrowind by Bethesda Softworks.** The artists have carried the organic, flowing designs of the concept work into the hard, exact environment of digital 3D.

3–5. **Evil Genius by Elixir Studios.** Real-world elements reinterpreted for a fictional setting.

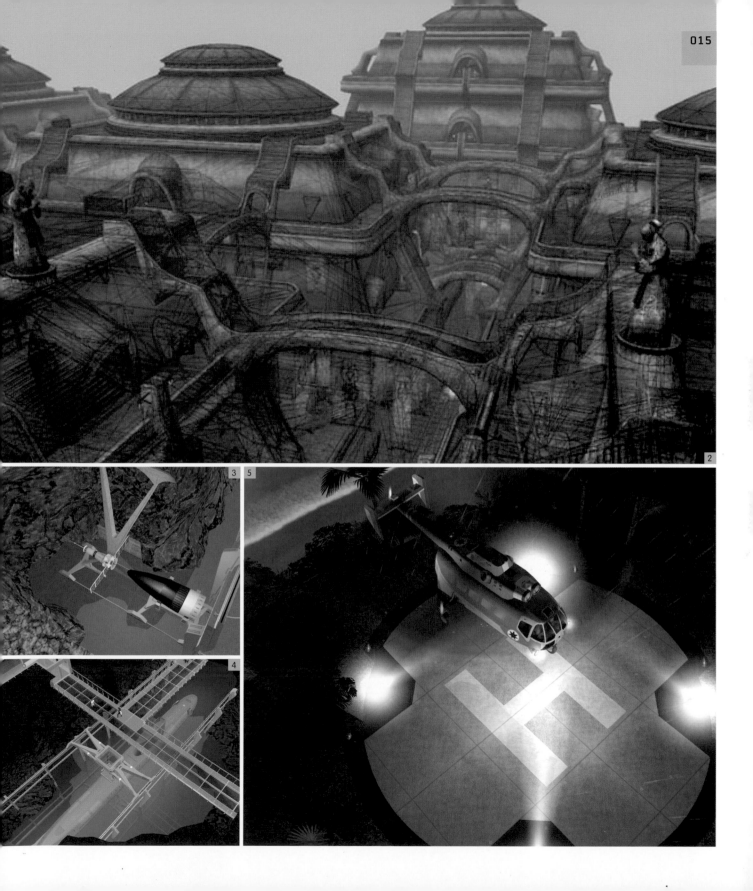

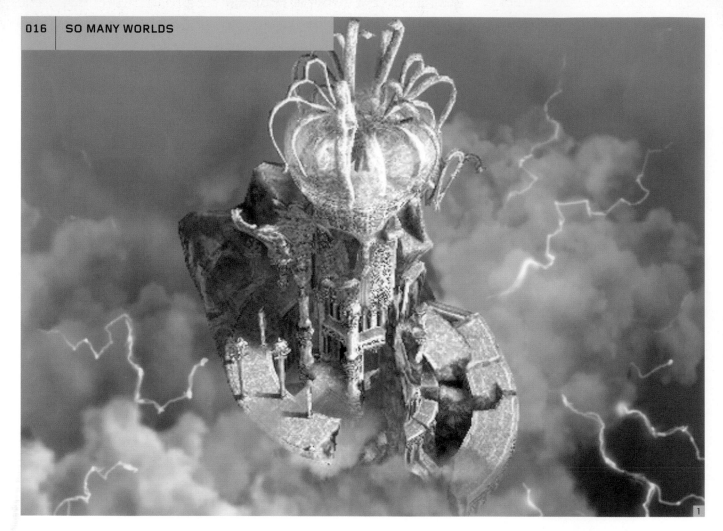

1

What game worlds do you find particularly successful, from an artistic standpoint?

Marc Holmes, who is currently working on *Middle-Earth Online* at Turbine Entertainment, says: "Other than *Middle-Earth*, of course, I'm a big fan of the *Morrowind* world. Bethesda did a great job of reinventing the fantasy genre. The new Cyan game, *URU*—that's looking amazing. Bioware's take on *Forgotten Realms* has been a big part of my gaming life, more so for game design than the art. I think the *Silent Hill* series has done a great job of building a world, as have the great artists on *Oddworld*. And *Homeworld*, for creating the futuristic feel of space exploration. *World of Warcraft* is starting to pique my interest. You can't beat the nostalgia of going back to the land of *Warcraft 2*—I wanna be a zeppelin pilot!"

Apart from obvious elements such as textures, lighting, and sound, what factors do most to define an imaginary world?

"Weather and time are increasingly important," says Owain Bennallack. "*Ocarina of Time* has changed this forever for me. No 'open all hours' world ever feels entirely real in its wake. Weather is a function of time, and is at least as interesting. Apart from a few driving games, few games have used weather to any great effect. *Lord of the Rings*, *Aliens*, and *Seven* are all films that show what a missed opportunity this is."

1, 3. **Final Fantasy X-2.** Square Enix's designs are always striking, and memorable for their beautiful colors and rich ornamentation.
2. Wireframe from **Vega$: Make It Big** by Deep Red Games.

4–7. **Chrome** by Techland. Working with 3D real-time environments, the games artist also has to be an architect.

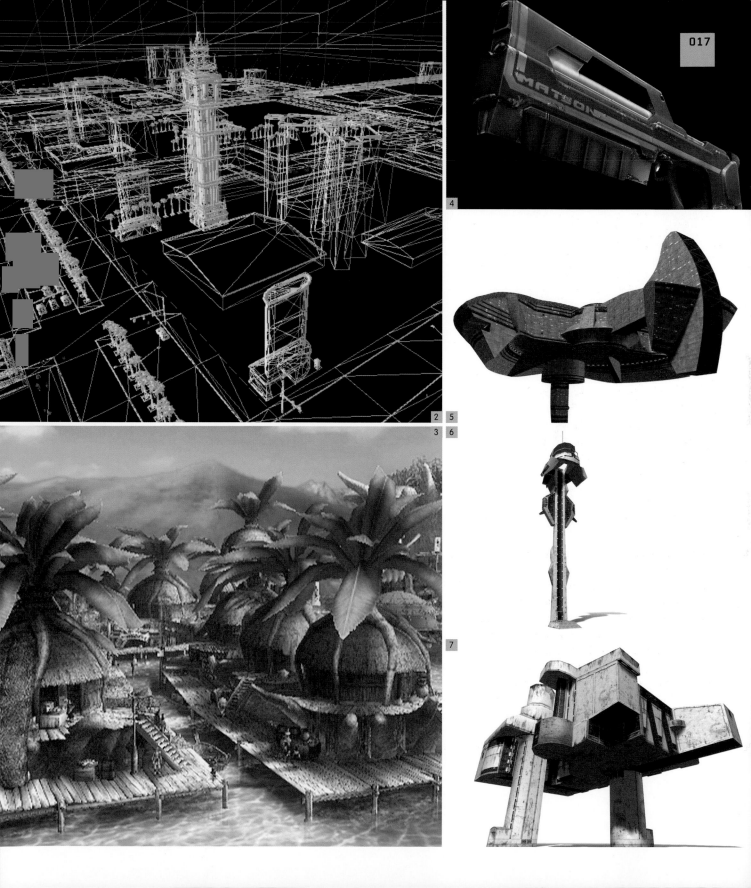

4

2 5

3 6

7

SURELY YOU'RE JOKING, MR. BOND

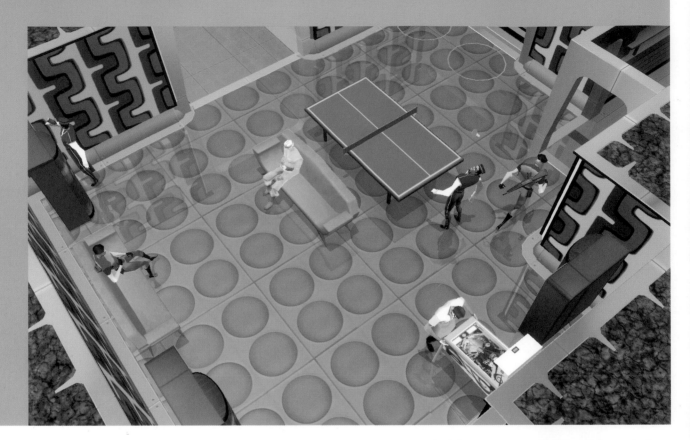

A white cat, a Nehru jacket, and a cool postmodern pad with a mountaintop view and optional nuclear-missile silo. What more could a boy want—apart, perhaps, from one million dollars? Elixir Studios' second game is to be *Evil Genius*, a funny and stylish look at the 1960s spy genre after it discovered pop art.

Judicious thought has gone into the game's production design, and it shows. The characters and settings are gloriously disdainful of photorealism. In the era on which *Evil Genius* is based, abstract art is all the rage, so bright, solid colors and unfussy textures abound, giving the impression of a universe conforming to the artistic vision of Lichtenstein, Hockney, and Warhol.

The environments create a heightened, theatrical world, peopled with stylized characters dressed not as in real life, but as in the movies of the day. The henchmen and pretty girls look as if they have been chosen by a casting director and clothed by a movie costume department. The gadgets are big: computers spin tape reels the size of bicycle wheels; control panels are made up of heavy levers, dials, and buttons. Pinpoints of light pick out the glossy plastic and metal surfaces, the reflective floors, and the geometric furniture.

The result of Elixir's attention to detail is a distinctive look that sets *Evil Genius* apart at a glance. This level of art direction is common in television—where the goal of creating a brandable look is paramount—but relatively rare in games development. As competition among games intensifies, though, the need for a unique visual style is becoming increasingly important. Developers are starting to realize that there is no point in having great game design if players can't tell your product from the rest. We can only hope the result will be more games that stand out from the crowd.

All images from **Evil Genius** by Elixir Studios. The basis of the game is the '60s Bond-style romp. Elixir's design takes the cliché and expands and enriches it to the point where it assumes its own original identity. Note the reflections on the floors, a subtle but important effect only recently available with faster graphics hardware.

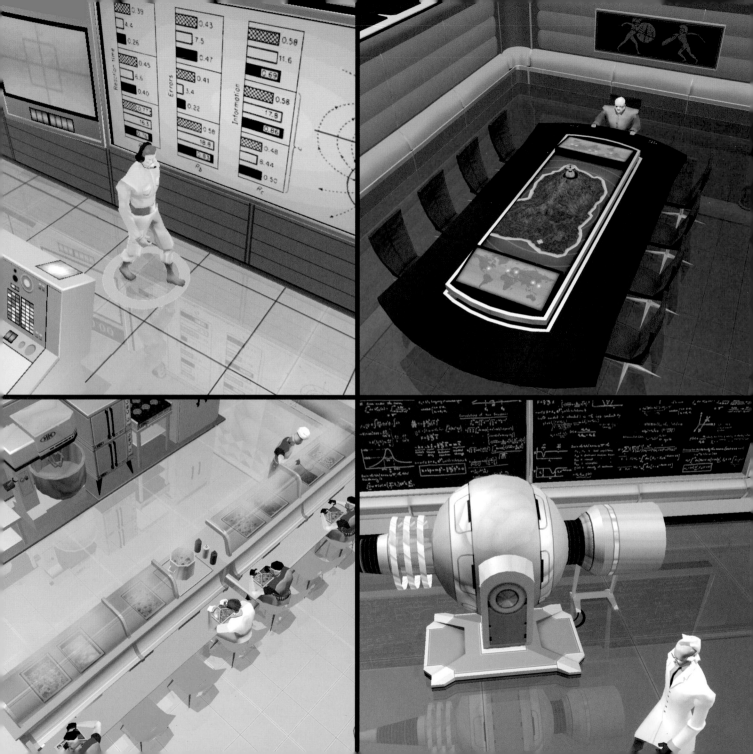

HANDS ON: FIAT LUX!

THE INSPIRATION AND PITFALLS INHERENT IN CREATING NEW WORLDS

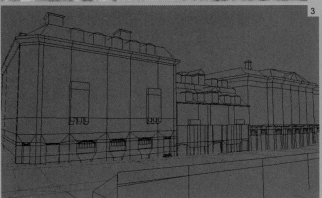
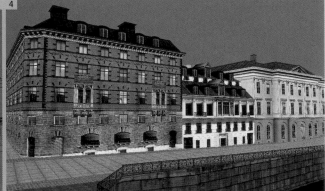

1 2
3 4

Right from the days when computer games were just handfuls of pixels, their creators have strived to improve graphical quality. Now games are at the point where they rival Hollywood in realism and visual splendor. Sometimes gameplay, which, in theory, should be the heart of the product, takes a back seat to graphics—a triumph of style over content.

THE ART OF THE GAME

When creating game environments, every element—from the great palace to the texture on a rotting hovel door—should always be considered for its effect on gameplay. Will it rack up the tension? Provide an uneasy calm before an onslaught by the enemy? Subtly point out the solution to a puzzle? Straightforward, practical considerations also have to be accounted for. Does that beautiful candelabra that you spent three days building obscure the player's line of sight during a firefight? That moody lighting—does it mean the player misses an important clue? Is the landscape so vast that the player gets bored trudging around—or worse, lost?

ART IN THE GAME

Beyond gameplay lies the game's esthetic. Any good artist will know how to create quality art through training and study of the great masters, but game design requires a number of special artistic and technical considerations.

1, 2. Nadeo's **Virtual Skipper 3**, along with many other simulations, has discovered a secondary purpose beyond the game itself: virtual sightseeing. In re-creating exotic locations, players can tour the world at a fraction of the cost of a real cruise.

3–6. **Project Gotham Racing 2** by Bizarre Creations. The more realistic the simulation, the more immersed in the game the player becomes. Here we see a small section of a Stockholm street beautifully re-created as it appears in the developer's level-editing tool; as a wireframe; as untextured polygons; and as it finally appears in the game.

1

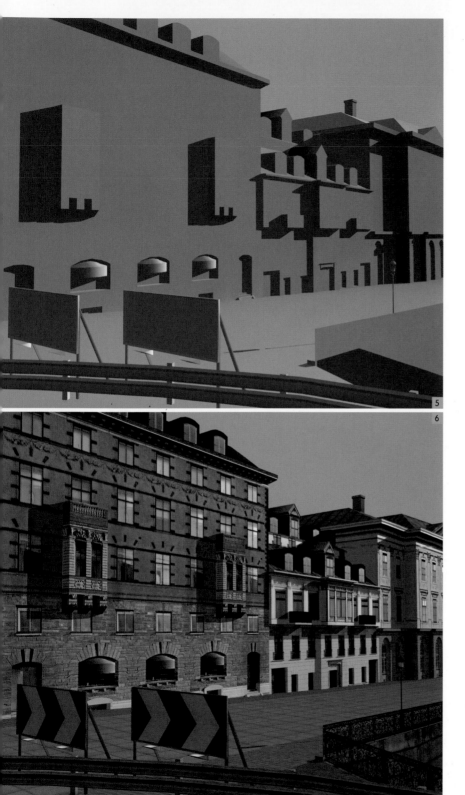

5

6

IT'S A WORLD

Real-time 3D means that game designers have to create a more extensive environment than is necessary in any other medium, including film. As technology improves, players are demanding more free-form environments to explore. The artist must always keep in mind the big picture—how each individual element fits into the game world at large.

IT'S BRICKWORK

When designing game environments, the artist is really an architect. This study of the architecture should progress beyond the simple structure of buildings to consider the emotional responses that architectural space can evoke, from the way a building occupies the landscape to the esthetic proportioning of ceiling coving.

IT'S A BRAND

Hundreds of games are released every year. A title is much more likely to stand out from the crowd if its whole game world is made visually brandable. Even realistic games like racers and simulations have to strive for a style beyond deadpan realism. Style may be expressed in the exaggerated thud as a bullet hits, the way the sun diffuses on a metal surface, or the movements of the camera. It gives the game identity, the same way a director stamps his identity on a film.

LESS IS MORE

2

MINIMALIST GAME ENVIRONMENTS

THE BASICS OF DESIGN AND COMPOSITION ARE IN THE ATOMS OF OUR PERCEPTION: FORM, COLOR, AND LIGHT. USED TOGETHER, IN AN INFINITE VARIETY OF COMBINATIONS, THESE CREATE AN EMOTIONAL RESPONSE IN THE VIEWER. THE MOST EFFECTIVE WORKS OF ART ARE THOSE THAT CONNECT DIRECTLY WITH THE VIEWER'S EMOTIONS WITHOUT GETTING CAUGHT UP IN THE RIGID VISUAL LANGUAGE OF EVERYDAY LIFE. IN SHORT, ABSTRACT BEAUTY HOLDS THE GREATEST TRUTH.

Killer7 by Capcom

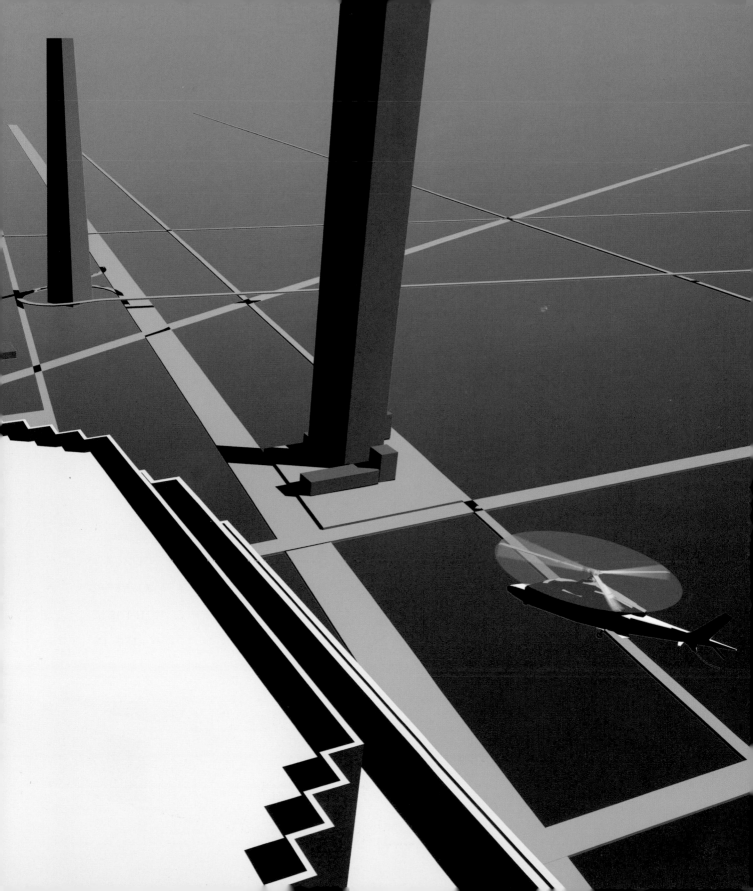

DRIVEN TO ABSTRACTION

WHY DO SO FEW CURRENT GAMES MAKE USE OF ABSTRACT ENVIRONMENTS?
ARE THEY A DYING BREED?

1

"As our ability to re-create the real world grows, the need for abstract environments has declined," believes Tim Shymkus, producer of Disney's *The Haunted Mansion* at High Voltage Software. "With early computer graphics, making anything look real was difficult at best. If you go back to the Atari days, you will find many of those games to be very abstract. Yet as graphics have evolved, we've moved more to realism simply because we can now make it believable. Right now, I think we are in a cycle that leans farther toward reality; but, as with anything, it will eventually exhaust itself and games will again be looking for unique experiences in nonstandard environments.

"If your game environment is abstract, players can only evaluate it based on what you've given them. Getting players to buy into an abstract world can be very difficult. We are creatures of comfort and we like to see and experience things we can connect to. It is important that when creating an abstract world, you make sure to give people baselines that they can understand."

"I think it's much more difficult to be abstract," says Marc Holmes of Turbine Entertainment. "That's really putting the weight on the artist's shoulders—to construct the entire world from their mind's eye. Most art directors enjoy the luxury of just handing out photos for reference! On the other hand, these constraints can be the most rewarding for the artist, if they're given enough creative freedom to work within them.

"As an industry we are currently pursuing the goal of movie-quality imagery in games. The game artist is working to draw you into the world—the sense of verisimilitude—and that is usually more based in reality than in abstraction. Certainly in console development, we are seeing some more aggressively designed projects. *Killer7* and *P.N.03* come to mind."

1–4. Game worlds don't have to be landscapes with buildings. They can also be idealized re-creations of quotidian reality. In the case of WildTangent's **Xbox Music Mixer**, the player not only enters the world of virtual clubs in a literal sense; he or she also gets to travel into the psychedelic "inner world" that is the essence of the clubbing experience.

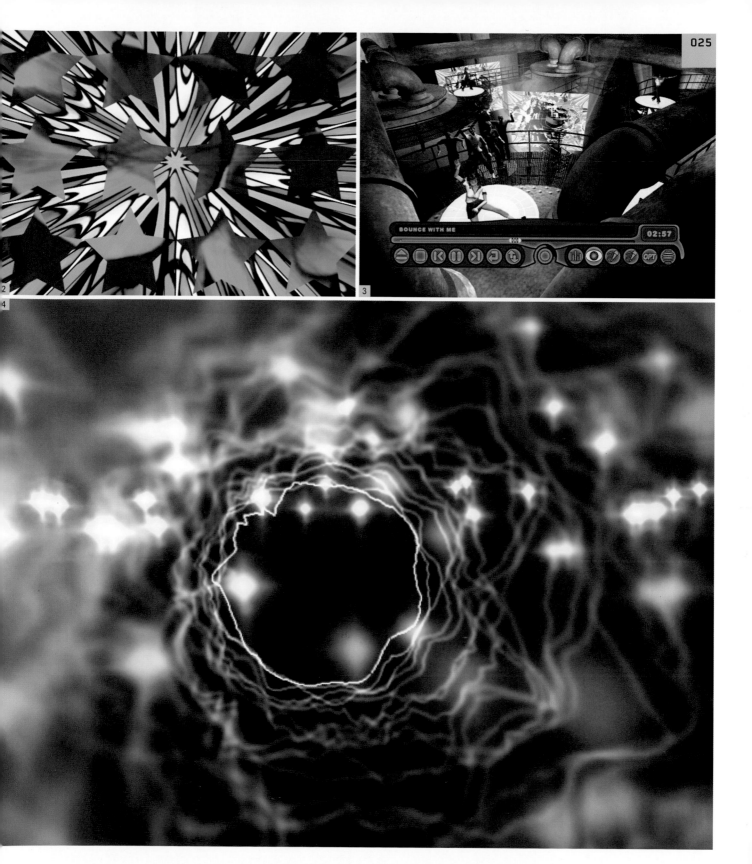

BOUNCE WITH ME

02:57

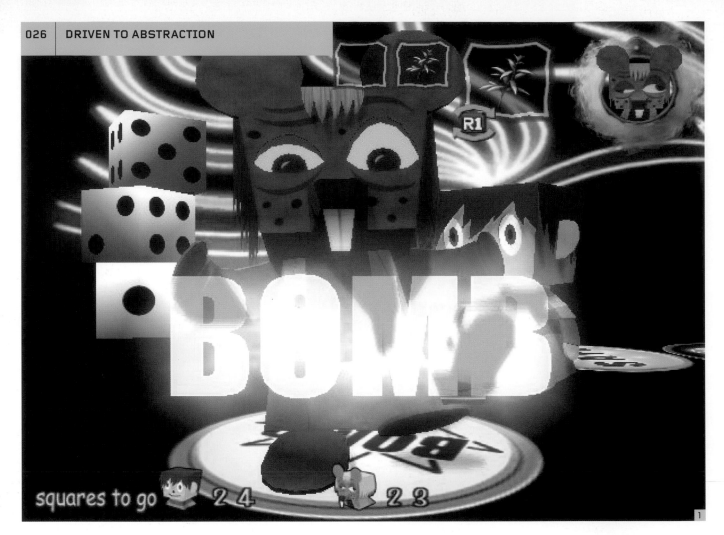

squares to go 24 23

Ian Lovett, director of art at Big Blue Box Studios, notes: "As the industry tries to win larger, more mainstream audiences, abstraction is often a choice that is passed over during the conception phase, in favor of more understandable environments. Hopefully once the industry matures, and as sources of revenue start to support smaller niche games, more daring worlds will return."

Ernest W. Adams, cofounder of the International Games Developers Association, agrees. "The biggest problem with abstract environments is publisher resistance. Publishers are reluctant to fund any game that isn't blindingly obvious, and by their very nature, abstract games are not blindingly obvious. There will always be a few around—as when geniuses like Alexey Pajitnov (the inventor of Tetris) come along—but not many.

"It is easier to be representational rather than abstract because representational game worlds come with an entire set of symbols and relationships that we can expect the player to be familiar with. It is not necessary to explain a World War II battlefield or a racing car to the player. Abstract worlds require the designer to explain the situation to the player, and that's not easy to do in a way that feels smooth and natural."

"Literal environments are more accessible to the audience," says Chris Bateman, managing director of International Hobo. "But abstract game settings are easier to design because there are fewer restrictions. All game worlds will inevitably be abstracted to a certain degree, but the days of completely abstract settings—like *Pac Man*—are mostly behind us."

1. Parts of **Gregory Horror Show** by Capcom are a lot like a board game, but one where the player sees the action from the point of view of a playing piece, lending an unusual dash of realism to the abstract format.

2. **Catan** by Capcom reproduces the abstraction of a board game, all the way down to digital dice. The board game format has always been visually enticing, although when it's translated to the screen, it lacks the physical feel of the playing pieces and the all-

important social gathering around the dining room table.
3. Images to conjure with from **Sudeki** by Climax.
4. Capcom's **Gotcha Force** is a game of battling toys. Here the game uses the minimalism associated with toys.

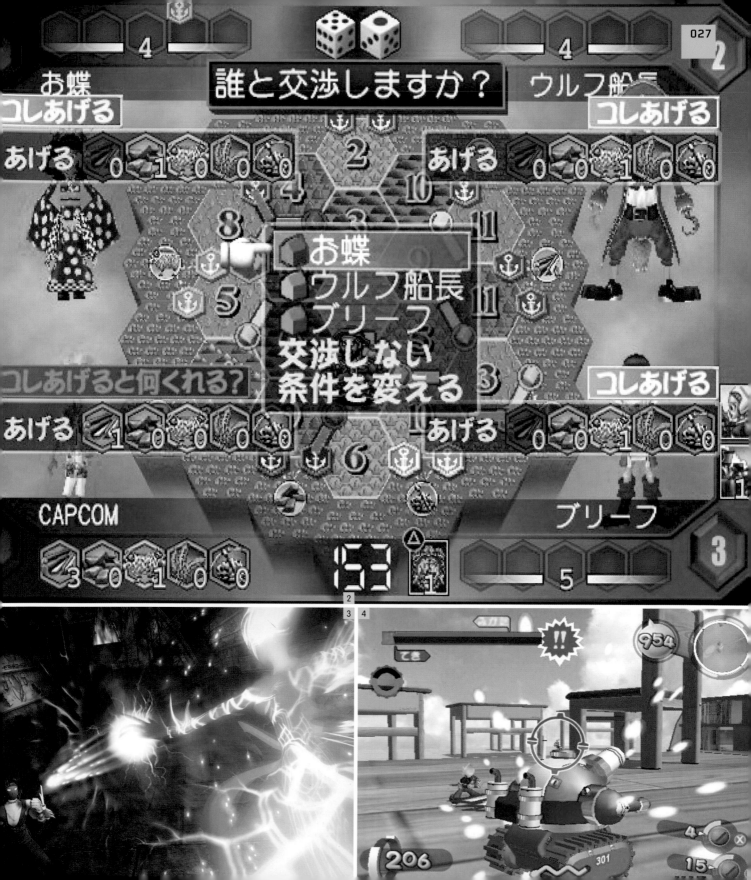

INSIDER SECRETS: WORKING METHODS

INDEPENDENT GAME DEVELOPER **ANTHONY FLACK** DESCRIBES HIS METHODOLOGY
FOR CREATING VIRTUAL WORLDS:

"My requirements for making games are fairly simple. I don't need much space or a whole lot of equipment—just a small desk with the computer on it, and next to it another small desk where I set up my camera and lighting and do all the animation.

"The models are mostly just made out of solid plasticine—I use either Van Aken modeling clay or Jovi Plastilina, depending on my requirements. If I am going to be doing a lot of rigorous animation with a particular model, as I would with the main character in a game, for example, then I'll take the extra trouble to build a posable skeleton for it out of wire and air-hardening epoxy. I also make any small, detailed parts out of oven-hardening polymer clay (Sculpey III is the best kind), so I don't have to worry about them getting messed up during the animation process. Any kind of energetic animation sequence will mince up the models

pretty quickly, so anything I can do to make the models more robust is well worth it. Trying to complete an animation sequence while the model is falling apart on you is not much fun! But if the model is only meant for a short, simple animation sequence—or if it's just a static background object—then I'll just make it out of solid plasticine. One of the great things about solid plasticine models is that as long as you have a decent selection of colors, you can pretty much conjure up whatever you're thinking of—and in quite a short time, too.

"As far as modeling tools go, I just use my fingers—and occasionally, a regular kitchen knife.

"The models are photographed with a Canon EOS-D30 camera, which was the first semiaffordable digital camera to come out that looked and acted just like a proper SLR camera. It's a few

►►

All images from titles by Squashy Software. Animated clay figures have always had strong appeal. Part of the success of Flack's style is that nothing appears too finished; the objects still

look like clay—often still bearing the artist's fingerprints—offering a refreshing, almost tactile connection between the artist and gamer. Flack makes clever use of 2D technology to

render 3D game material. Almost all current game engines generate 3D in real time, with models created virtually inside the computer rather than physically on the tabletop.

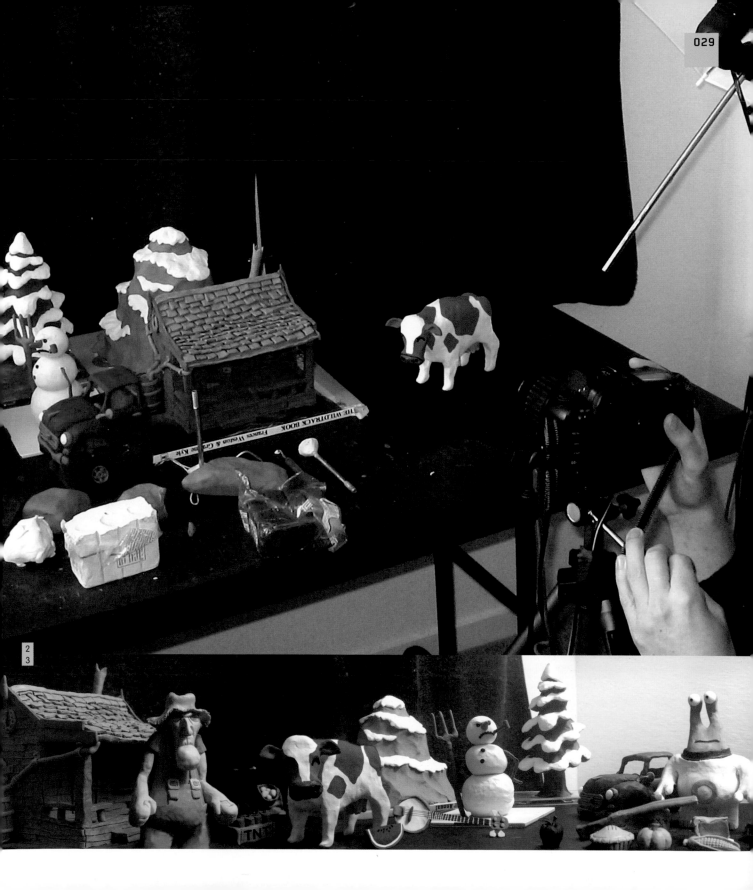

1

years old now, and the new cameras that are coming out these days are just getting better and better, but I love my D30, and it takes great pictures. Another advantage is that I can control it directly from the computer—a simple click of the mouse, the shutter snaps, and the picture is sent straight to my hard drive via the magic of the USB port.

"Once the images are on the computer, I use Adobe Photoshop to remove the background, clean them up a bit, and convert them into a format suitable for use in a game. Sometimes I have to apply a bit of digital trickery to make small adjustments to the image—to move an arm slightly, adjust the tilt of the body, turn the head a little more, that sort of thing. These adjustments are necessary because, unlike conventional stop-motion animation, in which each frame in a sequence follows on naturally from the one before it, animating a character for a computer game requires many different sequences of animation to match up with one another seamlessly. Sometimes I have to cheat a little to make them all fit together properly. After that, I'm ready to get the images actually up and running in the game.

"I swap my animator hat for my programmer hat. I'm currently doing all my programming in Blitz3D, which is a terrific little language designed especially for making games. I love it because it's very immediate. I don't want to spend my time wrestling with obscure compatibility issues, or glitches with hardware drivers—I want to get the images on the screen with the minimum of fuss. And I want to be confident that if it works on my machine, it'll work on everyone else's machine, too. Blitz3D takes so much of the hassle out of PC programming, yet it's also flexible enough to meet my slightly unconventional requirements.

"Finally, once I have written the necessary code to deal with the new graphics, that's when I get to the exciting part. I compile the code, the game runs, and with any luck, I see the new model come to life onscreen for the first time. This is always the most enjoyable part of the process; it's what makes all the hard work worthwhile. The last thing left to do is play around with it a bit, making small adjustments to the code until the new addition is looking and behaving just the way I want it to. Then it's time to start the whole process again, and add the next thing."

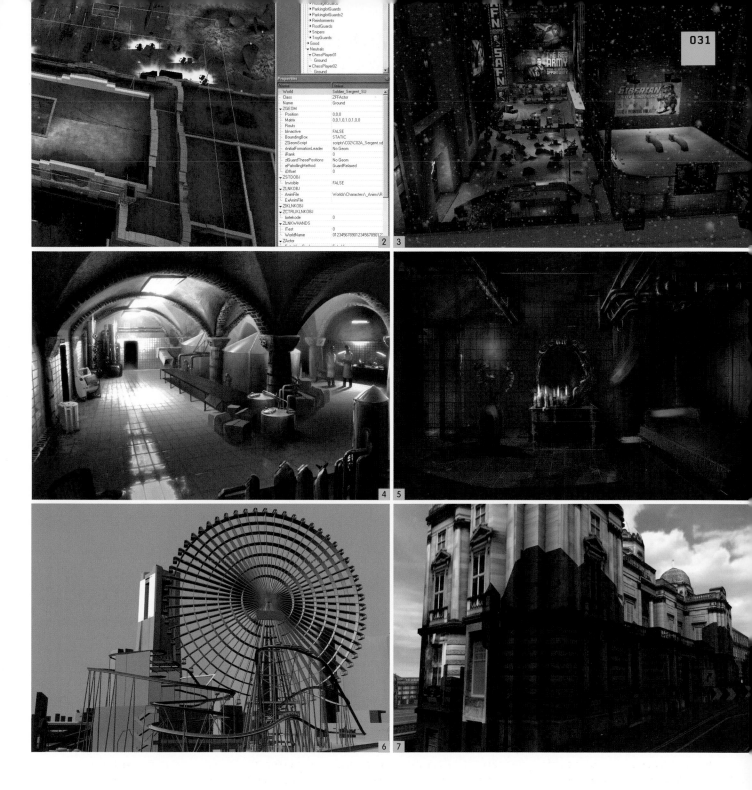

1. Level design for **Enter the Matrix** by Shiny Entertainment, reconstructing environments from the films.

2, 3. **Freedom Fighters** by IO Interactive. Some of the level design is shown in IO's main level editor.
4, 5. Concept art from **Hitman 2: Silent Assassin**, IO Interactive.

6, 7. **Project Gotham Racing 2** by bizarre Creations. Yokohama and Edinburgh, meticulously re-created.

HANDS ON: DRESSING THE SET

The artist has godlike powers of manipulation over a player's experience of the game. This is true in other media as well—the director's role in film production also consists of manipulating the disparate elements of script, actors, cameras, lighting, and so on to form a single unified experience for the viewer.

SCALE
Exaggerating the size of some buildings and landscape features can take the breath away, but it can be a drag for the player struggling across them. Small spaces, like cramped rooms or sewage pipes, often have to be rendered larger than in real life because the player character is less agile than a real person at moving around in a restricted environment.

STRUCTURE
The Greeks built a bulge into the columns that held up their temples—not for any structural reason, but because if the columns had been straight, they would have looked too weak to support the roof. The theory of giving buildings realistic weight is important to game architecture too, especially since these structures are an illusion composed of flimsy polygons.

ESTHETICS
Beauty resides primarily in finding a proportion and composition of elements of a structure that just look right. The difference can be in a few millimeters in the length of roof, the thickness of a window frame, or the placement of a couple of "random" rocks on a beach.

1–7. Concept art from **Freedom Fighters** by IO Interactive. Any modern game requires hundreds of concept drawings. Apart from establishing the game's visual style, these provide an essential central reference that the whole art team can work with.

8. Test level from an early build of **Hitman: Contracts** by IO Interactive. These buildings are finished but are temporarily assigned placeholder textures while they are awaiting their proper surfaces.

COLOR

Color comes locally from objects and combines with the color of the light illuminating them. A common mistake is to oversaturate colors. While a TV tube can display RGB red at maximum saturation, you would never see such a hue in real life. Color can provide cohesion to a level. It can also be used (most often in lighting) as an important navigational aid to the player, who could otherwise easily become lost in a virtual landscape.

COMPOSITION

The traditional idea of composition gets turned on its head when the third-dimension is added to game worlds, and the player becomes free to move and look around. It seems that the artist must give up the compositional control that is so important in static 2D imagery. The rules of composition—the descending order of importance of visual elements, framing, the flow of lines, and so on—can still apply whether the player is still or moving. You need to build composition into the 3D structure of the world at every level.

JUSTIFIED AND ANCIENT

3

OUR DISTANT PAST

"MY NAME IS OZYMANDIAS, KING OF KINGS,

LOOK ON MY WORKS, YE MIGHTY, AND DESPAIR!"

PERCY BYSSHE SHELLEY, *OZYMANDIAS*

THE CLASH OF ARMS, THE SMOKE OF TEMPLE FIRES ... THIS WAS THE TIME WHEN CIVILIZATION WAS YOUNG AND STILL HAD A BILLION POSSIBLE FUTURES. FASCINATED BY OUR ORIGINS, WE NOW HAVE THE OPPORTUNITY TO TRAVEL BACK, TO BE DROPPED IN AT THE DAWN OF HISTORY AND FEEL FOR OURSELVES HOW IT MAY HAVE BEEN. IS IT THE LURE OF SIMPLER TIMES? THE PURITY OF A WORLD THAT SOMEHOW SEEMS CLOSER TO THE SACRED? OR MERELY A FLIGHT BACK TO INFANCY, AWAY FROM FEARS OF OUR OWN ERA'S MORTALITY? FOR WHATEVER REASON, GAMES ARE RECASTING THE PAST IN THE PRESENT TENSE TO ENABLE US TO BECOME TOURISTS OF DISTANT TIMES.

Age of Mythology: The Titans by Ensemble

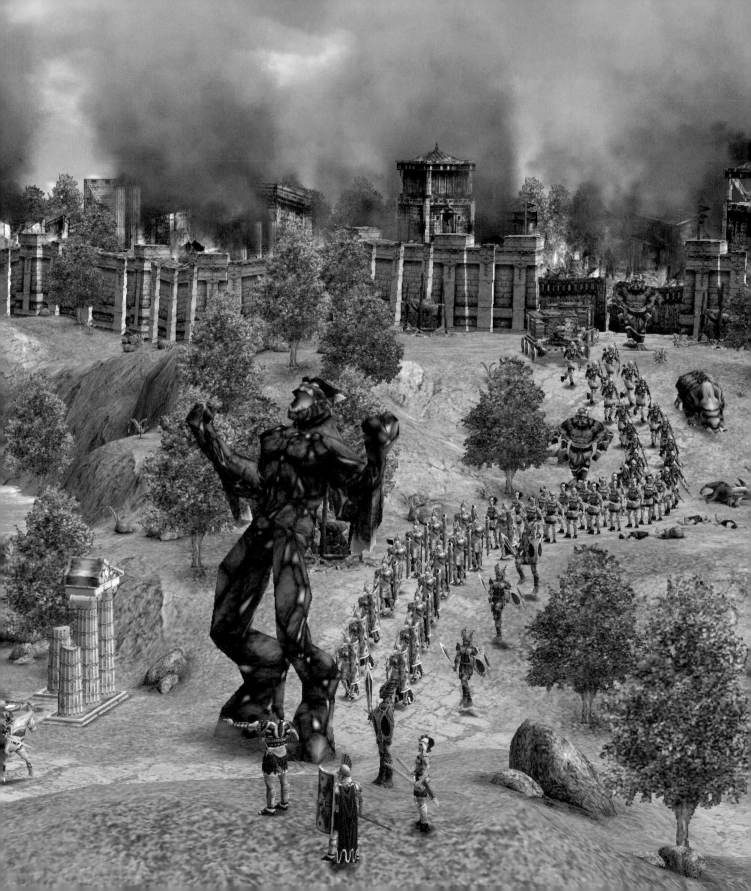

DIGITAL EPICS

"THE CLOUD-CAPP'D TOWERS, THE GORGEOUS PALACES,
THE SOLEMN TEMPLES, THE GREAT GLOBE ITSELF,
YEA, ALL WHICH IT INHERIT, SHALL DISSOLVE
AND, LIKE THIS INSUBSTANTIAL PAGEANT FADED,
LEAVE NOT A RACK BEHIND."

WILLIAM SHAKESPEARE, *THE TEMPEST*

Not all cultures have shared our modern obsession with the past. Few of our ancestors would have seen any point in archeological digs unless there was the chance of finding some gold. To most people from past generations, the idea of probing, cataloging, and reimagining the past would simply be cause for bewilderment. Old ruins were a source of new building stone, the Sphinx's nose was good for target practice, and the only use for adornments that were centuries out of style was to melt them down and start over.

Why is it different today? Where did we get our interest in the distant past?

Perhaps modern visual media has something to do with it. Reading books about ancient times cannot compare to flying over Alexander's army on the march, or taking a virtual tour of Nero's palace—experiences we are only now granted thanks to modern CGI.

"Ancient civilizations are being brought to life in an entirely new way as computer graphics and archeological data have taken radical steps forward in the last few years," says Tim Shymkus from High Voltage Software. "Really, for the first time, people can experience history, as opposed to simply reading about it. Games

have allowed us to re-create the glory and brilliance of the ancient world and in turn have allowed us to become a living, even controlling, part of it."

Games can take us right into a long-dead civilization and make it leap into vibrant, bustling, noisy life. The portrayal of ancient worlds in games can be so vivid—and our immersion in them so complete—that we are apt to forget that it is still just an artist's vision, not the way things really were.

Some artists embrace this. The worlds of LucasArts' *Gladius* and Acclaim's *Gladiator: Sword of Vengeance* do not depict a historically accurate ancient Rome. The games use Rome as a springboard to build a new fantasy setting of a kind we haven't often seen in games. This is a Conanesque Roman empire peopled by magicians, giants, bikini-clad Amazons, and talking apes.

1–5. Although it's a strategy game, Lionhead's **Black & White 2** opts for a completely free-roving camera, enabling the player to swoop, disembodied, into the thick of the action. The effect is quite startling, reinforcing the fact that we are witnessing a new art form that can only be created digitally.

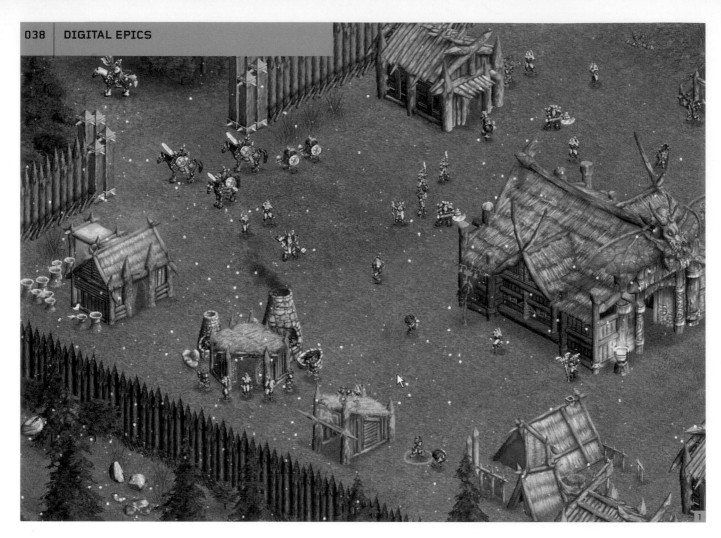

All of this calls into question the notion of there being any such thing as historical authenticity. Miguel de Cervantes wrote that history is the mother of truth. As interpreted by Jorge Luis Borges, this means that "Historical truth…is not what has happened; it is what we judge to have happened." Why, then, shouldn't game artists seek to portray a subjective version of the past—a model as valid, if not more so, as an archeologist's attempts at veracity? When the streets of Rome look sparkling clean in *Age of Empires*, for example, is that not a perfectly valid depiction? Even if the historical streets would have seemed squalid to somebody stepping directly off an airplane from the twenty-first century, that is only reality seen through a tourist's eyes. To a Roman, it was home.

Other games prefer to serve up their historical sources without the trimmings. *Dead Man's Hand* from Human Head Studios and Related Designs' *No Man's Land* are authentic—or rather, objectively credible—re-creations of the past.

Against Rome, from Independent Arts, is based on an in-depth reconstruction of a real historical period. It is set around the fourth and fifth centuries AD, the time when the Roman empire began to falter in its expansion into the numerous surrounding "primitive" territories, which the Romans disparagingly called Barbaria. The player has control of a barbarian tribe and can send raiding parties to snipe away at the wealth of Rome.

Beginning in a small village in Germania or Sarmatiana, the player raids other settlements in search of food, weapons, and gold. The tribe grows and flourishes and eventually takes on the might of Rome—a seemingly impossible struggle, but in reality, within another century the entire Western empire had fallen to the Visigoths and Ostrogoths.

With their implied agenda to make us active participants, not merely spectators, in an imaginary world, games may hold the key to a fresh new way of shedding light on the farthest dark corners of history. As in all art, the journey is a search for truth. The interesting question is what truth really is.

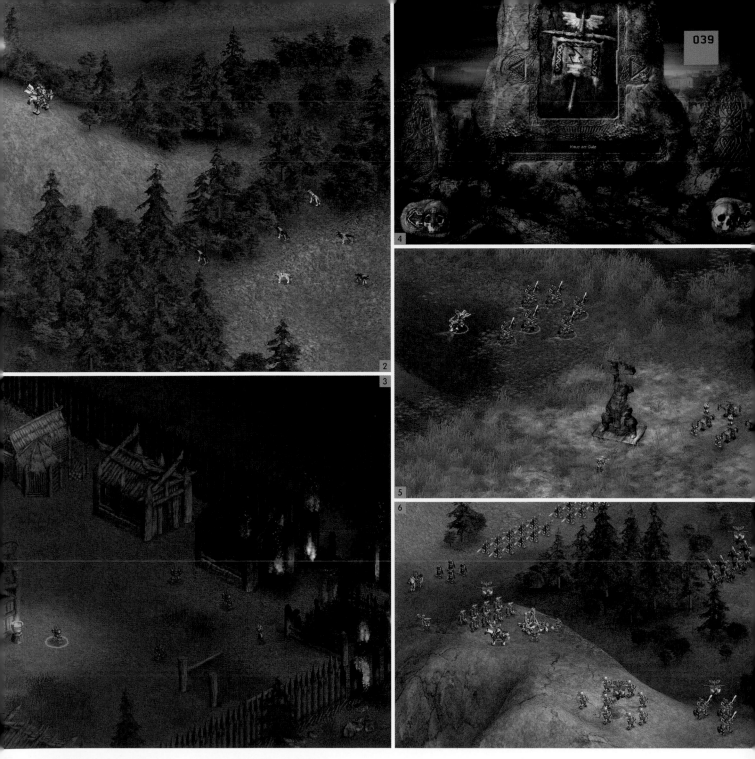

1–4. **Against Rome** by Independent Arts. Like many strategy games, this opts for an overhead view, reflecting tabletop wargaming.

5–6. The effect of foliage in the 3D landscape is clear in these shots from **Against Rome**. Until recently, if vegetation appeared at all in a game, it was made up of crude, hard polygons. Modern 3D graphics systems allow for more realistic and plentiful foliage, which has the important effect of softening the digital landscape, giving it a gentle beauty akin to impressionist painting.

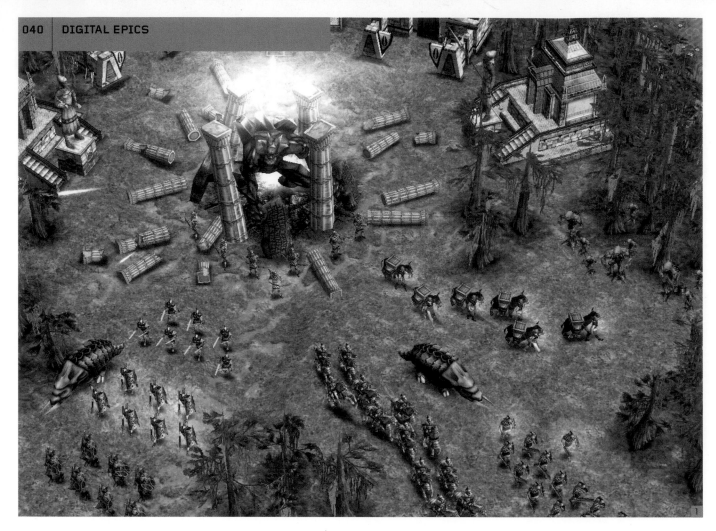

"To what extent should game artists and designers worry about authenticity in historical games?" asks Ian Lovett. "That entirely depends on the result you are trying to achieve. If you are trying to create a realistic game world that is historically accurate, then you should takes great pains to do that. However, one should not lose sight of the fact that this is entertainment. Educational games and other media might well have different criteria."

"Authenticity has an important role," says Marc Holmes, "but there are many other concerns to do with technical limitations and gameplay—how the models are constructed and animated, how the gameplay really works. The sheer inherent difficulty of getting a great-looking game running at a good frame rate seems to preclude exact authenticity and to encourage artistic solutions."

"The question of authenticity largely depends on how the game is positioned," says Tim Shymkus. "My preference is that, if the game is going to be based on real historical events or people, the team should strive for as much accuracy as possible—the reason being that these games are at the same time teaching players about history. You may find people who would never pick up a history book,

and yet they may completely enjoy a game like *Age of Empires*. If this becomes their sole resource for historical information, then I think we have some responsibility to give them the facts as they are currently known. Certainly some liberties will always be taken, but the core should remain as true to fact as possible."

The authors of this book can confirm the wisdom of this. Master Inigo Hartas, son to one of us and godson to the other, knows at age 5 the story of Joan of Arc in some detail—not from books or from talking to us, but simply from playing *Age of Kings*!

Age of Mythology: The Titans by Ensemble Studios. This series opts for a crisp, colorful style that helps the player track the myriad different units that can be in play at any one time. The beautifully modeled characters and buildings have an almost jewellike quality about them, while the clear blue sea teeming with fish, its gentle surf lapping on the beaches, looks enticing enough to jump into.

3

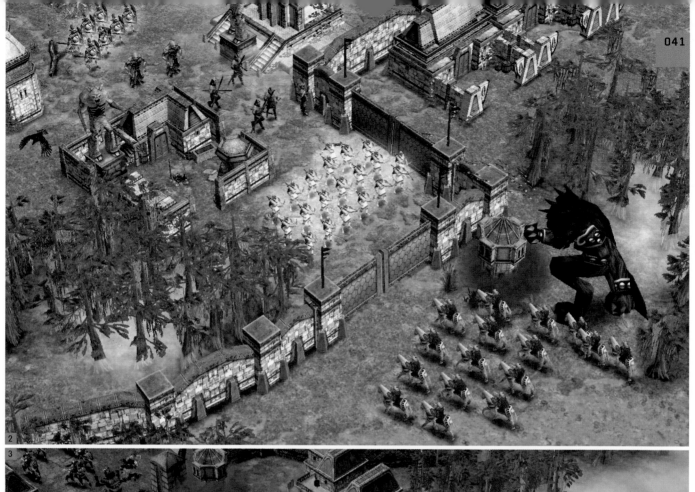

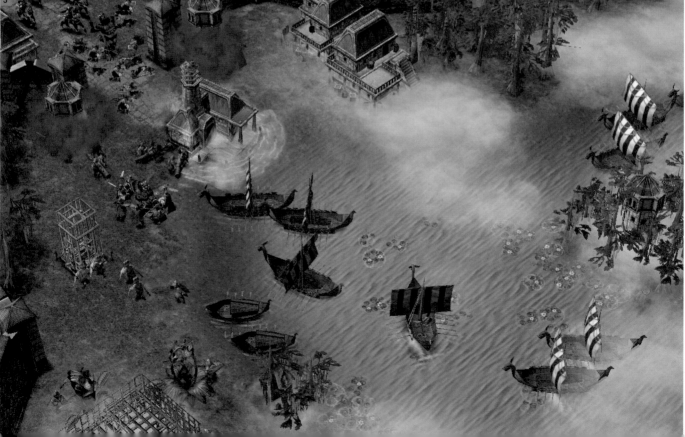

INSIDER SECRETS: ET IN ARCADIA EGO

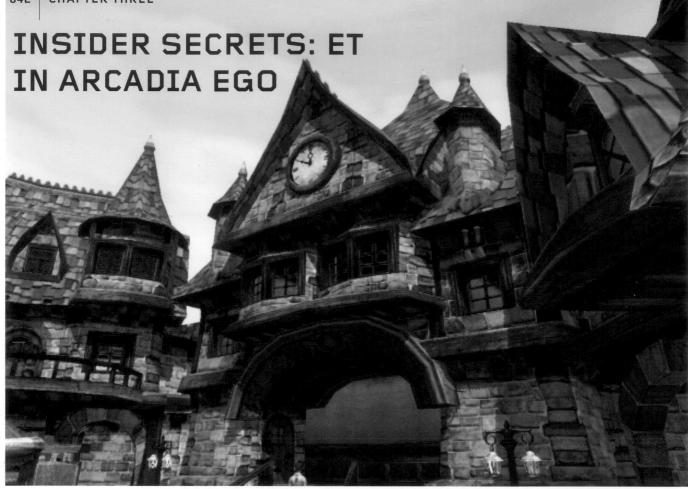

Big Blue Box Studios, one of Lionhead's satellite studios, is currently developing *Fable*, which promises to be an exciting video game evolution. Art director Ian Lovett tells us: "One of the many areas we spent a lot of time on during the development of *Fable* was making our landscapes believable without looking photorealistic. We spent a lot of time on referencing—taking lots of our own photos, looking at books, the Web, everything we could find. It's pretty easy to find photorealistic ground or rock textures, make them tileable, and stick them into a game engine. But for *Fable* and the game style we'd chosen, we wanted something that looked believable but not obviously taken from a touched-up photograph. That meant basically hand-painting all the ground textures, and then making sure each ground texture worked well with other textures in the area.

"Having a powerful game engine and editor made the job of creating the feel and style we wanted technically a lot easier, allowing us to quickly paint down and blend textures as we created them. Every area of the game has specifically created ground textures to reflect both the geography and the flora within the region. We went through many iterations for every texture to avoid obvious repetition, and to make sure that each texture looked natural within its chosen region. Often what might look good in Photoshop looked completely unconvincing in-game, not because the texture was bad, but because the element of natural believability (looking natural and believable, but not photorealistic) wasn't there. That natural believability was key in making the *Fable* landforms look the way they do."

Fable by Big Blue Box Studios highlights the growing importance of lighting effects, which in the past were either overlooked or were technically impossible. Effective lighting can not only make the gaming experience more realistic, but it can transform the game's world into a glorious interactive work of art—as though you're stepping into a painting.

3

HANDS ON: THE LIVING ROCK

CREATING REALISTIC LANDFORMS AND TEXTURES FOR LANDSCAPES

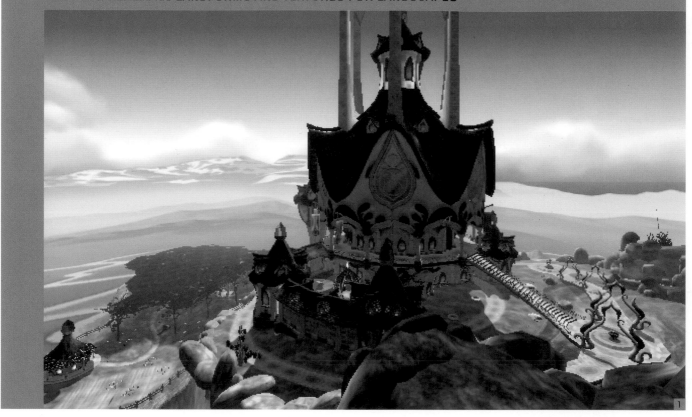

Whereas a game set in a futuristic environment can sometimes get away with fairly bland, simple industrial metal textures; in an historical setting there is no escape from Nature. Sure, you can keep your audience locked up in a virtual castle dungeon, but sooner or later they will escape into the great outdoors. All too often, a quick height map of rolling hills with a dull blanket of tiled grass thrown over it is all that greets them. As technology advances, we are seeing improvements in this area. Long grass waves in the breeze, and the leaves of trees turn yellow in the fall. While this is welcome, many artists forget other aspects of the landscape: the shape of rocks crushed by untold seismic pressure, the scars left by winter rains, the delicate folds made by the primitive farmer. The best way to bring reality into the game is to step out of the studio door and experience it for yourself.

WIDE ANGLE

One of the biggest problems for the computer game artist is the sheer scale of a landscape. Many 3D games set outdoors suffer from a strange sense of claustrophobia, a feeling that one is walking around a TV set and will stumble into the painted backdrop at any time. Exterior game environments essentially have to be set up this way because of the limits of computing power. Color is the best way to add a sense of distance: cool blues, purples, and greens will visually recede into the distance. Also handy are the old tricks of forced perspective—telegraph poles or train tracks converging into the horizon, and miniature animated birds or spacecraft in the distance—beloved of filmmakers obliged to fit the whole of imperial Rome, say, onto a single sound stage.

1. Not all worlds are realistic. In **Kameo: Elements of Power** by Rare, the feminine style is not restricted to the architecture but is also carried through all elements of the landscape.

2. In Phenomic's **SpellForce: The Order of Dawn**, this beautiful sunrise works so well because of the exaggerated rays that fan out across the sky and are carried to the viewer through the morning mist.

3. **Middle-Earth Online** by Turbine. A dour day perfectly captured, not only with rain, but also other important atmospheric elements: the low cloud, the diffused, low light, and the gray drizzle obscuring distant hills.

3

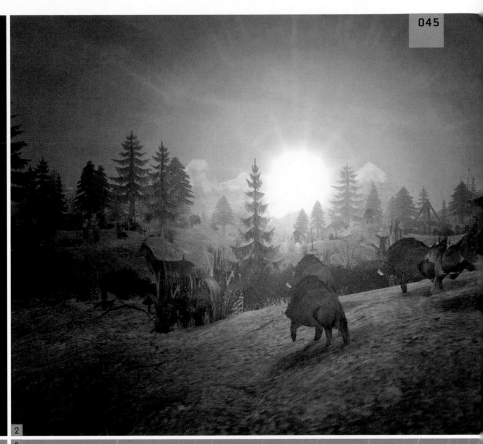

SERRIED RANKS

A huge landscape means a huge quantity of work. Many elements—like trees and rocks—have to be cloned, otherwise the effort of modeling hundreds of individual specimens would quickly become overwhelming. One approach is to model a few of each element and scatter them around, randomizing their size and angle to disguise repetition. The problem is that this has a sameness that can bore the player and reduce the feeling of distinctness of place, which is important for navigating. Another method used is to procedurally generate foliage and landforms. With every passing generation of software, this is becoming more convincing, but it still tends to suffer from a generic quality. Ideally, the artist should place individually crafted landmarks in the landscape as much as possible.

THE WHOLE LANDSCAPE

A true landscape experience is made up of more than just physical forms. Weather, light, and sound—elements that regularly get skipped in the hectic melee of game development—all play an equal part. Work closely with the sound engineer to produce a changing soundscape, layering the noise of wind in the trees, the buzz of insects, cries of distant wildlife, and the background "hum" that exists in even the most remote places. Weather effects and the motion of the sun through the sky add to the sense of realism that is vital in even the most fantastical world.

THE PAST IS A FOREIGN COUNTRY

4

HISTORICAL VISTAS FROM THE MEDIEVAL PERIOD ONWARD

HISTORY PROVIDES A RICH SOURCE OF ARTISTIC REFERENCES THAT GAME DESIGNERS HAVE BEEN SWIFT TO EXPLOIT. ONE ADVANTAGE OF DRAWING ON A HISTORICAL PERIOD FOR INSPIRATION IS THAT PEOPLE RECOGNIZE IT. ALSO, THE ARCHITECTURE, COSTUMES, AND COLOR PALETTE ALL COME AS A READY-MADE, INTERNALLY CONSISTENT PACKAGE. ALL YOU HAVE TO DO IS RESEARCH IT—ALTHOUGH EVEN THAT MAY NOT BE AS SIMPLE AS IT SEEMS. THERE IS NO SINGLE MIDDLE AGES, FOR INSTANCE. RATHER, THERE ARE MANY VISIONS AND MANY SHADES OF SUBJECTIVITY IN HOW TO MINE AND WORK MATERIAL FROM SUCH A RICH VEIN.

Sudeki by Climax

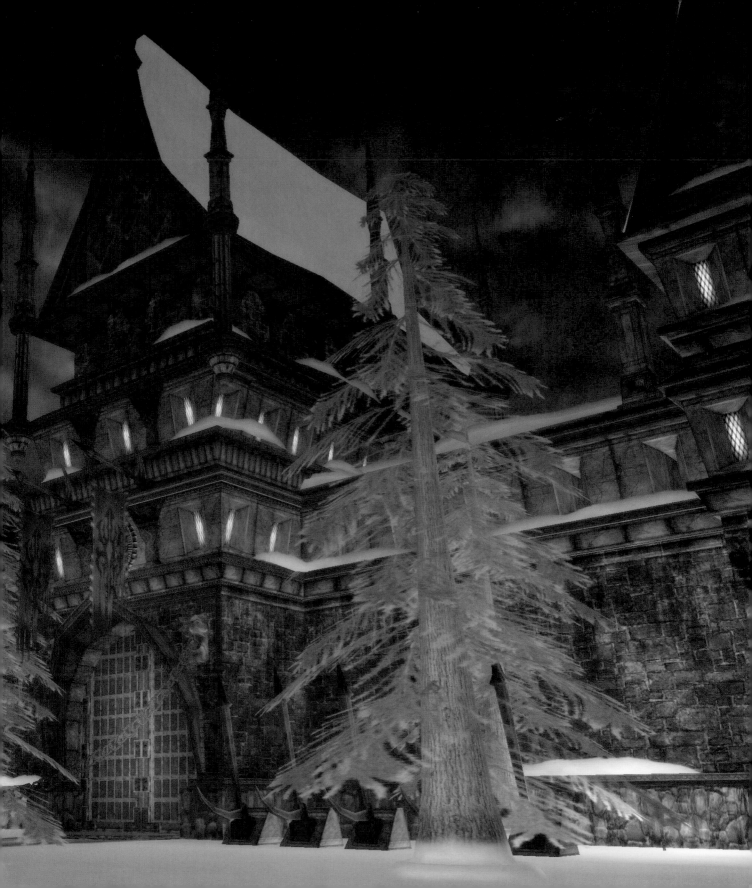

SERF 'N' TURF

"TO BE IGNORANT OF WHAT OCCURRED BEFORE YOU WERE BORN IS TO REMAIN ALWAYS A CHILD."

MARCUS TULLIUS CICERO, *ORATOR*

1

The ancient world—in its modern manifestation, at least—was a time of innocence. Wars were nobly fought, great empires built, deeds undertaken that would be sung of for millennia. Love and hate blew like summer clouds—the swift, strong, primary emotions of children and gods.

That being the case, the Dark Ages came on like adolescence. In fiction and imagination, the chivalric age that followed still had its heroes, but they were as often plagued by doubt as by passions of boldness and daring. Gawain is racked with guilt, Lancelot runs mad and naked in the woods. When Alexander slays his best friend, the very act speaks of a divine king's tempestuous passions. The same deed committed by Charlemagne places him in the company of Al Capone or Stalin.

The allure of the medieval era, then, is that it seems more real, more down and dirty, than our idealized, Hollywood-wrapped image of the ancient world. It's the time when history broke out in zits.

1, 2. Capcom's **Robin Hood: Defender of the Crown** presents a cleaned-up, idealized view of medieval life, but it's perfect for the collective childhood memory of the story.

3. **Middle-Earth Online** by Turbine. The increase in processing power allows developers to add more detail, which is important if we are to find smaller environments convincing.

4. Ubisoft's **Prince of Persia: The Sands of Time** revamps an old classic. Tales from the medieval Middle East make a visually rich game world.

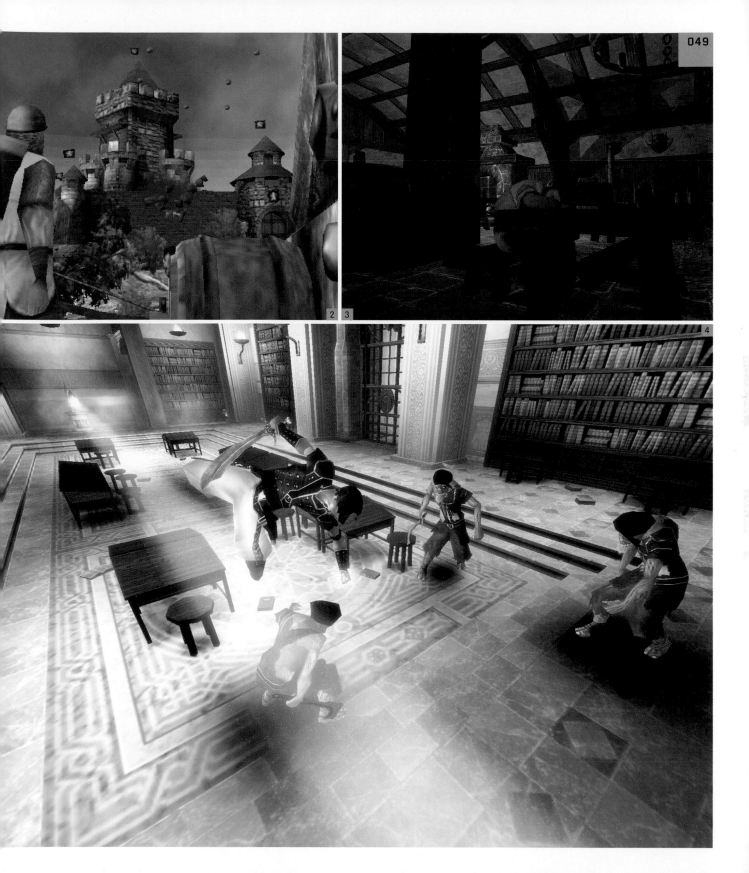

CENTURY DUTY

WHY AREN'T THERE MORE "STRAIGHT" HISTORICAL GAMES? IN FILM, WE GET EPICS
LIKE *GLADIATOR* AND *ALEXANDER THE GREAT*, BUT GAMES USUALLY LIKE TO SPICE UP ANY
HISTORICAL SETTING WITH FANTASY. IS THAT INTRINSIC TO THE MEDIUM?

"It's because a lot of the people who currently make and buy games have strong leanings toward science fiction and fantasy," says Matt Kelland of Short Fuze. "Okay, I'll say it: a lot of gamers are geeks. And a lot of geeks like sci-fi and fantasy, so they make the games they like. That said, I'm surprised by the number of historical games that can be found out there if you look around. Mostly they're produced by small indie companies and don't make the big time, but they're out there."

"The temptation to tamper is always strong when you're creating a world from nothing," points out Big Blue Box Studios' Ian Lovett, "especially when you consider that games are at their heart an interactive entertainment form. However, I would say there is a broadly similar spread of historically accurate titles available in both genres. *Age of Empires* is one very successful franchise based on

historical accuracy, and there are now a huge number of games based around real-world conflicts. In fact, if anything, I think Hollywood has a more easygoing attitude to reality when it comes to history. Game settings are generally moving closer to the real world. *Gran Turismo*, *The Getaway*, *Max Payne*, *Commandos*, and so on are all striving to re-create either historically accurate worlds or realistic modern ones."

"In cinema, the storyline carries us along," says designer Ernest W. Adams. "The medium entertains through narrative, which includes as an essential element placing someone or something that we care about in danger. This danger need not be physical; it can be social, economic, or even moral. Introducing magic into *Gladiator* would only distract from our desire to know whether Maximus achieves his revenge or not.

1, 5, 7. Arkane Studios' **Arx Fatalis** is a near-perfect medieval world, but missing the build-up of detritus, weeds, and dirt in the corners—and sans the Black Death, too.

2. Capcom's **Chaos Legion**—a fabulous reinvention of Gothic architecture.
3. **Elder Scrolls III: Tribunal** by Bethesda Softworks: an interesting mix of Gothic and Oriental forms.

4. A grim day amid a beautiful sculptured landscape, in **Gothic 2** by Piranha Bytes.
6. Riding through the glen in Capcom's **Robin Hood: Defender of the Crown**.

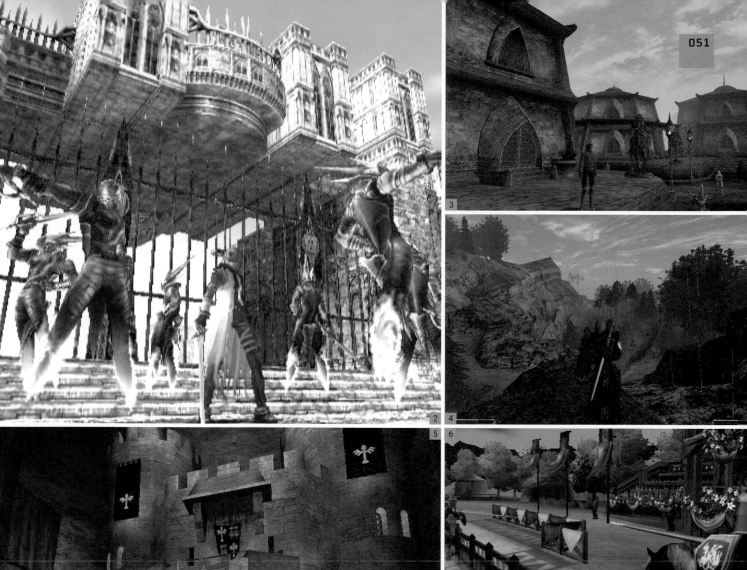

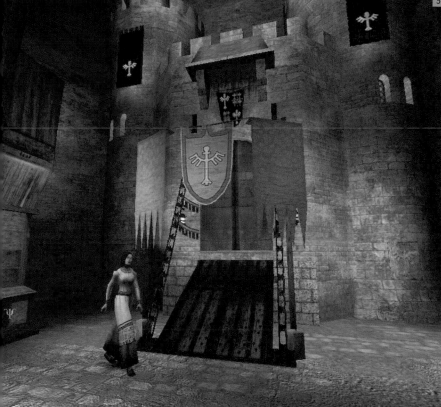

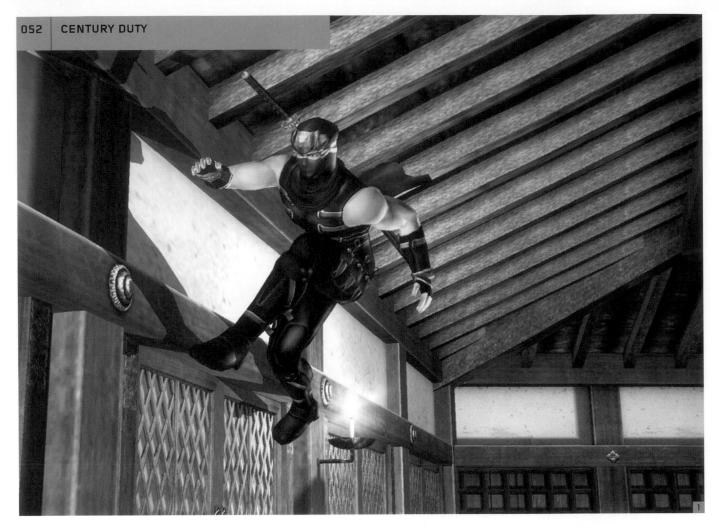

1

"In games, the player seeks the power to act upon challenges. For the most part, games offer an opportunity to do things that we could not do in the real world: explore dungeons, and so on. Unfortunately, in most historical settings, the people had more limitations than they do today: simpler, weaker weapons, slower transport, and so on. These detract from the player's dreams of power. As a result, there has been a tendency to give the player fantasy powers whenever the game has a historical setting."

Turbine's Marc Holmes says: "It seems limiting to stick with Roman soldiers when you could be doing Mars, god of war. I think historical settings will become more appropriate if games ever develop into character-driven stories. But at the moment, this is primarily a visual, visceral medium."

Fantasy, then, at least in the opinion of these developers, will remain the dominant genre in historical games. We've already noted that the Middle Ages are a very common game setting, perhaps connected with the trend in fantasy gaming that originated with the paper-and-dice role-playing game, *Dungeons & Dragons*. Are any historical periods underused in games?

"I've always felt that the history represented in games is driven by the cultures that create them," says Ian Lovett. "We also have a tendency to concentrate on the really dramatic periods of the world's history, perhaps overlooking visually and culturally rich periods of peace and order.

"I feel that South American history is one area that has been overlooked, along with the dramatic changes that swept through the world during the British colonial period, particularly in India and the Far East. Maybe we'll get around to creating a world populated by conquistadors one day."

"Far and away the most ignored historical period is the high Islamic civilization of the thirteenth century," says Ernest W. Adams. "While Europe was living in drafty castles and expending its energy on feudal and religious squabbles, the Islamic empire stretched from Persia to Spain and made advances—or preserved advances from earlier periods—in medicine, astronomy, chemistry, mathematics, architecture, and many other fields. This period is not forgotten in the Middle East, where it is still looked back on as an age of glory; but the West is largely ignorant of it."

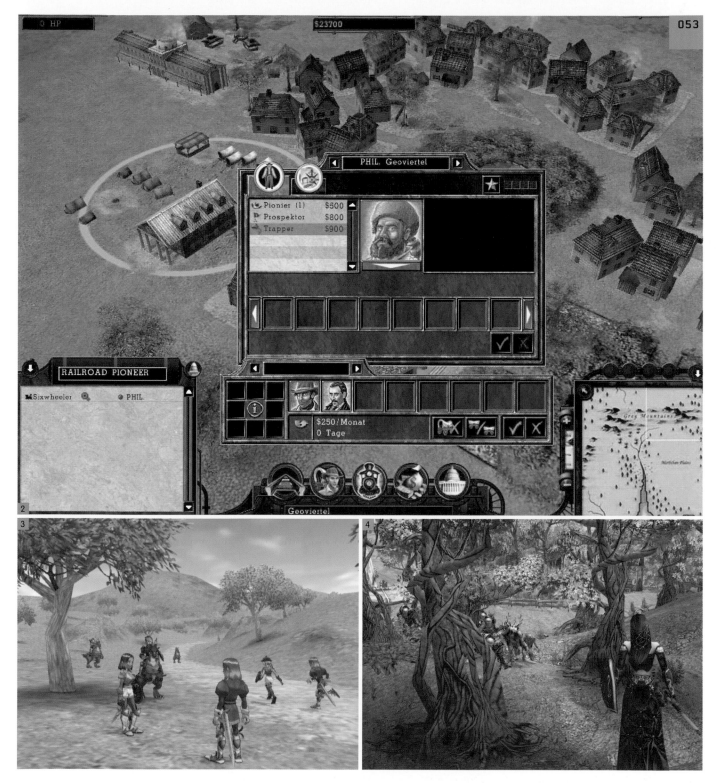

1. Tecmo's **Ninja Gaiden**.

2. **Railroad Pioneer** by Kritzelkratz 3000. Historical accuracy is becoming attainable in games—except for the interface, a necessary but artificial construct that developers can only design in the flavor of the period.

3. Level 5's **True Fantasy Live Online**.

4. Phenomic's **SpellForce: The Order of Dawn** takes place in a pure fantasy world, but with many references to historical fact.

FACING YOUR DEMONS

CAPCOM'S *ONIMUSHA 3* IS PART OF A NEW TREND IN GAMES: INSTEAD OF PLAYING FAST AND LOOSE WITH HISTORICAL AUTHENTICITY, IT USES REAL EVENTS AS A SPRINGBOARD FOR A NEW STORY.

On Midsummer Day in 1582, the warlord Nobunaga Oda was assassinated by his rivals, the Akechi family. He had spent the night at the Honnoji monastery, on the Nishi-Toin highway, and was ambushed there at dawn by Mitsuhide Akechi and his men—an attack that took Nobunaga by surprise, as the Akechi were his supposedly loyal retainers.

Thus far the story is as history records. In *Onimusha 3*, the battle at the monastery focuses on Samanosuke Akechi. The forces fighting to protect Nobunaga now include demons—a not unreasonable poetic liberty, given historian Sir George Sansom's analysis that Nobunaga was "a cruel and callous brute" given to wholesale slaughter for the sake of raw ambition.

A rift in time propels Samanosuke forward to Paris in the year 2004, where an army of demons is creating havoc. Swapping places with him, French commando Jacques Blanc is carried back to the sixteenth century to face Nobunaga.

Grounding *Onimusha 3* in even a few grains of historical truth is more typical of movies than of fantasy games, which, up till now, have tended to operate from the perspective of comic-

book writers that everything is permitted, and which would normally plunder the superficial characteristics of a historical period without bothering to remain true to personalities or events. *Onimusha 3*'s approach seems closer to that of a big-budget movie such as Richard Donner's *Timeline*.

This new maturity is reflected in the casting of prestigious actors Takeshi Kaneshiro and Jean Reno in the lead roles, and in the involvement of fight choreographer Donnie Yen, and CGI movie director, Takashi Yamazaki. In the case of Jean Reno, the Blanc game character has even been modeled to resemble him—part of a fashion, in Japanese games at least, for voice actors to truly "star" in the production.

All images from Capcom's **Onimusha 3**.

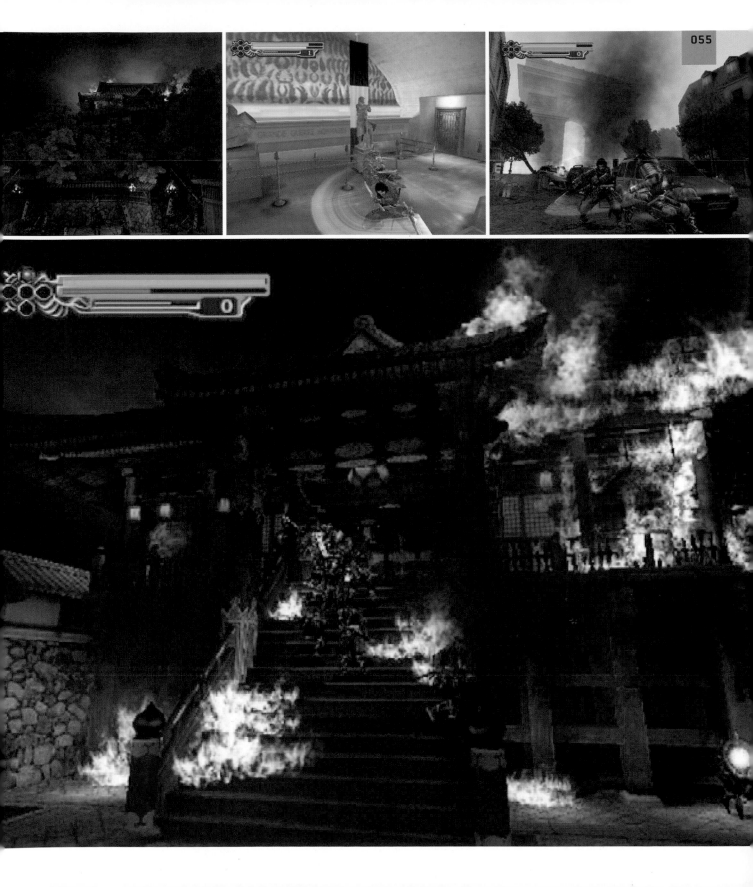

HANDS ON: FROM COTTARS' HUTS TO CATHEDRALS

RE-CREATING HISTORICAL ARCHITECTURE

Often the artist will have no say in the setting, as the game may well be based on a very specific point in history, such as a famous battle. If some latitude is given, it is wise to consider carefully the time and place. Some periods and locales are simply best avoided. The grand churches of eighteenth-century Bavaria, for example, could tie up an artist for a whole month with a single wall's over-the-top baroque adornment. If such detail is required, it is important to identify the essence of the style so it can be simplified to a manageable level.

GATHERING REFERENCES

The easiest way to create historical architecture is, whenever possible, to visit the real site and take careful photographs of each face of the building. Unfortunately, it is not then just a simple matter of slapping each photograph onto the polygons of the model. The photographs must be adjusted to account for changes in light on the day they were taken. Perspective distortion must be removed. Then the textures must be touched up to highlight details and exaggerate surface depth.

FANTASY HISTORICAL

Most fantasy games make extensive use of real historical architecture, particularly in the Gothic tradition, but frequently miss the point of it. The mistake lies in thinking that anything goes in the fantasy environment, even changing the proportions and subtle esthetics of architectural movements. Even if a game is a fantasy reworking of a historical style, it should never lose sight of the fundamental artistic elements that constitute that style. The Golden Ratio applies even in worlds where dragons fly!

1, 3. In Radon Labs' **Schwarzenberg**, a replica of the historical wartime location is created for the game.

2. **The Lord of the Creatures** by Arvirago. Although this game echoes a number of traditional styles, it is a new and interesting hybrid.

4. While nodding in the direction of historical accuracy, Capcom's **Robin Hood: Defender of the Crown** features a wonderfully light style reminiscent of children's book illustration of the 1950s.

5. In **Elder Scrolls III: Morrowind** by Bethesda Softworks, architectural styles are freely mixed to create new fantasy art, while at the same time, the quality of proportion is preserved.

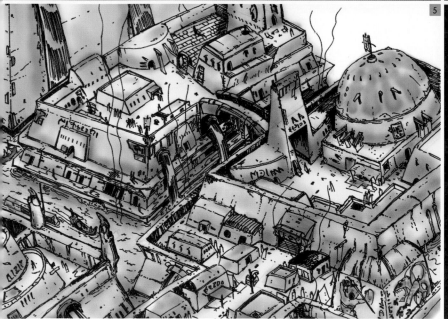

One of the pleasures of creating a historical building is piling on the detritus that builds up in virtually every era. Adding dirt is an art in itself, requiring careful study of how grime climbs a wall or dust lightens the top of cupboard. Dirt and wear make a place look solid and lived-in, adding to the game's realism and even giving clues to the player as to who or what lives there. The pitfall is that too much dirt can adversely affect the overall visual style of the game, making it disappear into the formulaic recesses of predictable cyberpunk gloom.

ONE RING TO RULE THEM ALL

5

FANTASY KINGDOMS AND DREAMLANDS

"CHARM'D MAGIC CASEMENTS, OPENING ON THE FOAM
OF PERILOUS SEAS, IN FAERY LANDS FORLORN."

JOHN KEATS, *ODE TO A NIGHTINGALE*

"WHY PLACE AN ANGEL ON A DIFFERENT BASIS FROM A STOCKBROKER?" ASKED E. M. FORSTER RHETORICALLY, ADDRESSING THE FACT THAT MOST PEOPLE WILL HAPPILY ACCEPT A WORK OF FICTION IN WHICH PEOPLE AND THINGS BEHAVE AS THEY DO IN THE REAL WORLD, BUT ONLY A MINORITY FIND IT EASY TO INVOKE KEATS'S "NEGATIVE CAPABILITY" SO FAR AS TO ACCEPT A FICTIONAL UNIVERSE OF MAGIC AND IMPOSSIBILITY. HOWEVER, WHILE HIGH FANTASY GAMES MAY NOT ACHIEVE THE POPULARITY OF MORE CONVENTIONAL GENRES LIKE DRIVING AND MODERN WARFARE, THERE WILL ALWAYS BE A READY MARKET FOR RESCUING DAMSELS—AND EVEN MALE DREAMBOATS—FROM DRAGONS.

Middle-Earth Online by Turbine

BEYOND THE FIELDS WE KNOW

1

"O HARK, O HEAR! HOW THIN AND CLEAR,
AND THINNER, CLEARER, FARTHER GOING!
O SWEET AND FAR FROM CLIFF AND SCAR
THE HORNS OF ELFLAND FAINTLY BLOWING!"

ALFRED TENNYSON, *THE PRINCESS*

"The inspiration for the story and world background of *Warrior Kings* came from history itself," says Jamie Thomson, creative director of Black Cactus Games. "We wanted to present to the player a world that was rich in fantasy, but also culturally familiar—to those of us in the West, at any rate. So I put together a kind of alternative historical Europe, a what-if of history taking slight turns, and then mixed and matched events, characters, and anecdotes from real history, giving them a bit of a fantastical twist. What I found was that truth really is stranger than fiction. I couldn't have made up half of the stuff that went on if I'd tried. So most of the events, people, and places of the *Warrior Kings* universe can be found in some shape or form in the pages of history books. Since most of it was based on reality, it gave us a much more fully realized and logically consistent world upon which to build."

1, 3. Bethesda Softworks' **Elder Scrolls III: Bloodmoon**. Although castles are historically familiar and icy wastes can be found if one travels far enough towards either pole, the combination of the two creates a strange new world.

2. Gas Powered Games' **Dungeon Siege** introduced pack animals rather than the surreal notion of characters shouldering another 300lbs of equipment and still being able to move silently.
4. **Gothic 2** by Piranha Bytes.



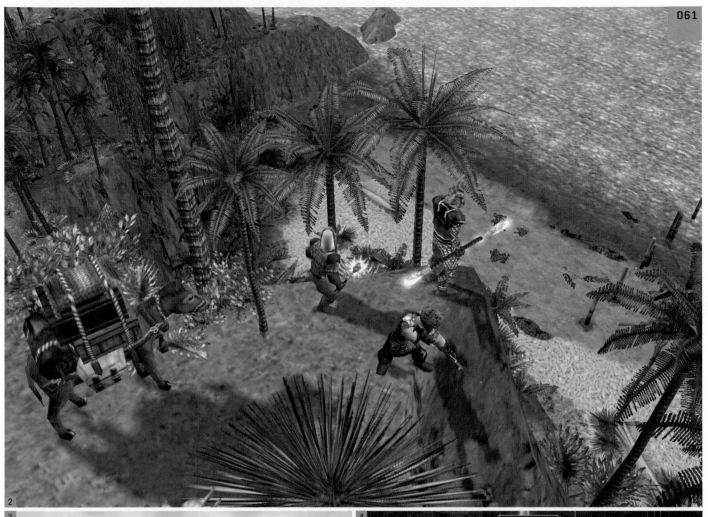

2

3

4

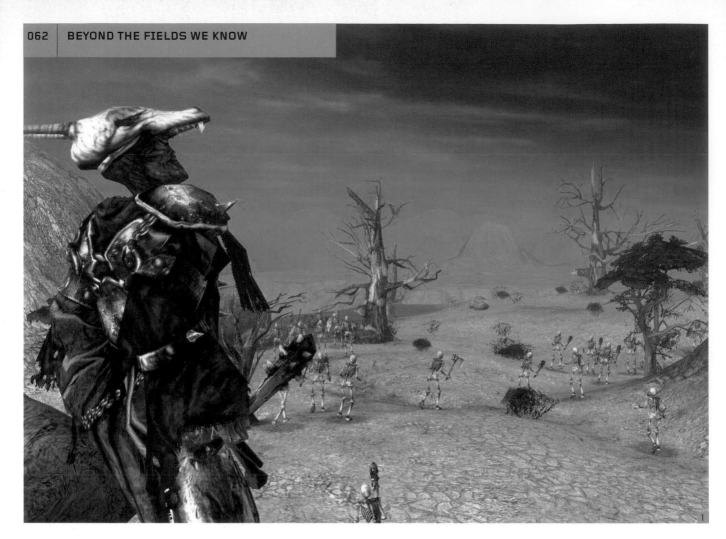

The scope of fantasy, in theory, has no limit, as it covers all that can be imagined beyond the normal limits of reality. The fantasy in computer games is more specific, however. One of the most common fantasy-game subtypes is drawn from well-known folk traditions in Western storytelling. The anchor point for these games is J. R. R. Tolkien's *The Lord of the Rings*. Tolkien created a world with the clearly defined theme of good in conflict with an overwhelming evil—a theme that creates the perfect context for a player pitting himself alone against all enemies.

In addition to telling a story, Tolkien provided encyclopedic detail of his fantasy world, Middle Earth, which he created by drawing on the great Anglo-Saxon sagas. It could be argued, in fact, that the setting of *The Lord of the Rings* is not a fantasy; it is how people of the Dark Ages really believed the world to be.

The Tolkienesque brand of fantasy has been further developed by way of games like *Dungeons & Dragons*, where all of the components of fantasy are netted, methodically gassed in a jar, and mounted on the pins of game rules. Modern computer games, where the player has freedom to roam, similarly require their designers to build in every detail. It could be argued that such taxonomy is anathema to fantasy—that knowing the digestive habits of the orc robs it of its capacity to reveal a deeper truth about ourselves. Yet games require systemization. Ironically, shining the light of scrutiny onto fantasy may actually risk burning off the magic.

1. **Not your usual Saturday afternoon crowd in SpellForce: The Order of Dawn** by Phenomic.
2. **The world of Panzer Dragoon Orta** by Sega is full of lethal beauty.

3. **The plants return the light that they absorb from the sun in True Fantasy Live Online** by Level 5.
4. **Concept art for Rare's Kameo: Elements of Power**.

330 PTS.

2 3

4

MIRROR, MIRROR...

GIVEN THAT MANY PEOPLE HAVE FIXED EXPECTATIONS ABOUT FANTASY WORLDS,
HOW DO YOU ADDRESS THOSE EXPECTATIONS AND STILL KEEP YOUR WORLD DISTINCTIVE?
DO ELVES ALWAYS HAVE TO SING IN THE WOODS?

Marc Holmes of Turbine Entertainment replies: "This is a complex question with a very simple answer. We will create the best-quality art we possibly can—and in doing so each artist draws or models the internal vision they have of the character. So really, every game is uniquely the product of the people who make it—even if it is based on a great license. No two studios could make an exactly identical game, even if they wished to."

"There was a time when I would grimace at the thought of being asked to produce a typical fantasy environment with elves, dwarves, and so forth," says Chris Bateman of International Hobo. "But these days, for a Western audience, one must accept that a familiar setting has a broader appeal. This does not mean that your world cannot be distinctive—the narrative content of a fantasy game is often what distinguishes it from its peers; the key lies in drawing from the full mythological framework, and not just stopping at *The Lord of the Rings* or *Dungeons & Dragons*."

"It's much easier for people to take on board a modified stereotype than it is to understand a wholly new idea," agrees Ian Lovett. "A game may only be played in 10-minute chunks, which can make it very hard to develop believable new worlds and settings. You need a very strong idea to break out of the accepted fantasy mold and the vision to 'make' people believe."

"You can create a fantasy world that's as outrageous as you like," maintains Matt Kelland of preproduction consultancy Short Fuze. "*Final Fantasy* creates a world unlike anything else—steampunk crossed with space opera and high fantasy—and it works because it's not in thrall to conventions. Also, the usual technique when creating a fantasy world is to base it on one or more historical, or otherwise familiar, settings.

1, 3. **Giving the monstrous hordes a taste of their own medicine in Chaos Legion by Capcom.**
2. **Studying big blue clocks in Fable by Big Blue Box Studios.**

2

3

1

By plagiarizing interesting and unusual settings, you can create a world that is distinctive but uses the conventions. For instance, you base your wood elves on Jivaro Indians or on Congolese pygmies. And by mixing and matching, you can create even more fantastic worlds. Why not throw in samurai orcs, hobbits who live in an Athenian democracy, and a race of benevolent Buddhist mermen?"

Ernest W. Adams, coauthor of *Rollings & Adams on Game Design*, points to fantasy authors like Ursula Le Guin, who eschew the grab-bag approach, preferring to create original settings out of their own imaginations. "The Earthsea books are about wizardry and magic, and they include some of the standard elements. Wizards have staffs, familiar animals, and ancient books. There are dragons. There are no firearms. The world is essentially feudal. Yet Le Guin adds twists of her own on all this. Hers is a seafaring world set on a large group of islands. Most of the people are copper-brown or black; only a few are white. Magic consists of knowing the names of things, but not all things have the same names in the same places, so magic works differently in different places. It is not a universal power available to the wizard wherever he is. In short,

choose carefully the core items of the fantasy that you need to keep your audience, then add elements of your own to make it unique. Seek the essence of the experience and make sure you preserve that—magic, warrior culture, or whatever—then embroider it with new material."

Ian Lovett recalls Appeal's *Outcast*, a seminal game in the science-fantasy adventure genre: "*Outcast* created a simply stunning-looking world that was vibrant and very different from the mass of gray/brown *Quake* worlds available at the time. The combination of a very different esthetic and the orchestral score made me feel like I really was taking part in an epic sci-fi movie."

1, 5. **Storm drains and draining storms in Kameo: Elements of Power by Rare.**
2, 3, 4. **The great classic of fantasy adventure gaming: Outcast by Appeal.**

2 3

5

4

WHY ARE SO MANY GAMES BASED ON FANTASY? WILL THE MEDIUM EVER BECOME REFINED TO THE POINT WHERE A HARSH WORD WILL DELIVER MORE OF AN IMPACT THAN A MAGIC FIREBALL?

"I hope so," says Marc Holmes. "I would like to see the day we invest as much in story as we do in technology—but that, I think, has to wait. The key element for me is the idea of authorship. When the day comes that one person can author a game themselves—as in the case of a book or comic—then stories can become much more specific experiences. But for now, it is a medium requiring tremendous feats of teamwork and technology—so the subtle elements can be lost along the way to the fireballs."

Ernest W. Adams answers: "Fantasy is simple to do in a shallow fashion. We don't have high expectations of its literary quality. It tends to be more about plot than about character, and plot is more easily converted to the game medium. There will come a time when a harsh word has a tremendous impact, as it does in soap operas and other fiction based on character; but for a computer game to have that degree of subtlety requires both better writing and better AI (Artificial Intelligence) than we have now. Even when we do achieve it, it won't be in the fantasy genre. That's not what most people want of fantasy."

"When you look back at the origins of video games and their early developers," says Tim Shymkus of High Voltage Software, "you get a demographic that grew up playing pen-and-paper games like *Dungeons & Dragons*. These games were almost entirely encapsulated within the players' minds and, outside of a few pewter figurines, the game world was only one of imagination. When the video game boom hit, it became a tremendous vehicle through which these worlds could be realized. That being the case, game developers were very eager to transport fantasy elements into almost every genre. Now, as fantasy games have to some degree run their course, game designs are starting to touch more upon historical fact. I also believe that as we explore the ancient world, we will see a vast wealth of myth and mysticism that we can exploit, and which in turn can still fulfill our fantasy needs."

1. Mad, bad, and dangerous—it's the Balrog from Turbine Entertainment Software's **Middle-Earth Online**.
2, 3. No longer facing just simple ghouls and ghosts in Capcom's **Maximo vs. Army of Zin**.

4. **True Fantasy Live Online** by Level 5 features cities emulating and embracing natural forms.
5. **Fable** by Big Blue Box Studios showcasing naturally cast shadows from a large window.

2

3

4

5

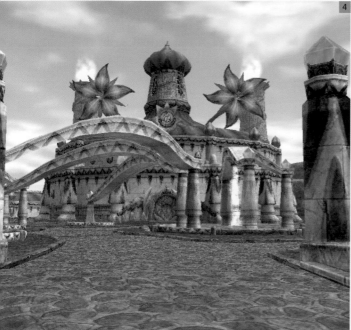

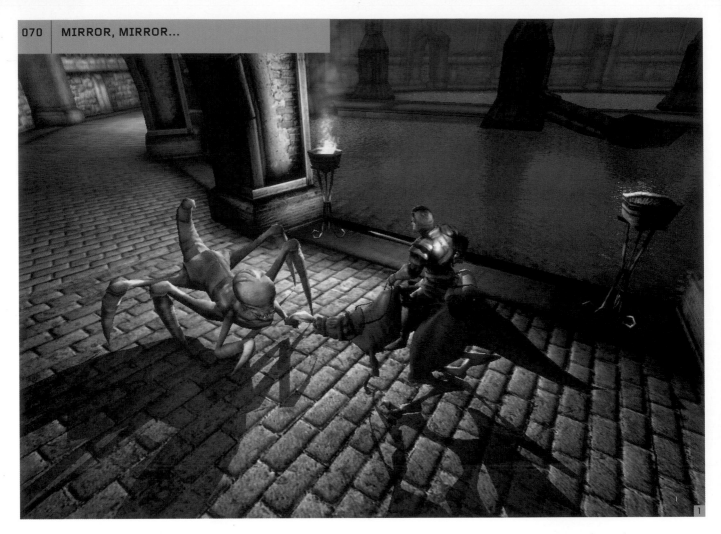

How can you make a world fantastic, but still familiar enough to be accessible? And how familiar is that, anyway?

Ian Lovett replies: "If you include enough familiar references and nods to accepted stereotypes, most people will happily accept the more fantastical elements of your world. Pander to popular preconceptions if possible, but twist them if you can!"

 "Sadly, game worlds are at their best when they're close enough to understood worlds, but with a dash of the exotic," says Owain Bennallack, editor of *Develop*. "Places where you can get on with being a hero, rather than feeling like a tourist. These understood worlds needn't be the real world—they can be tried-and-tested fantasy worlds familiar from other media."

Can fantasy ever become fresh again?

"Of course!" says Ian Lovett. "Just look at cinema to see how settings and genres reinvent themselves. *Pirates of the Caribbean* took apart the stale and dying swashbuckler flick and made it fresh and accessible once more. Like everything, games are subject to fashion. Sometimes it takes something very special to reinvent an ailing genre."

"For some reason, fantasy games never got beyond *Dungeons & Dragons* and Tolkien," says Chris Bateman, "but there is a wealth of inventive and imaginative fantasy novels that show that the scope of the genre goes beyond the basics. Greater integration with the new breed of game writers will greatly revitalize fantasy games—the key will be striking a balance between the familiar and the inventive."

 "Let me ask this," says Marc Holmes. "Are myths, legends, and fairy tales worn out? Can the impulse to imagine a world of good and evil, magic and monsters, or heroes and devils, ever really just vanish? There is a time and a place for any kind of entertainment—you cannot live on a steady diet of a single genre—but out of all of them, I would say the human fantasy life is here to stay."

1. Arvirago's intriguing **The Lord of the Creatures.**
2. **True Fantasy Live Online** by Level **5.**
3. **SpellForce: The Order of Dawn** by Phenomic.

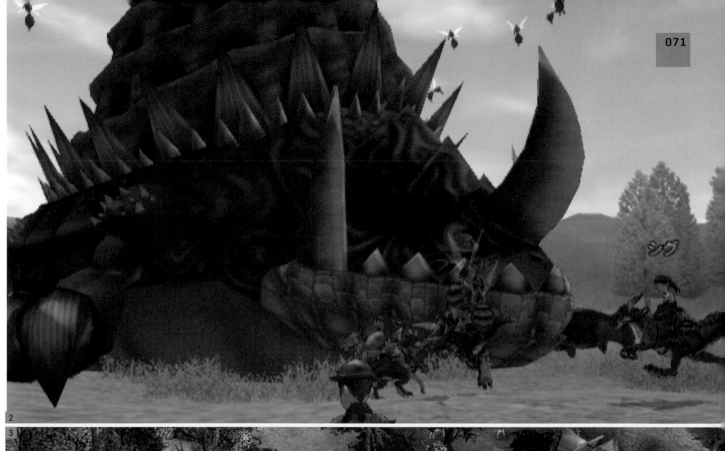

INSIDER SECRETS: A SHIRE THING

MARC HOLMES, PRODUCTION DESIGNER AT TURBINE ENTERTAINMENT, REVEALS SOME OF THE CAPTIVATING SCENES FROM *MIDDLE-EARTH ONLINE:*

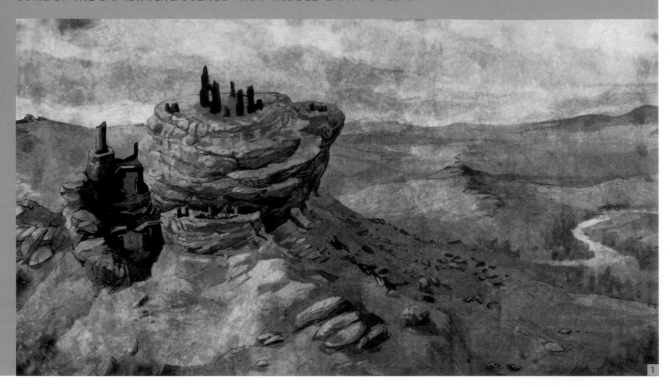

"Working in the world of *Middle Earth,* the setting of J. R. R. Tolkien's *The Lord of the Rings* trilogy, which is probably the greatest seminal work of Western fantasy fiction, is both an inspiring opportunity and a tremendous responsibility. The world presented in the books seems so amazingly real and detailed—full of culture, history, and legend. But translating those lyrical descriptions to the visual medium of games—that's the task that keeps us up at night. So many details to be captured! And a stirring mood must be built— one of great deeds and heroic people in a world moving inexorably toward a final war between good and evil. To that end, we really want to capture the comfortable, familiar places of Middle Earth: the Shire, the town of Bree —and the Prancing Pony Inn, of course. Players should feel a comfortable attachment to the land of Middle Earth, so that they can appreciate the threat emerging from Mordor."

1. All images from **Middle-Earth Online** by Turbine. "The ruins of the ancient watchtower at Amon Sul are one of the most picturesque landmarks along the Fellowship's journey. Players should have an amazing view from the top!"

2–5. "The Barrow Downs—a haunted graveyard of the Edain, human kings from long ago—is now a dark and dangerous place full of corrupt spirits. This was one of the most exciting settings for adventure in the early stages of the game."

HANDS ON: FLOATING PALACES

HOW TO ANCHOR BUILDINGS IN A LANDSCAPE

"ALWAYS DESIGN A THING BY CONSIDERING IT IN ITS NEXT LARGER CONTEXT—A CHAIR IN A ROOM, A ROOM IN A HOUSE, A HOUSE IN AN ENVIRONMENT, AN ENVIRONMENT IN A CITY PLAN."

ELIEL SAARINEN

Game artists have to master a number of skills. Besides character design, they must learn landscaping, vehicle design, furniture visualization, and architecture.

Genre affects how architecture is handled. Levels in first-person shooters and driving games are built entirely by hand and do not change during play. Strategy, world-management, and real-time strategy games require that the player place buildings, or that the structures emerge during gameplay. These buildings have to sit believably within the landscape. Although nothing more than texture maps over infinitely thin polygons, they must convey the impression of weight and solidity.

The artist must consider the essential relationship between the buildings in the game and their surroundings. A peasant's hovel should almost look as though it has grown out of the land, a construction of nature out of the materials close at hand. A grand temple or castle should be designed so that it stands out from its surroundings in total opposition to nature, built using imported materials and finished with defiantly man-made angles. However, even the grandest buildings will settle over time. Rain will fling dirt and moss will creep up the walls, and slowly, nature will reassert her dominance. Buildings will also bear the stamp of occupancy:

1. **Note the way the fences follow the landscape in Phenomic's SpellForce: The Order of Dawn.**
2. **Electronic Arts' SSX 3** shows a bridge that is intrinsically integrated into the landscape.

3. **Big Blue Box Studios' Fable.** Of special importance is the point at which buildings meet the landscape. Dirt, dust, and grime blend structures with nature. Clumps of grass and foliage also help camouflage the join.

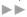

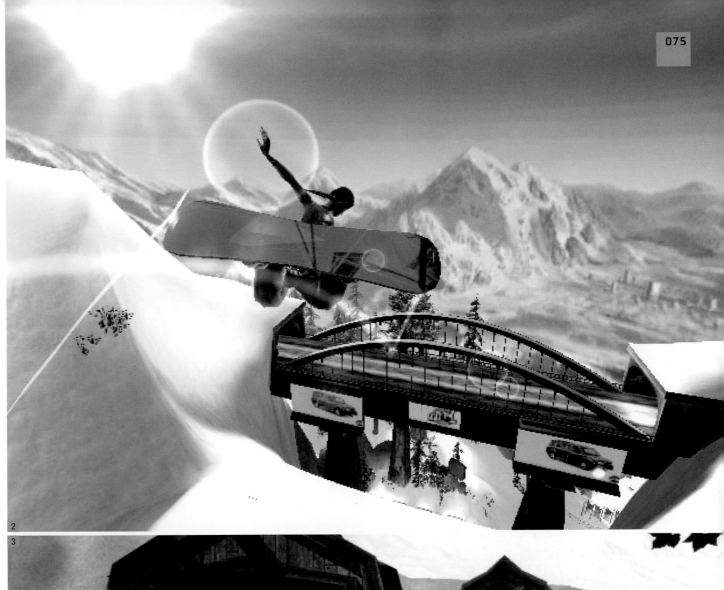

roads and tracks, gardens, and household junk. These are factors that need not trouble a real-life architect, but they must be considered by the game artist.

Foliage and trees make a heavy demand on polygon count and textures, and their production has, until recently, been labor-intensive. Now, with techniques for procedurally generating grass, bushes, and trees, the "greening" of the typically sterile game environment is achievable.

Strategy games require buildings that look appropriate wherever the player chooses to place them. While 2D games offered the discipline of a tiled landscape, allowing each

building to have its own surrounding landscape attached when it was placed, a building simply plonked down in a green field in a 3D environment looks artificial, like a toy on a green carpet. Because of the quantity of artwork required to suit every eventuality, players are artificially restricted as to where they can build. Terrain must be flattened before the building models are placed. This is a pity, as it means sacrificing the visual variety and beauty of architecture shaped to the landscape—such as the Great Wall of China snaking through the mountains, a Cornish fishing village precariously clinging to a hillside, or Petra built within its crevice of rock.

1. These towers from Bethesda's **Elder Scrolls III: Morrowind** seem to grow out of the earth, mimicking the landforms around them.
2. **Uru: Ages Beyond Myst** developed by Cyan. In common with the rest of

the Myst series, the buildings are designed together with the landscape to create a fully integrated vision.
3. Epic's **Unreal Tournament 2004**. A wonderful castle squeezed between the rocks.

4. **Söldner: Secret Wars** by Wings Simulations. Modern buildings look less blended into the landscape.
5. **Sudeki** by Climax. Note the detail of snow clinging to the base of the trees and topping the fence.

6. **Warrior Kings** by Black Cactus Games show the difference that vegetation can make to a landscape. Even so, the average computer will still grind to a standstill if asked to render too many trees.

TIPS FOR THE ARTIST

There is a lot more to creating a believable landscape than a simple flat texture map. These tips will help to flesh out your 3D world by adding a touch of reality.

LIGHT

Consider the light source. If it is part of the game physics, it will be generated for you, but if it is prerendered, make sure it is the same for all objects, buildings, landscape, and characters.

SHADOW

Everything casts a shadow, even in overcast conditions. A shadow cast by a building helps to anchor it to the ground.

TONE

Textures on all objects in the game should be in a similar tonal range. Against a darker environment, a brighter tonal value on buildings will make them look like toys.

TEXTURES

Buildings will appear to belong to a landscape if they are built from the materials at hand.

5

6

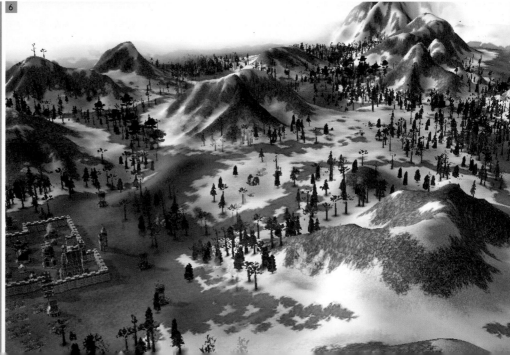

VEGETATION

Grass and ivy growing up the walls of a building give it a sense of age, while trees and bushes break up harsh lines and angles.

SHAPE

If possible, make the polygons that are in contact with the landscape undulate to fit it.

LIFE

The inhabitants of a building affect the land around it. A building should be more than just the structure: Add adjacent polygons with tracks, garden junk, and trampled grass.

THE REAL THING

Look at the world outside your door. Draw sketches to help you see how buildings fit into their surroundings.

THE FINAL FRONTIER

6

THE ICY REACHES
OF OUTER SPACE

"WEST OF THESE OUT TO SEAS COLDER THAN THE HEBRIDES I MUST GO

WHERE THE FLEET OF STARS IS ANCHORED, AND THE YOUNG STAR-CAPTAINS GLOW."

JAMES ELROY FLECKER, *THE DYING PATRIOT*

IF EVER THERE WAS A PLACE OF HIGH ROMANCE, A PLACE FOR THE DREAMER OR EXPLORER, IT'S OUT AMONG THE

STARS. NO MATTER HOW ANY EARTHLY SETTING MIGHT BE OVERUSED, OUTER SPACE WILL ALWAYS PROVIDE

UNLIMITED POSSIBILITIES FOR THE IMAGINATIVE ARTIST. GAMES ARE BEGINNING TO REVISIT THE EXHILARATING

IDEAS OF THE GREAT SCIENCE-FICTION AUTHORS, JUST AS EARLY MOVIES LOOKED TO THE GREAT AUTHORS OF

THE DAY. WILL WE SEE ASIMOV'S FOUNDATION, VANCE'S GAIAN REACH, AND NIVEN'S KNOWN SPACE GIVEN

SUBSTANCE BY THE SCI-FI GAMES OF TOMORROW? ONLY THE FUTURE WILL TELL.

Haegemonia: The Solon Heritage by Digital Reality

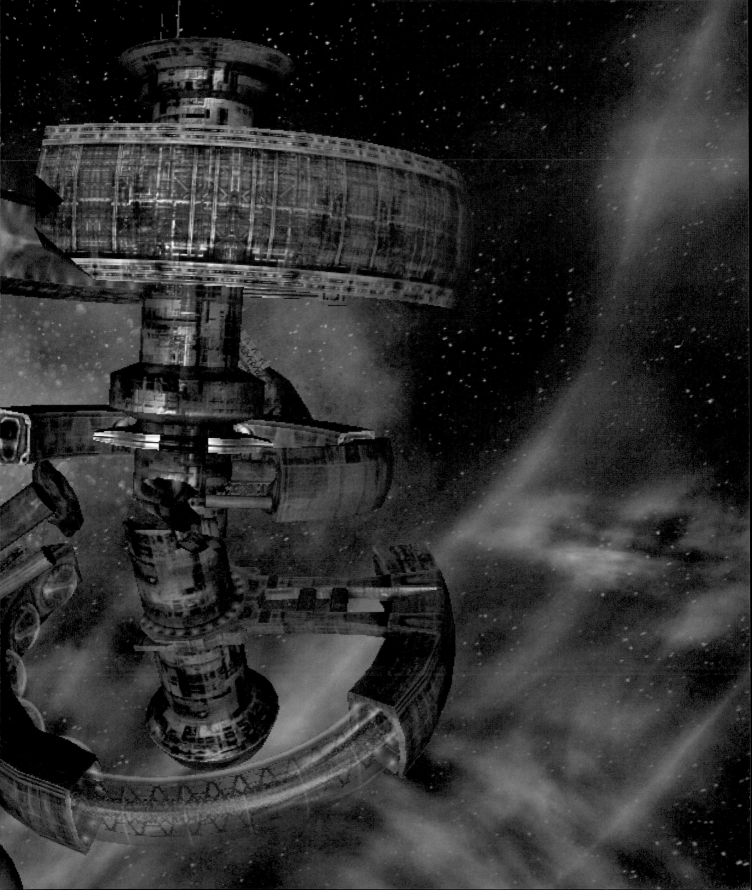

WHEN WORLDS COLLIDE

MAKING THE VACUUM INTERESTING
WE ASKED SEVERAL GAME DESIGNERS HOW THEY SEE THE ROLE OF SCIENCE FICTION
IN MODERN GAMING.

Is there such a thing as "realism" when the term is applied to alien worlds in distant solar systems?

"Every sci-fi game world must be realistic in the sense that it must be coherent and consistent," says Dave Lloyd, former chief technical officer at nGame. "There must be some underlying laws that explain why things are as they are, and the designer must know them even if the player doesn't. If worlds aren't consistent, people have a hard time accepting them. Of course, you can confuse the players, or deceive them, but you can't lie to them or contradict yourself. If gravity is only 0.1G in your world, then there must be a reason why gravity is suddenly 0.5G when you approach the Forest of K'zakk. Maybe it's because the phases of the moon are in sync at that point, or maybe there's an alien gravity-generator in the depths of the forest, or perhaps there's a negatively charged miniature black hole in the sixth dimension nearby. It doesn't matter as long as there is an explanation that the player can find out and accept."

Ernest W. Adams, a member of the International Hobo design consortium, finds scope for creative freedom in the limitations of modern scientific knowledge: "Sci-fi worlds are realistic in as much as they stick to what we already know—but that in itself is not much! The first extrasolar planet was discovered in my own lifetime. We have only the barest idea that such a planet might have Earthlike conditions."

1. Epic's **Unreal 2: The Awakening**. Although the FPS genre's foundations lie in the world of WW2, it soon moved toward science fiction and embraced the diverse range of environments and weaponry that it allowed.

2. Colonization on a cosmic scale in **Galactic Civilizations** by Stardock.
3. Breaking out of the construction kit in Electronic Arts' **Bionicle: The Game**.
4, 5. **Haegemonia: The Solon Heritage** by Digital Reality.

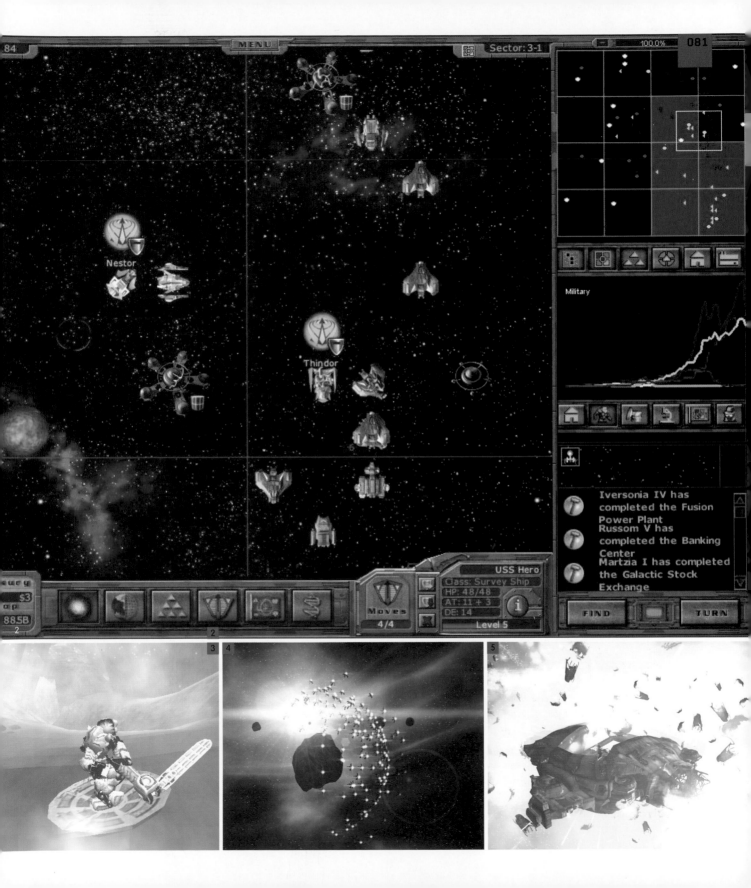

MENU Sector: 3-1

84

Nestor

Thindor

100.0%

Military

Iversonia IV has
completed the Fusion
Power Plant
Russom V has
completed the Banking
Center
Martzia I has completed
the Galactic Stock
Exchange

FIND TURN

USS Hero
Class: Survey Ship
HP: 48/48
AT: 11 + 3
DE: 14
Level 5

Moves
4/4

$3
op
88.5B
2

2

3 4 5

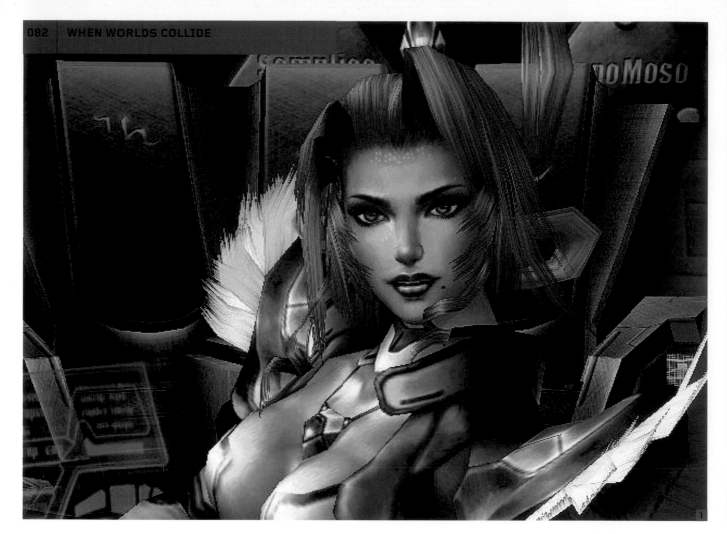

Can painstakingly modeling the physics, atmosphere, and so on of an alien world make a good springboard for creativity? Or would you rather define the feel of a world first and then force the physics to fit?

"Ultimately, games are fiction," says Ernest W. Adams, "and never more so than when they are science fiction. I believe we should concentrate on an extraterrestrial world as a fictional place rather than a scientifically accurate one. Ray Bradbury's *Martian Chronicles* is entirely outdated by modern science, but it remains deeply evocative: ruined canals and the crumbling remains of a vanishing alien civilization. The same is true of Robert Heinlein's *Mars*. These are great stories, even though their technical details have been shown to be dead wrong."

Designer Matt Kelland says: "Define the feel first. You're producing an entertainment product, and the first requirement is to ensure that the world you're building will be fun. However, you can do a lot with serendipity—mess with the physics, see what you create, and take it from there!"

Deep-space battles—in movies we're used to seeing starships bank as they turn, and to hearing the barrage of phaser fire. Is the fiction now stronger than the reality? Would it even be possible to produce a "realistic" space battle in a game?

"One could argue that the first-ever coin-op video game, *Spacewar*, was in fact a realistic space battle!" reckons Ernest W. Adams. "Gravity and inertia were accurately modeled, although only in a two-dimensional space. The main inaccuracy was that the ships did not consume fuel, so their masses did not change. It's perfectly possible to simulate a realistic space battle in a game, but it would be difficult for players to adapt to—and it might be rather boring."

1. A vision of the future in Koei's **Crimson Sea 2**.
2. An incredible level of detail is shown in **Halo 2** by Bungie.
3. Revolution in a high-tech world. **Galactic Civilizations** by Stardock.

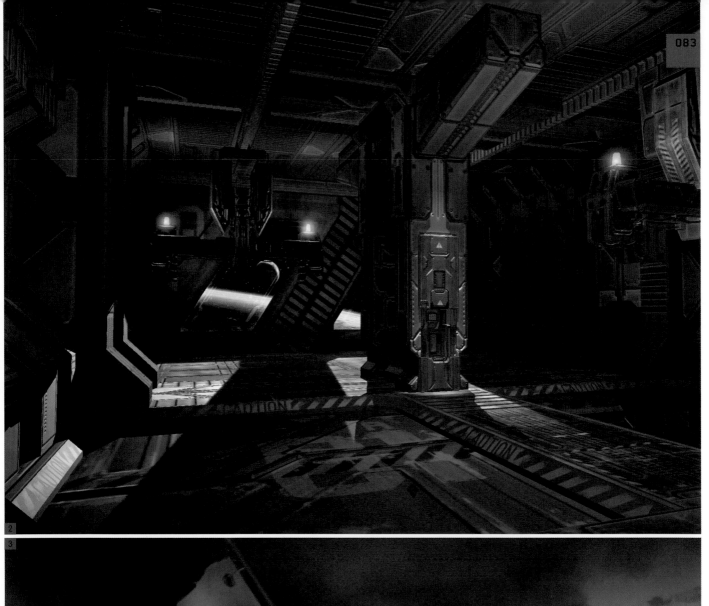

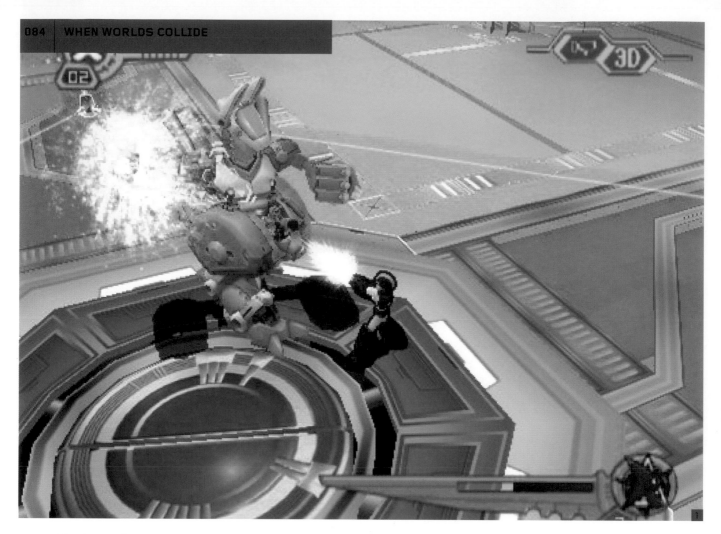

"You could make a really good space-battle game in the style of *Harpoon*," says Matt Kelland. "The player is engaging the enemy at ranges of a thousand miles or more, which would be tedious in a real-time tactical environment, but you could represent it all strategically and keep it tense and interesting."

"*Star Trek* has a lot to answer for," says Ian Lovett. "This is something that is begging for a harsh new approach to shake up the stale market."

Where do you go for ideas about creating alien races and architecture? To sci-fi literature, for instance, or to nature documentaries and periodicals like *Scientific American*?
"During the '50s, they were all borrowed from art deco," says Ernest W. Adams. "In the '60s and '70s, they came from the sterility of NASA's labs and workshops, with lots of plain white. Then with the arrival of the movie *Alien*, there was a strong move toward the biological—veins and intestines. William Gibson and *Blade Runner* gave us a decaying dystopia based on advances from our existing buildings—huge Fuller domes above New York brownstones. Most

of these are based on visual esthetics rather than utilitarian considerations, however.

"In designing a sci-fi game now, first I would define the physical characteristics of the alien race, borrowing from nature and animal documentaries. Then I would go on to Christopher Alexander's *A Pattern Language* and define a series of behavior patterns for the alien race. From those patterns, I could create their buildings in the same way that Alexander recommends particular architectures to support particular patterns of human behavior. In theory, this process yields an organic and plausible alien architecture. But, of course, purely esthetic considerations have to play a role as well."

1. Capcom's **Megaman X7** shows that not all sci-fi worlds have to be made of dull gray metal.
2–4. A surprisingly modern industrial esthetic combined with alien worlds in **Space Colony** by Firefly Studios.

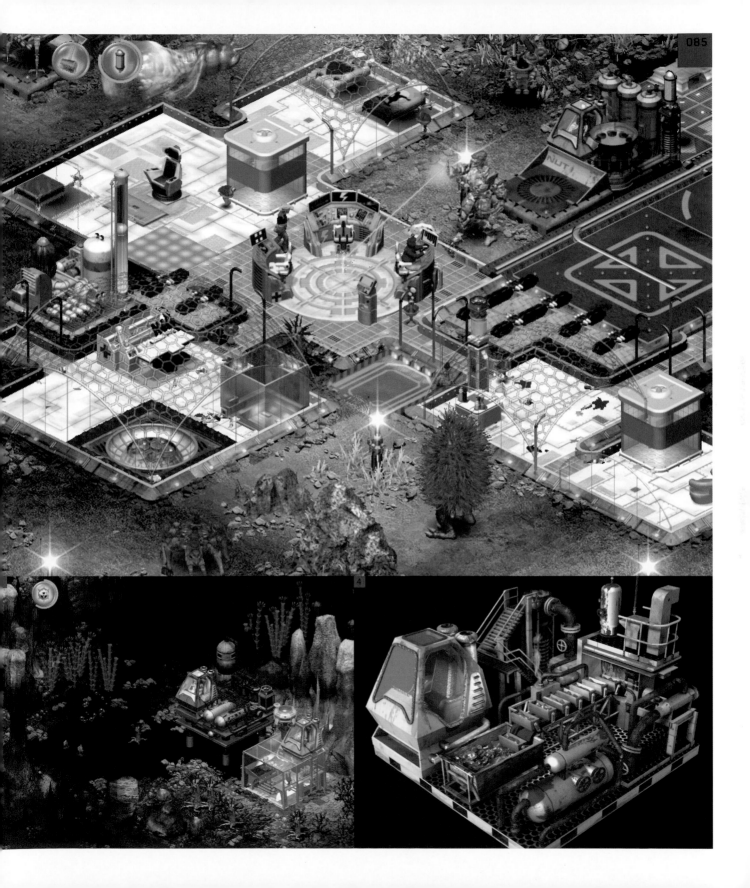

INSIDER SECRETS: SCHWARZENBERG

GERMANY-BASED DEVELOPER RADON LABS, CREATOR OF *PROJECT NOMADS*, IS WORKING ON *SCHWARZENBERG*, A HIGHLY REALISTIC RE-CREATION OF THE LATTER DAYS OF WORLD WAR II. WE ASKED **BERND BEYREUTHER**, LEAD DESIGNER, TO TELL US ABOUT THE PROBLEMS THAT THE QUEST FOR REALISM CAN THROW UP:

Obviously, much of *Schwarzenberg* is based on real towns of the period, but the interior drawings show a modernist version of German architecture. How did you go about designing and conceptualizing this alternate history?

"First of all: this is not an alternate history but a story that could have happened. The framework of the game is well researched and is 100 percent pure history. All of the game sets are videotaped from the original locations and then transferred back to 1945 using old photos. The sets are therefore, as far as possible, completely authentic. The 'modernist versions' of German architecture you see on some drawings are taken from original locations like Nuremberg, or from existing underground bunkers."

With computer technology improving all the time, more and more detail is available to the game artist. Is this becoming a burden in the quantity of work now required?

"Plainly and simply: yes. As the tools have become better and better, it now takes days to do tasks that some years ago would have taken weeks. But this means that the amount of work to get things looking really good is still growing, and this becomes more and more a burden on the budget. On the other hand, the quality of today's graphics cards allows any style you can imagine. So it's in the hands of the developer to define a style that requires less of a production workload, but that still works. The recent *Zelda* game is a good example of a very appealing style that is still simple."

Roughly what percentage of the game's art development is invested in the environment, compared to the characters and their animation?

"It's fifty-fifty."

1. Capcom's **Steel Battalion: Line of Contact**. The effect of highlight burnout gives **Line of Contact** a distinct style.

2. **Haegemonia: The Solon Heritage** by Digital Reality. Making the explosion purple indicates the futuristic nature of the weapon that caused it.

In each level, what are the number of polygons and textures available to the artist?

"We are using a dynamic streaming level-of-detail technology. So the polygon numbers per level are not relevant. The only relevant numbers are the per-screen polys, which are currently around 250,000 up to 500,000 on ATI 9600/9800 cards."

There is a wonderful sense of time, mood, and atmosphere. Has improved technology allowed for new atmospheric effects? What are these, and how do they affect gameplay?

"It's not in the technology. The mood and atmosphere are a result of sky color, architectural issues, lighting, and details. These screenshots do not have any DirectX 9 effects and look just as good on DX7."

Will *Schwarzenberg* have a freeform environment? What do you think about allowing freedom of movement compared to structured gameplay?

"Structured linear gameplay works well for some game genres, such as strict shooters, but the moment you add features like role-playing or adventure, then you have to break the linearity. There is an old dream of VR and game programmers of creating really huge, wide-open worlds. The constraints of technology and the market often make us forget these dreams—but they're still there. There will be games in the near future that offer us worlds we just can't imagine at the moment. Hundreds of square kilometers inhabited with living, breathing, (artificial) people that offer us untold stories, fresh gameplay, and totally new experiences."

1, 6, 7. Sci-fi goes medieval in **Quake 3 Arena** by ID Software.
2, 5. Epic's **Unreal Tournament 2004.** The unusually colored lens flares hint at specialized futuristic technology.

3. Beating back the wilds in **Space Colony** by Firefly Studios.
4. Capcom's **Steel Battalion: Line of Contact.** Fogging for effect rather than necessity.

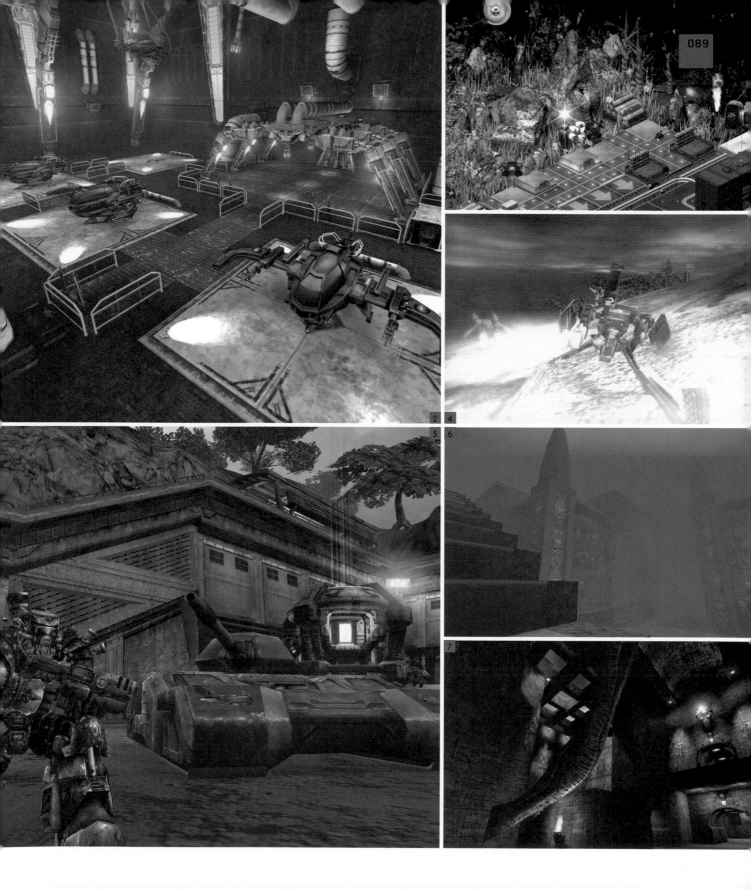

HANDS ON: DESIGNING SCIENCE

CONSTRUCTING CONVINCING LOGIC FOR SCIENCE-FICTION MACHINES

In space, no one can tell you how to design a spaceship. Science fiction posits an artificially constructed environment that only has to exist in the imagination. The "science" is really just a nod in the direction of actual scientific fact. Of far more importance in designing a sci-fi world—as in all fiction and art, generally—is the internal logic that should always apply. This has to be consistent; otherwise, the believability of your world will crumble. Architectural styles, for example, however outlandish they may be, should be in keeping with the backstory of your world. Even something as supposedly unruly as magic should have some internal logic.

THE REAL THING

The toughest challenge that a science-fiction game artist has to face is that of near-future realism, where all of the equipment needs to be a logical extension of what is available to us now. Establishing the limits of the technology is critical, as it will dictate all of the design in the game. Are there antigravity hovercars in this universe, or are people still driving around in wheeled vehicles? Are bullets still useful, or has the laser superseded them?

Military design is always easy because it consists of the bare minimum of functionality with brutal, even fetishistic overtones. Some items you design can't just look as if they might work—they actually have to. A hard-shell combat suit, for instance, must be articulated so that the character wearing it is able to move.

IT'S ALIVE!

The graphic style of a game will have a huge bearing on designing its machines. The more cartoonish a game, the more outlandish the machines may appear. Even if the game is realistic, you should think of the machine as a character with a personality based on its function. For example, a contraption that fires a ray into space could "squat" down as it gathers its energy, shake in anticipation, then rapidly expand as the ray is released. All of the pseudohydraulics, gears, and mechanisms contributing to the process should be allowed for. Tanks that carry huge mortars might have a body shape like a metal triceratops, while small fighter craft that skit around the enemy might have a light, nimble design like an insect.

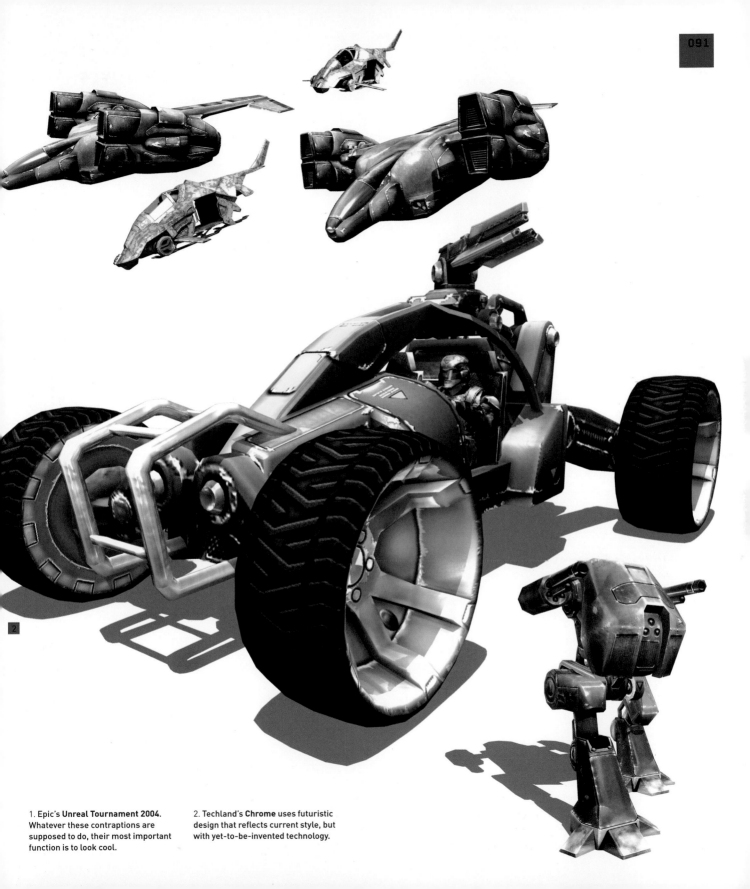

1. Epic's **Unreal Tournament 2004**. Whatever these contraptions are supposed to do, their most important function is to look cool.

2. Techland's **Chrome** uses futuristic design that reflects current style, but with yet-to-be-invented technology.

CITIES WITHOUT LIMITS 7

THE METROPOLIS FROM FRITZ LANG TO CLARK KENT

SINCE SHEPHERDS FIRST GAZED UP IN AWE AT THE WALLS OF URUK, HUMANKIND HAS BEEN FASCINATED BY CITIES. ON THE ONE HAND, THE CITY IS A PLACE OF COMMUNITY AND SAFETY; ON THE OTHER, A WARREN OF MYSTERY AND POTENTIAL DANGER, WHERE THE SWELL OF NUMBERS BRINGS ANONYMITY. GAMES ARE THE IDEAL MEDIUM TO INDULGE THE ARTIST'S PENCHANT FOR CITY-BUILDING—WHETHER IN COPYING AN EXISTING CITY LIKE MIAMI, RESTORING A LOST CITY LIKE TROY, OR ENVISIONING A CITY OF PURE IMAGINATION.

Vega$: Make It Big by Deep Red Games

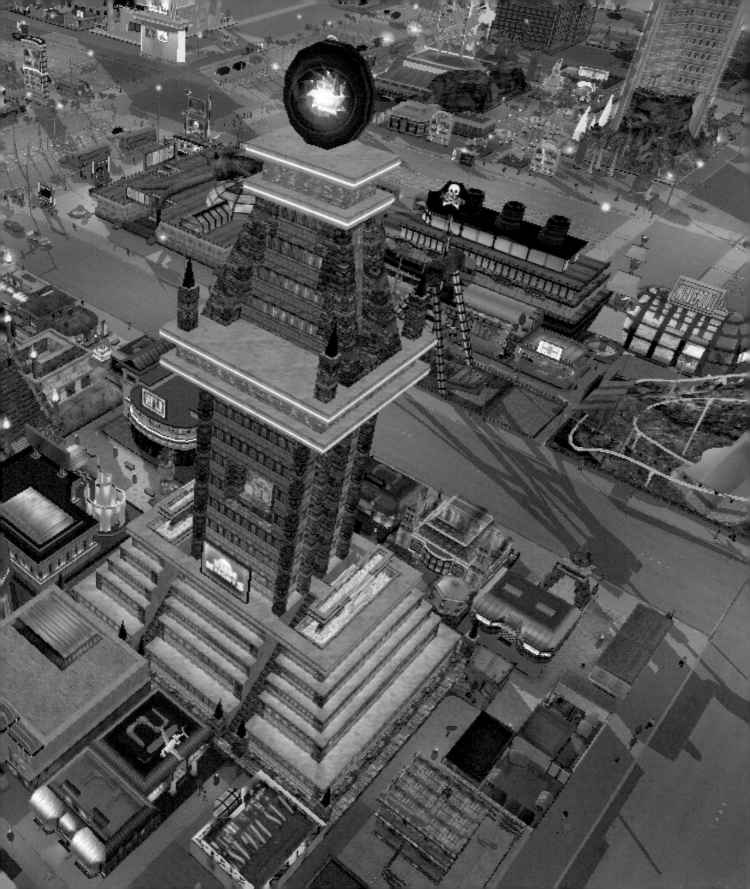

CIVILIZED PURSUITS

THE DEVELOPERS OF LARGE GAME ENVIRONMENTS—AND ESPECIALLY OF PERSISTENT
VIRTUAL WORLDS—ARE CREATING PLACES AS MUCH AS THEY ARE CREATING GAMES.
WHAT CONSTITUTES AN INTERESTING SETTING FOR A GAME? IS IT A PLACE YOU'D
WANT TO VISIT, OR A PLACE YOU'D WANT TO LIVE?

1

"Both and neither," says Owain Bennallack, editor of *Develop* magazine. "Players would behave very differently in solo game worlds if they thought they'd ever have to go there and account for their actions afterward. Try as I might, I just can't turn to the dark side in *Knights of the Old Republic*. In large measure, it's because the world is sufficiently morally loaded for me to understand what effect my actions would have on the characters, were they real— and if I am not going to act like they're real, then what am I doing?

"In contrast, it's never been clear to me whether I was a good guy or a bad guy in *Pac-Man*. But then, I wouldn't want to spend five minutes in such a nightmare scenario. Perhaps richness in our synthetic worlds is inseparable from at least a hint of morality? Or is this yet another example of the tourist imposing his own values on the country he visits?"

"Games, unlike almost any other media, allow players to be transported to worlds that can only be imagined," says Tim Shymkus of High Voltage Software. "With movies, there is an expectation of realism that often makes it difficult to create really unique and diverse worlds. Games are by nature rarely photorealistic and are in a much better position to go where no one has gone before. That being the case, we expect more from our game worlds. I think most people want to be transported either to a different place in time or another world entirely. We are always impressed when a game accurately depicts a real-world environment. But ultimately, we can experience that almost any time. It is rare one gets the opportunity to visit Mars."

"The most interesting game setting is a place that is informed by human history—something that draws from world

▶▶

1. **Freedom Fighters** by IO Interactive. The damaged, war-torn city presents a familiar environment in a new way, holding our grim fascination.

2. **Chaser** by Cauldron. You can be fighting down an alley while inside a huge metropolis. This combination of the vast and the intimate makes a perfect game environment.

3. **Driver 3** by Reflections. Individual buildings from Nice, Istanbul, and Miami beautifully re-created for unprecedented levels of gameworld reality.

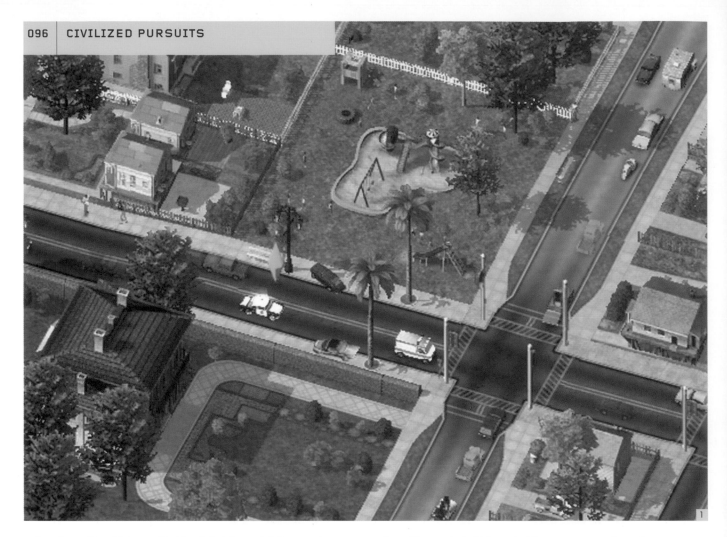

culture," says Marc Holmes of Turbine Entertainment. "We cannot find inspiration in a truly alien world. There have to be touchstones that reach us emotionally."

Big Blue Box Studios' Ian Lovett warns: "It's tremendously difficult to make up architecture from scratch. Also, considering the wealth of real-world inspiration that surrounds us, it's possibly a time-consuming luxury that few of us have! However, exaggerated forms are always easier to identify than nonexaggerated ones."

"Few people will really know if the architecture is true to the period or not," points out Tim Shymkus. "And, of course, we are talking about gameplay and providing a compelling experience. These things are most important and to some degree require us to pump up the mundane. Some liberties will always be taken for the sake of fun, but staying true to the baseline gives the setting a cohesive backbone that, if not always obvious, has a great deal of subliminal value."

"I really think it's not possible to invent entirely from scratch," says Marc Holmes. "Everything we have in our artistic repertoire comes from somewhere! The influence might just be a half-

remembered image, but all ideas start from some experience the artist has had. Personally, I do a great deal of research before and during a drawing—not only for inspiration, but also so that I can eliminate ideas that are overused or clichéd."

"'Living cities' are in vogue at the moment," says Chris Bateman of International Hobo, "but of course they carry with them enormous development overheads that are not necessarily justified for every project. At International Hobo, we can see semiurban and rural environments becoming increasingly more viable. A large open wilderness is easy to develop, and these can be peppered with key sites such that they will function as a city area, but at a fraction of the development cost.

"Also, the notion that each level must be inherently tailored to a specific chunk of gameplay is starting to pass. I don't believe gameplay requirements need to hold back visual style. The artists did an amazing job with the environments in *Ghost Master*, in part because the level designs identified only the required elements, such as connectivity and environmental features, and the rest was left for the art team."

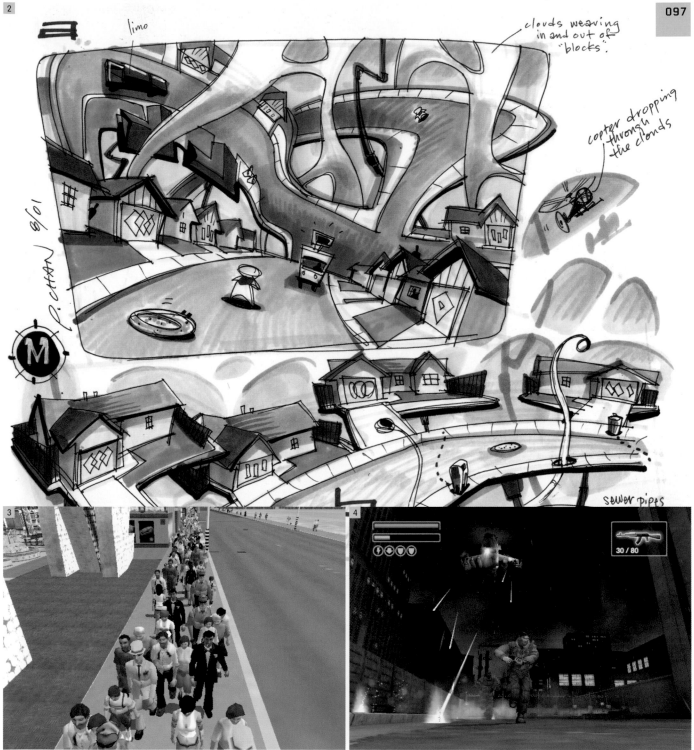

1. Maxis' **Sim City 4: Rush Hour**—a classic overhead view of the city that has the visual delight of a perfectly made scale model.

2. Concept art from **Psychonauts** by Double Fine Productions. In this cartoon world, streets have become wonderfully tangled up with sewers, roads, and the buildings themselves.

3. **Vega$: Make It Big** by Deep Red Games. Creating a believable population for a city has always been a challenge. As many different characters as possible must be

created, but you can always spot the repeats. Eventually, perhaps, software will procedurally create infinite variations, mimicking the real world.

4. **Freedom Fighters** by IO Interactive.

INSIDER SECRETS: FINAL FANTASY X-2

SQUARE ENIX'S *FINAL FANTASY* SERIES IS ONE OF THE ENDURING BRANDS IN GAMING TODAY. WE SPOKE TO **SHINTARO TAKAI**, ART DIRECTOR, AND **TOSHITAKA MATSUDA**, CONCEPTUAL ART DIRECTOR, BOTH OF WHOM WORKED ON *FINAL FANTASY X-2*.

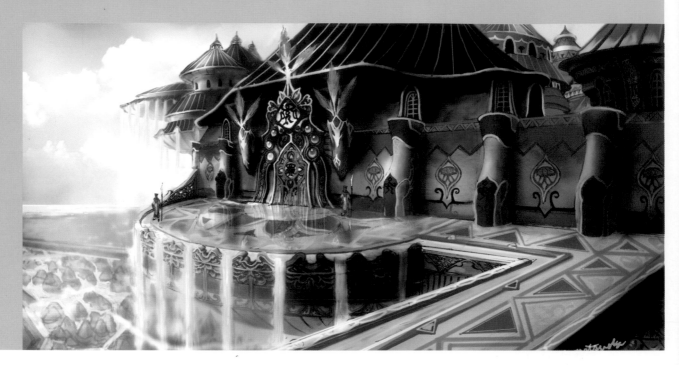

Are there any games that have particularly inspired you?
Shintaro Takai: *Vagrant Story*, *Ico*, and more recently *Half Life 2*.

What about media other than games—such as novels, music, or movies?
Takai: I find myself particularly inspired by movies. If I told you all of the movies that have inspired me, we'd be here forever. But I think that, above all, films set in fantasy worlds influence me most.

What else influences you when creating an involving gameworld? Do you set out to create a world that you'd want to visit—or even to live in?
Toshitaka Matsuda: With *FFX-2*, there are no actual places that have provided a motif for the gameworld. I feel we have created a gameworld whose ideas, feelings, dreams, and qualities can be seen as part of the player's own world. I think that in this sense, it is certainly a world in which I would like to live, and a fantasy environment that I would like to go adventuring in.

Can you tell us about the concepts around which you based the actual creative process?
Matsuda: Even if it's an imaginary place, even if it's an imaginary reality, I think that it must still contain some truth.

Light is very important. For example, natural light can be used to give a location a really sublime feeling. None of the lighting used onscreen is without meaning. Whether it is strong or weak light, we try our best to make all in-game lighting meaningful.

There are various uses for color, from simple decoration to making functional things beautiful. We aim in particular for colors that lie somewhere in the narrow gap between fantasy and reality.

With regard to architecture, we strive for beautiful lines and forms that the player has never seen before. These are the things that give the feeling of being in another world. Our aim is always to create something that moves people by creating a harmony between these two.

All images **Final Fantasy X-2**
by Square Enix.

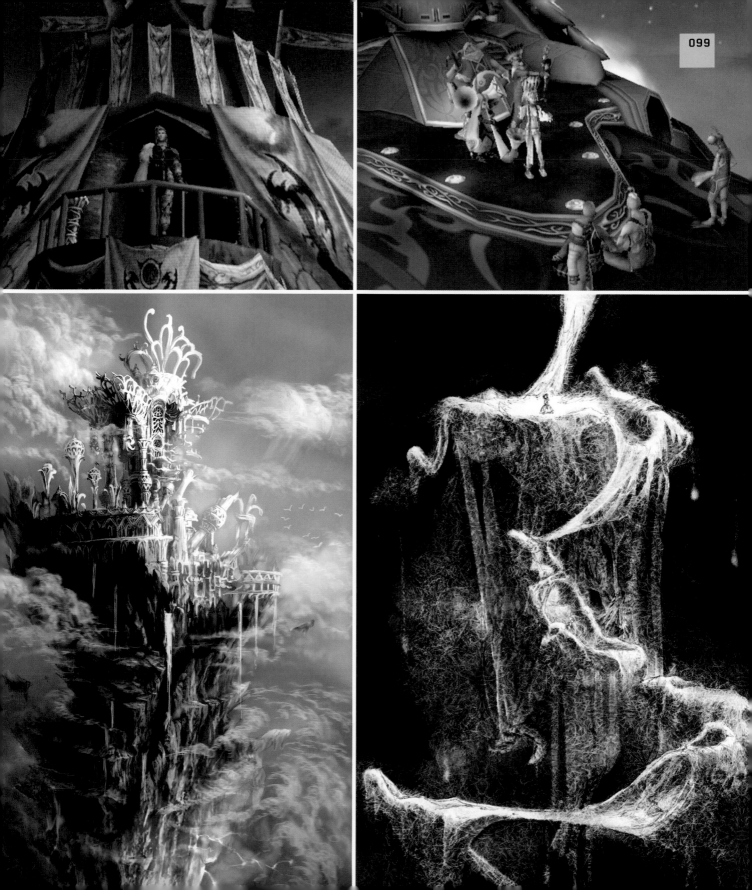

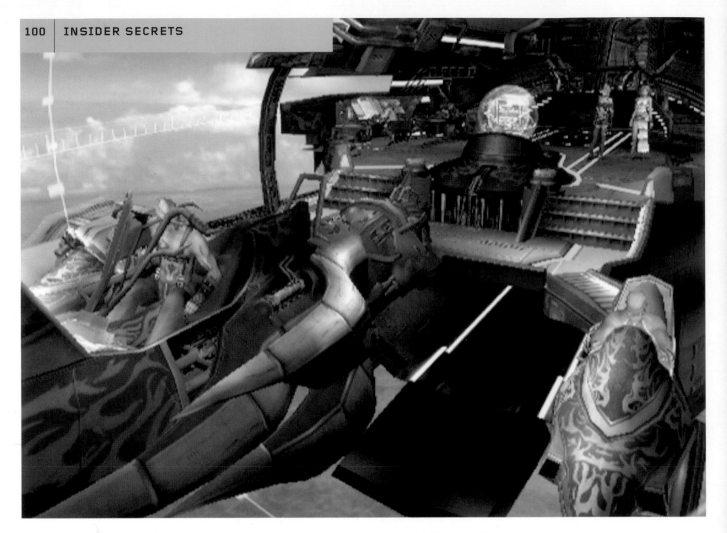

The customs and the ways of life of the people who inhabit our imaginary worlds are an extremely important factor. We are always trying to think about creating worlds that are different from the real world, but worlds in which you can believe people actually live.

Clothing is another important factor. At the same time as we are trying to create styles of dress that don't exist anywhere else, we also try not to forget reality by creating something ridiculous or impractical. Finally, we are very conscious of the massive effect music has on the player's reaction to and interaction with the gameworld, and on the overall feeling of the game itself.

Is there anything not mentioned in the above categories that you feel is important to the creative process?

Matsuda: Inspiration. From the very earliest stages, we have a rough idea about most of the game locations. From there, without doubt, the greatest factors in the creation of the gameworld are the ideas and opinions of the team.

When designing the look of the gameworld, what elements do you usually begin with?

Matsuda: The parts of the buildings. For example, we could develop the design of a whole building from just a hinge.

Please tell us about the *Final Fantasy* series.

Matsuda: Each installment in the series is developed by a different team. The design is never carried out by just one person.

Is consistency with earlier games in the series a factor when deciding on the style of a *Final Fantasy* game?

Matsuda: On the *Final Fantasy* games I have worked on, I don't think consistency has ever been a restrictive factor. I think the feeling is that the minimum requirement is to have the airship, Cid, and Chocobos. Since we usually try to create a completely new gameworld for every title, we in fact try not to make one in the series too similar to its predecessor.

All images **Final Fantasy X-2 by Square Enix.**

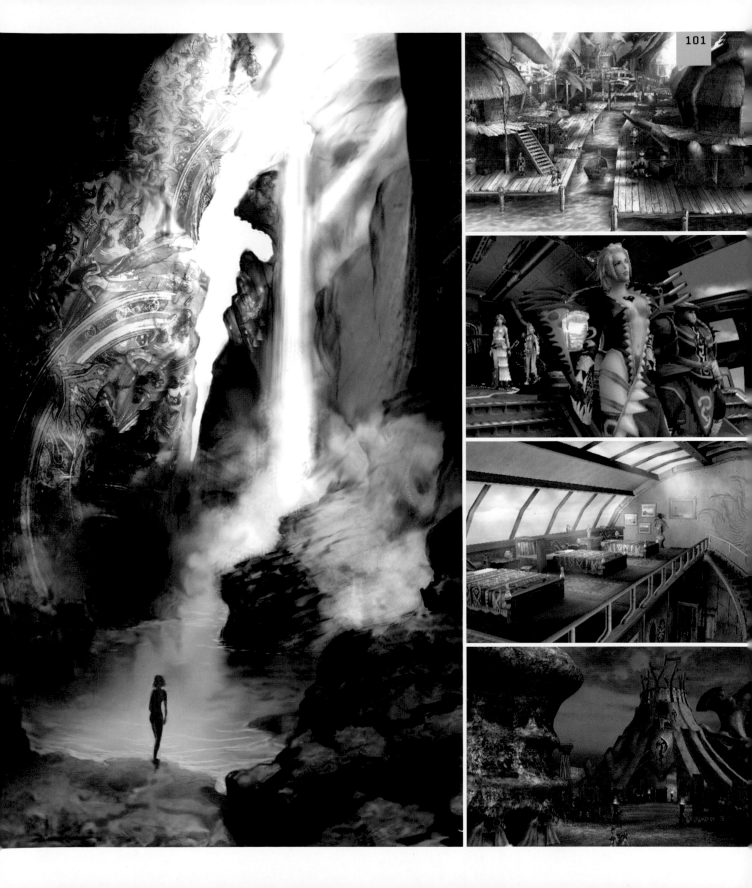

Takai: A new gameworld is created for every *Final Fantasy* game. You could say that the inconsistency of the gameworlds is part of the consistency of the series.

Have any significant problems arisen owing to advances in hardware, developments in 3D technology, and so on?
Takai: Obviously increased cost, but also the subdivision of every part of the process of creation.

What do you think about the increasing trend for realism in game graphics?
Matsuda: I think as a designer, it is something important to strive for, since nothing has more impact than realism. However, as far as games are concerned, I think that striving for realism to the extent where playability and responsiveness suffer is a grave mistake, and this is a balance that is going to become increasingly difficult to strike as technology advances.

Personally, I am a fan of both the *Zelda* and *Dragon Warrior* series and would love to see the development of the graphical styles used in those games. In fact, I wouldn't mind experimenting with them myself on a project.

In recent years, the *Final Fantasy* games have developed an amazing level of realism but have still managed to retain the flamboyant style of the series. Where do you think this very particular style comes from?
Matsuda: I don't know. As far as the quality of the series is concerned, I think the staff's acute awareness of the pressure on them to continue such an amazing series keeps the standard high.

"Style" can also mean "direction," and as such, I think that the sensitivity and feel for the series which the directors, scenario writers, and producers all have are also a major factor. Also, I know this is a little abstract, but I think that the power of the brand also plays its role in the overall "style"of the series.

All images **Final Fantasy X-2 by Square Enix.**

HANDS ON: CONCRETE JUNGLE

HOW TO POPULATE A CITY FOR GAME PURPOSES

1

Creating a city poses a distinct set of challenges to game designers. While building hundreds of identical skyscrapers is easy, populating them is not. Each city must also be highly individualistic, including the areas within it. You can scatter a few buildings around, or even build the place using mathematics, but your city would soon become bland and, as with generic landscapes, difficult for the player to navigate.

EMPTY STREETS

There's nothing worse than living in a computer city: it's a ghost town. Because of the logistics involved, most games have a limited population of automatons dragging their feet around the streets. Such an environment can feel badly underpopulated. Cars can help, as they require little animation, and a few vehicles can easily be cloned to provide a realistic gridlock. You can add color to your population by including a limited number of "landmark" characters:

a newspaper seller, a florist, a grumbling hobo, a couple of kids on skateboards, a brassy prostitute, or a fussy policeman. Such characters reflect the way we form our social map of a city in real life—by getting to know a few people among millions of strangers.

FREEDOM OF THE CITY

Games set in cities have, until recently, been artificially restricted because of technological limitations. The player could only explore a predefined, often linear route through a few streets—essentially a dungeon crawl with the roof off. This can be advantageous when the designer wants to unfold and control a story carefully, as in *Max Payne*. The vogue now, however, is for sprawling, freeform cities. Visual clues become crucial, aiding the player as he wanders. A badly wired electric light flickering over a particular doorway, a hole in the bottom of a fence, or a cloud of flies over a pile of garbage can provide useful landmarks.

1. **Driver 3** by Reflections.
2. Maxis' **Sim City 4: Rush Hour**. City transport systems require a high level

of sophistication to function in a game. Junctions, intersections, freeway ramps, and rail crossings all must

work, even when the player can place them almost anywhere.
3. **Enter the Matrix** by Shiny

Entertainment. This level editor shot shows the great complexity of design required in today's games.

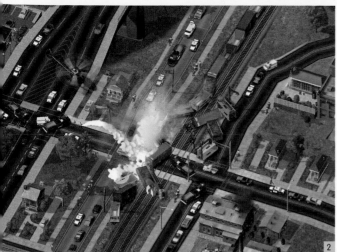

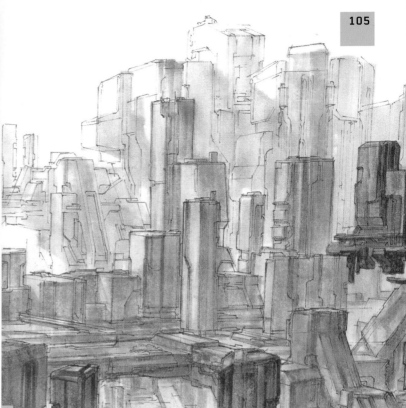

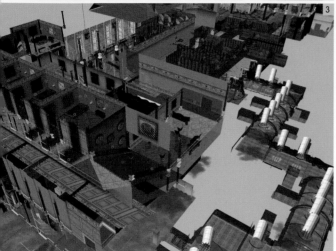

THE CITY THAT NEVER WAS

Fantasy and sci-fi cities often give the designer carte blanche. The temptation in such cases is often to use existing, real-world city structures as a basis—for example, a metropolis that sprawls around a river bend, its center rising in a cluster of skyscrapers. The city of the imagination can be any shape: a ball balanced on the edge of a bottomless crevasse, a strand of buildings stretched between two planets, a single spire reaching for the sun, or filthy congregations of humanity collecting in the valleys of an alien landscape. When presented with the freedom to invent, always take it to the extreme. In today's overcrowded market, your game will only succeed if it stands out.

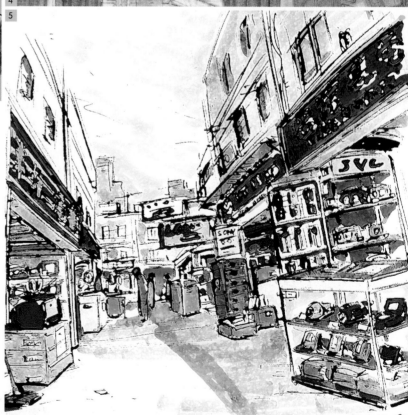

4. **Halo 2** by Bungie. Concept drawings. It's incredible that designers would even contemplate modeling these vast cityscapes.

5. Concept drawing from Sega's **Shenmue 2**. Ordinary environments can provide interesting and colorful backdrops to the action.

SHOCK AND GORE 8

THEATERS OF MECHANIZED WARFARE

"ARMS, AND THE MAN I SING."

VIRGIL, *THE AENEID* trans. JOHN DRYDEN

WAR MAY BE HELL, BUT IT'S ALSO HONEY AT THE BOX OFFICE AND IN THE GAME STORE. THE PUBLIC'S ENTHUSIASM FOR BATTLE SHOWS NO SIGN OF ABATING: EVERY MONTH, NEW TITLES EVOKE THE CLATTER OF GUNFIRE ON NORMANDY BEACHES AND THE ACRID STENCH OF NAPALM OVER RICE PADDIES IN THE MORNING. AMONG SOLO-PLAYER GAME TITLES, MODERN WARFARE ACCOUNTS FOR AT LEAST ONE IN TEN OF ALL NEW RELEASES, AND FOR MASSIVELY MULTIPLAYER GAMES, THE PERCENTAGE IS EVEN HIGHER. MEN LOVE THE IDEA OF WAR UNTIL REALITY REMINDS THEM OF ITS HORROR: WAR GAMES STRIP AWAY REALITY WITH UNLIMITED AMMO AND RESPAWNING LIVES, PROVIDING THE ULTIMATE MACHO PLAYGROUND.

Counter-Strike by Ritual Entertainment/Valve

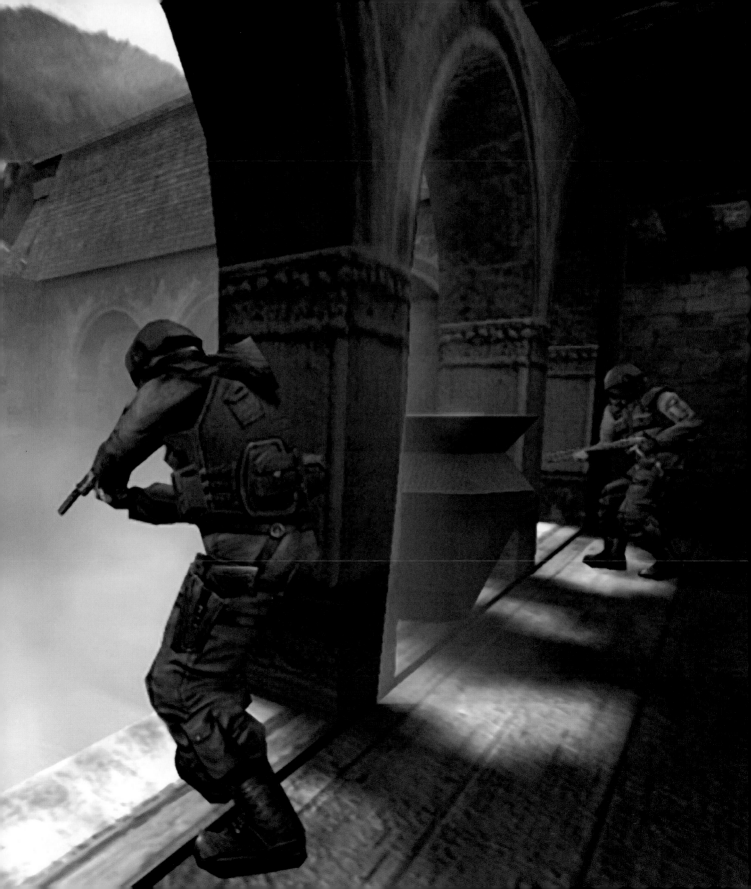

THE BLEEDING EDGE OF REALISM

CHRIS BATEMAN, MANAGING DIRECTOR OF INTERNATIONAL HOBO, COMMENTS ON THE MODERN-WARFARE GENRE.

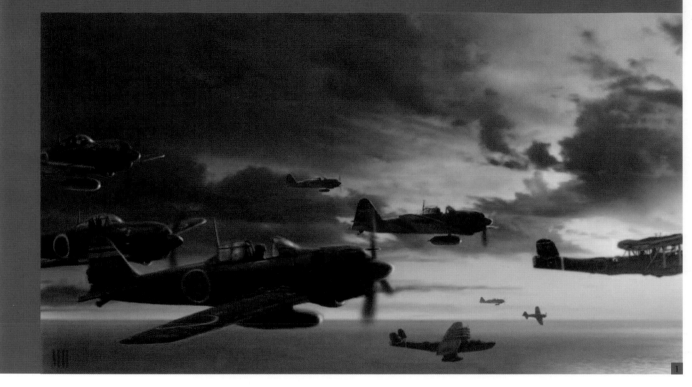

"I HEARD THE BULLETS WHISTLE, AND BELIEVE ME, THERE IS SOMETHING CHARMING IN THE SOUND."

GEORGE WASHINGTON

"The proliferation of games set in World War II is largely due to the familiarity of the setting—and the success of the movie *Saving Private Ryan* did much to catalyze this branch of games. However, the majority of WWII games are first-person shooters, which are fast becoming a niche market. In terms of appealing to the mass market, there are many settings currently underused or unused that may be more appropriate.

"The reality of modern war is that death can strike anybody without warning. Unlike in a Viking war game, for example, where if you want to kill another player you have to be able to best them in close combat, in modern war, a novice can shoot the head off a war-hardened veteran by pulling a trigger from over a mile away. Can that ever be translated into an interesting game of skill, or will it always just come down to a repetitive save-die-reload cycle?

"Most first-person shooters are built on the fail-continue structure because they are targeting a purely hardcore audience highly tolerant of—and largely in favor of—this kind of repetitive play. Therefore, highly fatal environments have become de rigueur. This is well suited to online play, which is in general fast and frenetic—hence the success of *Battlefield 1942* and many war-themed *Quake* mods.

"How do you create a level full of interesting gameplay choices that keep the action moving—as in, say, *Medal of Honor*—without it seeming too artificial? By supporting choices in the core game design and not in the level/world design. If the core gameplay is expressive, the level designs do not need to be constraining. Much of the problem comes when games try to be films. Games need to recognize their inherent interactive strength. Then levels become settings for gameplay, not the sole source of gameplay."

Snapshots of modern warfare:
1. **Medal of Honor: Rising Sun** by Electronic Arts.
2. **Command & Conquer Generals: Zero Hour** by Electronic Arts.
3. Electronic Arts' **Medal of Honor: Pacific Assault.**
4. **Schwarzenberg** by Radon Labs. A complete town meticulously re-created in its wartime state.

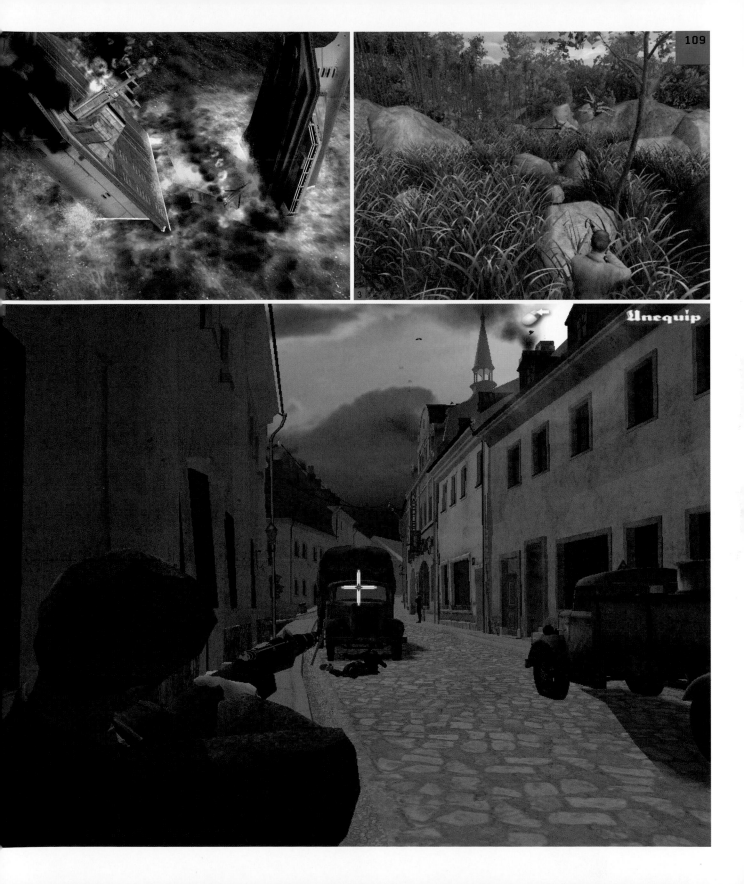

INSIDER SECRETS: WAR ON A BUDGET

WE ASKED **MATTHEW MILES GRIFFITHS**, SENIOR DESIGNER AT SCI GAMES, TO REVEAL SOME OF THE TRICKS OF THE VIRTUAL ARMS TRADE:

"Anyone trying to re-create a compelling scene of modern warfare is going to come up against the same barrier: getting enough people into the scene to make it look believable. Whereas even small-scale skirmishes in modern warfare include dozens, possibly even hundreds, of combatants, a modern console engine would be hard-pressed to have more than twenty fully active entities operating at any one time, and often quite a lot fewer. In the *Conflict: Desert Storm* series, for example, the engine is always running the four main characters, plus any entities with scripts to perform, such as sentries. This often leaves no more than four to five slots that can be used to spawn enemies to attack the character. While respawning obviously helps in trying to give the impression that the player is encountering a company of infantry, it can very quickly result in gameplay that is little more than shooting the same five guys again and again. What strategies, then, exist for us to try and convince the player otherwise?"

JUST BECAUSE YOU CAN'T SEE THEM DOESN'T MEAN THEY'RE NOT THERE

"One of the absolutely defining moments in a modern war game has to be the Omaha Beach landings in *Medal of Honor: Allied Assault*—a fact not lost on Electronic Arts themselves, who moved it from level four in the PC version to give it star billing as the opening level when the game hit PlayStation 2. And while that sequence owes a lot to *Saving Private Ryan*, it's astounding how compelling and believable a scene it is. You really feel like you and your squad of GIs are under fire from everything Rommel has to throw at you.

"Except, of course, you're not. Rommel's guys aren't there. The entire character register is used up to depict your brothers-in-arms and their various painful ends, while German involvement in the scene is restricted to two automated machine-gun

►►

1, 3. **Commandos 3: Destination Berlin** from Pyro Studios. The great strategy series returns in 3D.
2. An image from Pivotal's **Conflict: Desert Storm 2** showing the different

roles available to the player.
4. A new viewpoint in Electronic Arts' **Medal of Honor: Rising Sun.**
5. The hugely successful **Counter-Strike** by Ritual Entertainment/Valve.

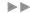

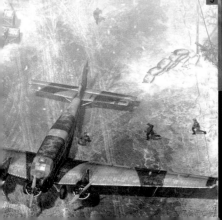

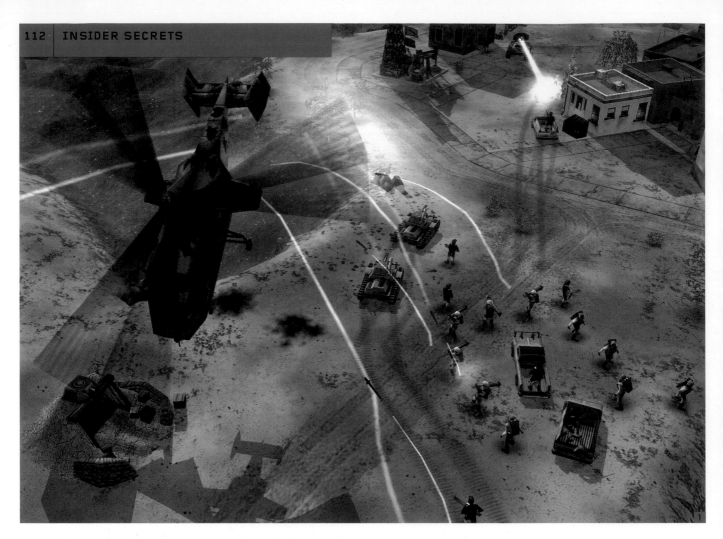
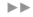

emplacements that take it in turn to target your position, and a whole host of prescripted explosions. While you're likely to die again and again as a player attempting this mission, you'll never actually see the guy who shot you. By the time you get inside the fortifications and actually start encountering real live Germans, all your comrades have been culled and you are completely on your own. An excellent piece of smoke and mirrors. *Conflict: Desert Storm 2* has a similar moment in it, when your squad comes under mortar fire while patrolling a street. After several hectic minutes of negotiating the bombardment, the player advances to discover the abandoned mortars, which of course were never manned in the first place."

SOUND AND FURY

"Any research into the subjective nature of modern combat reveals that the chief experience any individual encounters is one of confusion. Weapon fire comes in from all quarters, explosions rattle the mind and the body, enemies appear as if from nowhere, while comrades scream with urgency, terror, and pain. The mind is literally overloaded with input so that its focus narrows, and all it is concerned with is dealing with the most immediate threat.

"For us, then, the challenge is clear: All we have to do is present the player with as much information to process as possible. Given that the player can only look at one thing at a time, the best ▶▶

1. **Command & Conquer Generals: Zero Hour** by Electronic Arts takes one of the founding fathers of the RTS genre and gives it a sparkling 3D overhaul.
2, 3. Nival Interactive's **Silent Storm** brings strategy back to wargaming using turn-based scenarios.
4. Troubleshooting an alternate reality in **Söldner: Secret Wars** by Wings Simulations.

8

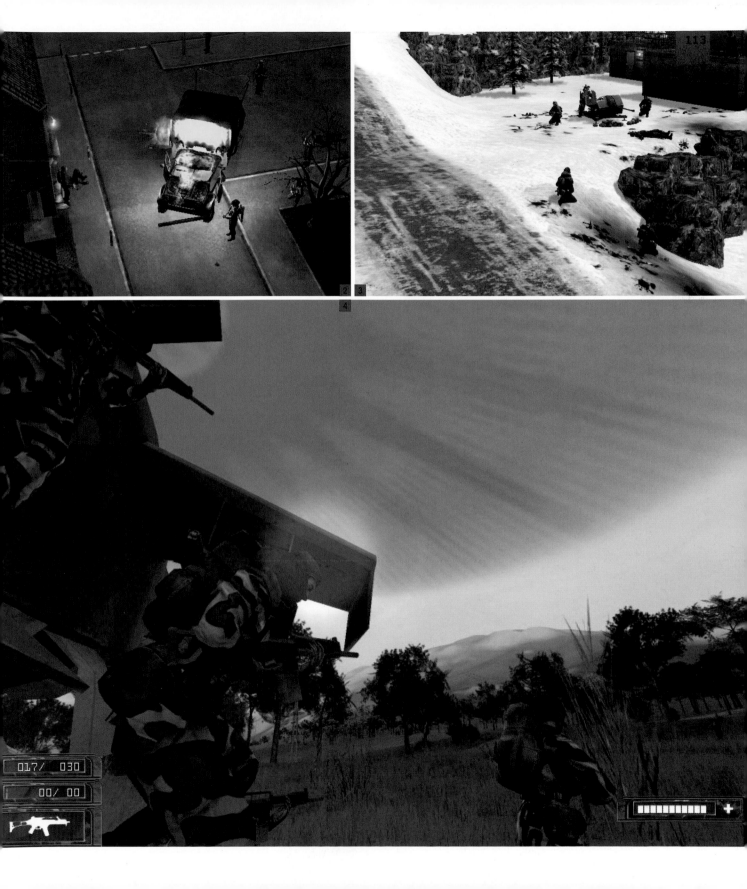

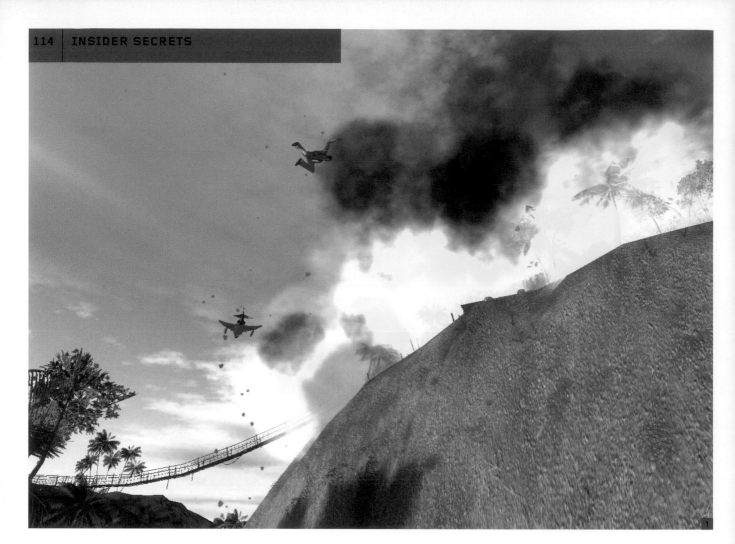

way to do this is with sound. First off, a good ambient track sets the tone. The distant thump and crackle of explosives and gunfire give the illusion that combat is occurring over a wide area. On top of this, every foregrounded gunshot, scream, garbled radio message, and vehicle engine contributes to an illusion of great activity. Positional sound can make a player feel like he is in the middle of a huge cauldron of action, turning a small-scale skirmish into just one fragment of a huge battle.

"In the *Conflict: Desert Storm* series, the element that best achieves this effect is the reactive speech of your AI (Artificial Intelligence) buddies. They are programmed to pipe up with an appropriately gung ho phrase every time they see an enemy soldier or vehicle, kill the same, throw a grenade, take a hit, see one of their fellows go down, or encounter any number of other situations. Given that there are three of these AI buddies, a player soon ends up bombarded with urgent shouts and warnings. This not only creates the verisimilitude of combat we are familiar with from its portrayal on film and television, but more importantly, it bombards the mind of the player with more data than it can usefully process. Even an encounter with a single sniper becomes dramatic and exhilarating, while a firefight with five respawning grunts becomes an extended struggle for survival against the odds."

1. The devastating effects of a bombing raid in **Battlefield Vietnam** by Digital Illusions.
2. Pivotal's **Conflict: Desert Storm 2.** The voices of your team mates adds immensely to the atmosphere.

8

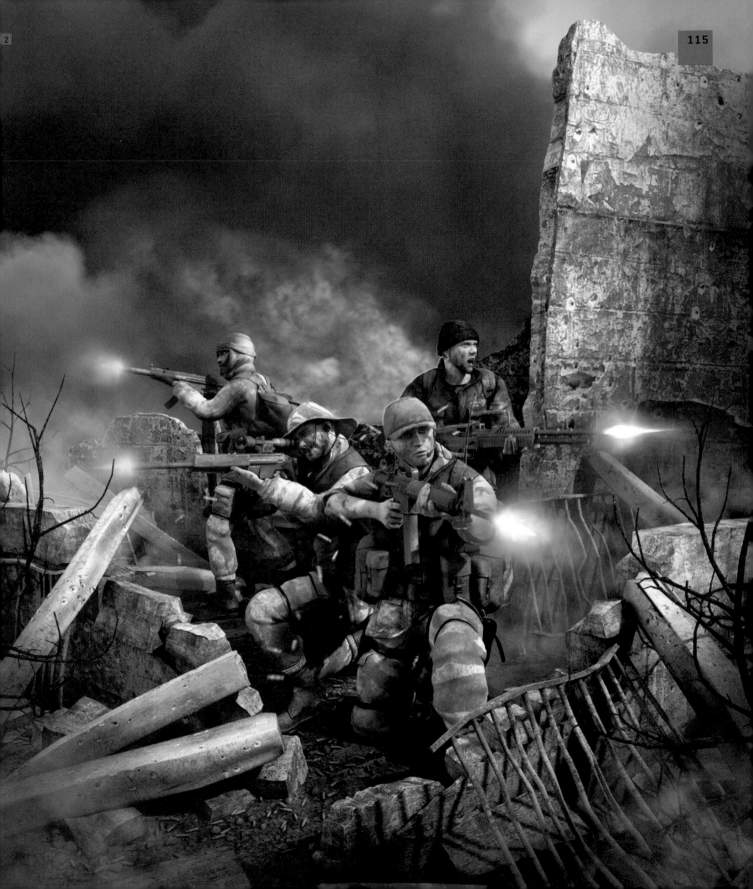

HANDS ON: PAINTING WITH LIGHT

LIGHTING HAS BECOME THE NEW PLAYGROUND FOR THE GAME ARTIST. ADVANCES IN
3D ENGINES AND GRAPHICS HARDWARE ARE ALLOWING INCREASING REALISM IN THE
WAY LIGHT BEHAVES IN THE GAME ENVIRONMENT. MIKE JEFFRIES, LEAD ARTIST AT
SURE FIRE GAMES, TALKS ABOUT USING LIGHT IN COMPUTER GAMES:

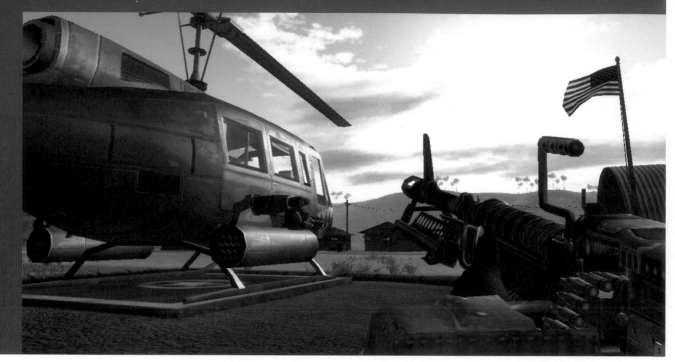

Do you consider lighting an important part of game design?

In the end, it is the final look of the game. Everything is defined in the 3D engine by light falling on it then bouncing out of the screen into the player's eyes, just like real life.

What about style?

You need to study cinema to see how lighting creates a visual style. Right back to the '20s, in films like *The Cabinet of Doctor Caligari*, you see lighting used to create powerful compositions.

Does lighting affect gameplay?

Profoundly. You can use it to hide surprises, draw the player's attention to things, set up suspense, and so on. And the player can use it—for example, by hiding in shadows in *Unreal*. More obviously, it can become part of the gameplay itself, such as a driving game at night. Of course, different genres call for different kinds of lighting. Strategy and sims usually go for regular, always-on lighting, but that's important too, where simple clarity is needed.

What about lighting in 3D environments?

It is tricky when you have a moving camera, like the player in a 3D shooter. You can't set up framed compositions. The idea is to think more about zones where you create the lighting mood. In *Max Payne*, lighting changed depending on where you were: soft domestic in the house, harsh overhead fluorescent in the subway, red-saturated colors and creepy darkness in the dream sequence.

Do you see a specific difference between lighting a fantasy or sci-fi game and a real-life environment?

Not really; both need unreal lighting. People often try to light real things with real light, but if you ever look at a film set, the lighting is anything but real. Reflectors are used to fill actors' faces, impossible lights illuminate corners, shadows of trees across a path are manufactured, etcetera. Nature is definitely enhanced.

1. Chasing cinema's tail—the very latest in evocative real-time lighting in Digital Illusions' **Battlefield Vietnam.**
2, 3. Classic chiaroscuro in Pyro Studios' **Commandos 3: Destination Berlin.**
4. Lighting serves gameplay well in Wings Simulations' **Söldner: Secret Wars.**

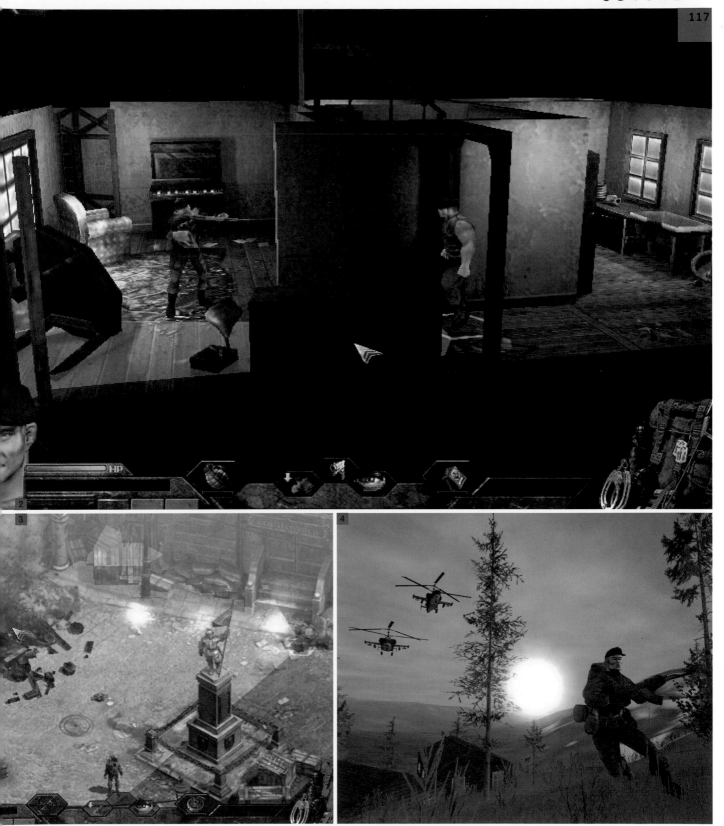

BEFORE YOU START
Think carefully about the game type and story, and the kind of lighting that will enhance the gameplay intent.

DARKNESS
Darkness or heavy shadow can be a boon, as it allows you to reduce detail in those areas.

FOG
Use fog sparingly, and only if the story or gameplay demands it. It has become a cliché in 3D design as a hangover from earlier games, which used it to hide distance.

LIGHTING MODELS
Look into how artists in the past have used light—such as chiaroscuro, a style used by Renaissance painters wherein a single light, such as a candle, picks out the subject from the surrounding darkness.

LIGHT TEMPERATURE
You can change the whole mood of a setting depending on the way you use bluish, cold light and reddish, warmer colors. The same applies to contrast—harsh, strong light is cold and discomforting, while soft, glowing light is welcoming.

LIGHT SWITCHING
Consider the dynamism of lights in the game: move them, turn them on and off, change colors, and so on. The blinking of a neon sign can be evocative, and the sun going down suggests the passage of time.

LIGHT AND 3D
Current game technology is amazing, but the delights of real-time 3D are often wasted with the flat digital lighting that is often used. Try subtle, analog-style lighting, like in *Ico*, to really show off the solidity and dimension of your models.

8

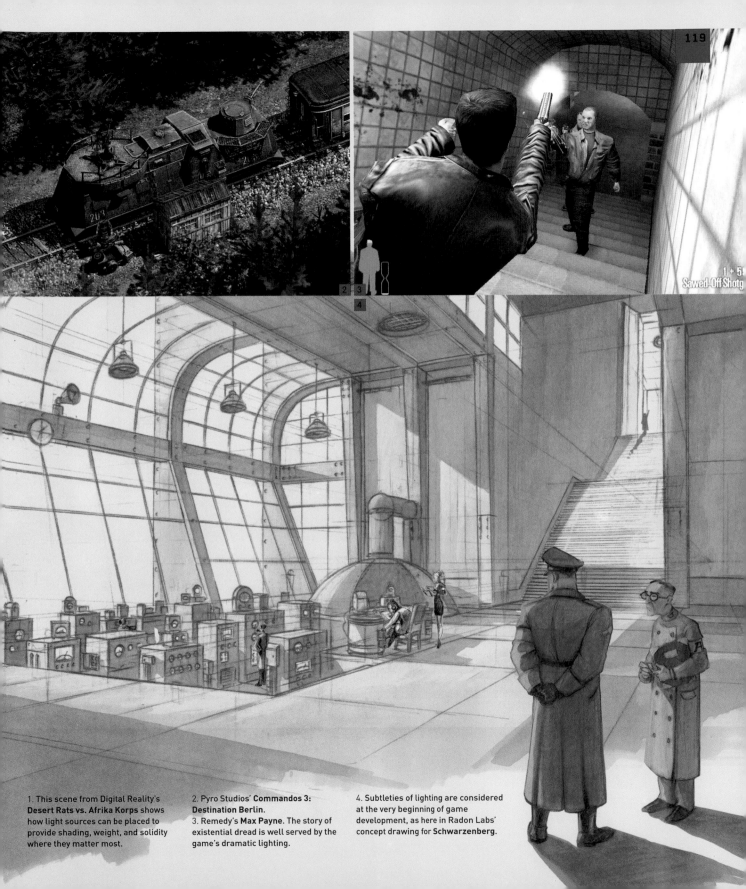

Sawed-Off Shotg

1 + 5

1. This scene from Digital Reality's **Desert Rats vs. Afrika Korps** shows how light sources can be placed to provide shading, weight, and solidity where they matter most.

2. Pyro Studios' **Commandos 3: Destination Berlin.**
3. Remedy's **Max Payne.** The story of existential dread is well served by the game's dramatic lighting.

4. Subtleties of lighting are considered at the very beginning of game development, as here in Radon Labs' concept drawing for **Schwarzenberg.**

KEEPING IT REAL

9

REALISTIC CONTEMPORARY SETTINGS

SINCE THE FIRST STORYTELLERS UNROLLED THEIR RUGS IN A SUMERIAN MARKETPLACE, THE ENTERTAINMENT MEDIA HAVE PROVIDED MIRRORS IN WHICH TO SEE OURSELVES. NOW, IN PARALLEL WITH THE PROLIFERATION OF REALITY TV SHOWS, A GAME GENRE THAT DEPICTS OUR LIVES IN THE OFFICE, THE SCHOOL, AT HOME, AND ON VACATION IS COMING TO THE FORE. WITH SUCH GAMES COMES THE OPPORTUNITY FOR SATIRE. "O WAD SOME POW'R THE GIFTIE GIE US," WROTE ROBERT BURNS, "TO SEE OURSELS AS OTHERS SEE US." TWO HUNDRED YEARS LATER, HIS WISH HAS COME TRUE—AND WILL WE EVER SEE OURSELVES THE SAME WAY AGAIN?

Project Gotham Racing 2 by Bizarre Creations.

FAMILIARITY BREEDS

"THE PROBLEM A GAME DESIGNER HAS, COMPARED TO A NOVELIST OR A FILMMAKER, IS THE 'WHAT'S BEHIND THE DOOR?' CONUNDRUM," SAYS **OWAIN BENNALLACK**, EDITOR OF *DEVELOP*.

"If there are doors that can't be opened, then the player is going to step back from really being there. It breaks the spell. On the other hand, if any door can be opened, the world is going to have to be pretty straightforward—or else it's not going to have many doors!

"Once we realize that 'door' is a metaphor—can I drive a car? Can I talk to those peasants? Can I fish in that river, and then sell the fish?—then we come full circle to why familiar worlds are so enjoyable. Because you know—to an extent—where the doors lead. It's much harder at the moment for games to 'inspire' through settings and milieu for this reason, compared to other creative media such as movies or novels. The inspiration in games comes from interaction with the environment, from opening the doors, from going through the motions.

"In total contrast to the above, the best fictional worlds for me in other media are those worlds that are entirely ordinary to the inhabitants and entirely extraordinary to me—*Neuromancer*, *The Lord of the Rings*, *Spirited Away*, *Top Gun*, *Dead Poets Society*, for example. These sorts of worlds are rare in games, although *Abe's Oddysee* by Oddworld Inhabitants is one that springs to mind."

Because we're so aware of all the details of everyday life, creating a realistic game environment is potentially a huge task. In *Shenmue* the player could walk down any alleyway and look at graffiti on the walls, and the job of creating these contemporary environments is getting bigger as the technology makes more detail possible. Where do you draw the line?

"If you created the whole of London in a game," says Jamie Thomson, creative director of Black Cactus Games, "it would soon become very tedious just wandering in its vastness. You need to control the player's access to the city, so that he can only navigate small sections at a time, and for a reason. Backdrops, sound effects of a teeming city, and using views of the city that the player cannot navigate are effective smokescreens. Also, you need to make sure that the screen is full of lots of characters looking busy. Control the size of the screen, so that tens of characters fill it up."

1. A vivid scene in **Ford Racing 2** by Razorworks.
2. Slices of life from **The Sims 2** by Maxis.
3, 4. Turning tricks in **SSX 3** from Electronic Arts.
5. Gnome wreckers from Maxis' **The Sims: Makin' Magic**.

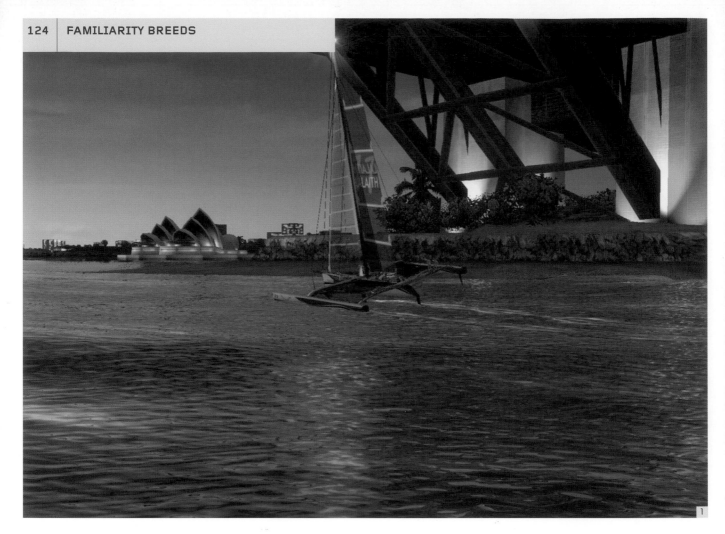

"The key is to identify your core gameplay activities," says Chris Bateman. "The natural structure of play defines the likely actions, therefore one can focus a game design to build upon the core play activities. Everything else can be left out. *Shenmue*, despite numerous bells and whistles, is focused on walking and talking (an adventure-game structure) coupled with a fighting engine. The vast majority of the *Shenmue* world is geared toward these activities, with much of the rest of the material being equivalent to 'bonus games' and frills, which to some extent could have been omitted."

"In general, realism is not the goal," says Jamie Thomson. "Atmosphere is the goal. Some games require realism to generate the right atmosphere. *Medal of Honor* is an example of this."

Grand Theft Auto 3 provoked fierce debate because of the level of violent actions that it allowed, while such actions depicted in a movie would be used to raise moral questions. The sense of an authorial presence in film seems to comfort viewers, whereas in a game, actions take place without a specific moral framework. The only judgment is made by the player—and many feel uncomfortable at being allowed to carry out such (virtual) immoral acts.

Apparently the specificity of *Grand Theft Auto*'s modern setting was what made it so contentious. Therefore, this could have a beneficial flip side, as perhaps games with realistic modern settings can provide authors with a new medium for conveying stimulating ideas. Great art, it is said, changes your life. Maybe one day we will see a game that achieves the same.

"It's certainly the case that games can provoke philosophical reflection just as books or movies can," agrees Chris Bateman. "But the quality of narratives at the moment, for the most part, is too poor to allow this. Any attempt to do a 'game as a film' is to miss out on a game's greatest strength: interactivity. We will eventually see games that are thought-provoking due to the implications of our actions on others in the gameworld, but they must let the player explore their own morality, not force a moral framework upon them."

1, 3. A life on the ocean waves in **Virtual Skipper 3** by Nadeo.
2. Come for the festival, stay for the racing—an Edinburgh street scene from Bizarre Creations' **Project Gotham Racing 2.**

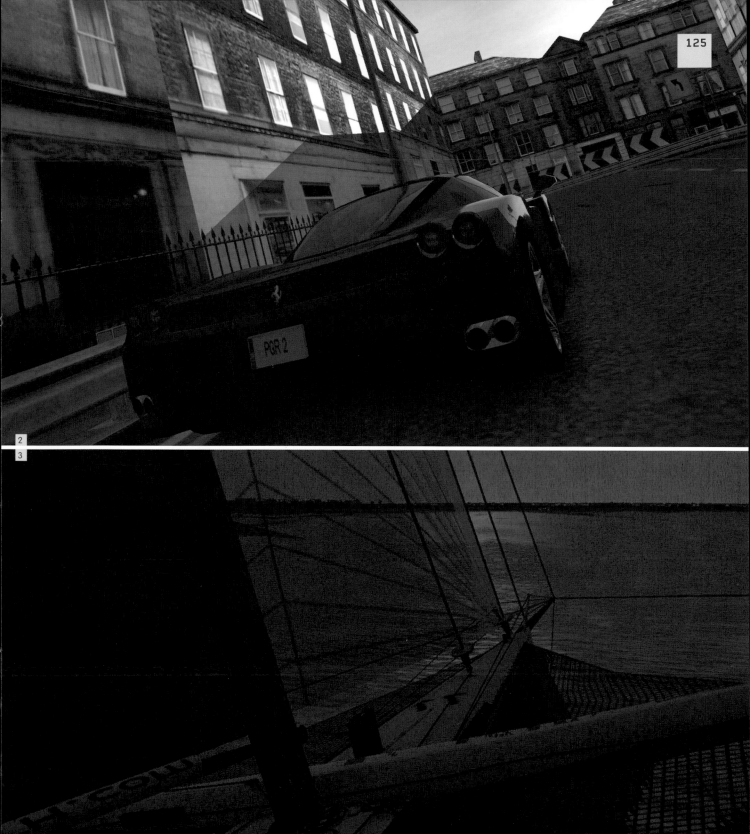

INSIDER SECRETS: HOLLYWORLDS

PATRICK O'LUANAIGH, CREATIVE DIRECTOR OF SCI GAMES, TALKS ABOUT TAKING
PROJECTS FROM HOLLYWOOD TO PLAYSTATION:

"Games based on movies have had a very patchy track record. For every success story like *Goldeneye, Aliens vs. Predator*, or *The Lord of the Rings: Return of the King*, there are many poor titles that have sunk without a trace. In fact, the most famous games-industry disaster story was based on a movie, when millions of copies of the *E. T.* game were allegedly buried in an American desert when the company behind it massively overestimated the demand for what was a truly dreadful game.

"Part of the reason for the dubious history of movie-based games is that publishers often used to bolt film licenses onto games that weren't very good, in the desperate hope of salvaging some decent sales. Fortunately, things have been changing for the better over the last few years, and more and more companies are realizing that a movie license doesn't stop you from creating an original, unique, and extremely enjoyable game.

"I have had the fortune to work on a number of games based on movies, including *The Italian Job* (the first game, based on the original film with Michael Caine) and *The Great Escape*, and I am now doing preproduction on *Reservoir Dogs*.

"So how do we approach the design of our movie-inspired gameworlds? Well, the first thing to do is to get an accurate idea of how much flexibility the licenser—normally a major movie company—will give you. Too much freedom might encourage you to stray too far from the original film, and your game could end up looking unrecognizable to fans of the original. Too little freedom, and your game is stuck within rigid locations, with no ability to tailor the license to the very different requirements of video games (which tends to mean more action and less dialogue).

"It is highly unusual to attempt to try to change the mood of a film and produce, say, a dark, sinister game based on a bright, fast-paced action epic—although I'd quite enjoy giving this a go! If you want to appeal to fans of an original movie, then you need to retain the film's identity in terms of the artwork and visual style. But movies

►►

1. No, it's not a dream. That really is
Starsky & Hutch by Minds Eye.
2–5. Cinematic realism from Electronic Arts'
The Lord of the Rings: Return of the King.

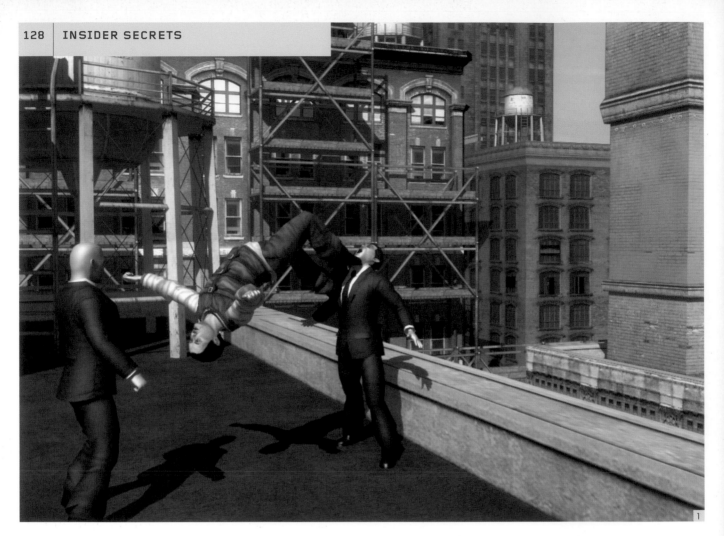

last around two hours, whereas gamers want at least fifteen hours of varied gameplay. Therefore, it is vital to have the freedom to build on the original, taking the game into other places that feel 'right,' and creating additional fresh material.

"The vast majority of movies are set in a real-world location, whether it is 1920s New York or modern-day London, so designing new environments initially appears to rely mainly on finding accurate reference material. However, the real challenge is in consistently replicating all the unique elements that make up cinematography. Camera-lens angles, camera movements, lighting, contrast, and a host of other graphic elements all combine to make, for example, a typical Hitchcock movie different from a typical Spielberg movie. So understanding what makes the original film work is vital when you need to create new original locations for the game.

"It is also vital to understand what made the film memorable for the audience. With *The Great Escape*, one of the key parts that people remembered was the fantastic motorbike chase at the end, with Steve McQueen trying to jump the fence. We could easily have created a game based entirely on sneaking out of POW camps, but

the decision to include the ability to leap on a motorbike and ride for freedom was a key one, and one that I believe played a major part in the game's strong sales. In this case, it was essentially a game-design decision, but often it can be an artistic design decision as well.

"So, making games from movies is a unique challenge, but one that needs to be approached with a real desire to create an original game, and not just throwing a license onto an average game. Understand what makes the movie so memorable, and why it looks the way it does. Then craft a world based around the movie, adding exciting additional features and locations, always retaining the fundamental style and mood.

"Remember this, and you stand a chance of not only appealing to fans of the movie, but of making an impressive and unique game as well."

1. Chewing the fat with the **Bullet Proof Monk**, from Mucky Foot.
2. *Ay caramba!* It's Warthog's **Looney Tunes Back in Action.**
3. More Errol Flynn than Ethelred the Unready—the Middle Ages, Hollywood-style, in Capcom's long-awaited revamp of an old classic, **Robin Hood: Defender of the Crown.**

2

3

HANDS ON: EYE CANDY

CREATING ATMOSPHERIC AND SPECIAL EFFECTS

1

The wonderful thing about the virtual computer-game world is that special effects cost a fraction of what they cost a movie. Powerful new graphics processors are now dedicated to handling visual effects at a hardware level. When faced with this freedom, however, don't overdo it. Like real candy, too much can make you sick.

BLOW UP

Every boy has a yen for destruction, and the only place you can do it without upsetting the authorities is on a computer monitor. But there's an art to destruction, especially if your explosions are going to stand out. The type of explosive and what's being blown up are important. Is your explosion a short, flameless, staccato blast, or a slow, rolling balloon of orange flame? Play with the colors: deep warm reds, white heat, or an icy shattering of cold blues. Think around the explosion: the cloud of dust, flying fragments of debris, and the noise of splitting, tearing, and wrenching. What about the effect of the shock wave? Some games represent explosions by jolting the camera or distorting the image, but this is really just a lazy steal from a different medium and only draws attention to the

player's position as an external observer. Instead, think about people being thrown to the ground and the shattering of distant windows. Imagine the aftermath, the time-delayed collapse of buildings, the clatter of debris as it rains down, and the final eerie silence punctuated by the cries of the injured.

VORPAL SWORD

It's tempting to go overboard and fill the screen with sheets of flame, fireworks of stars, and rainbows of color just because it's something the latest version of Direct X can deliver. Unfortunately, other developers will be using precisely the same effects. Restrain this urge and calibrate each effect to suit the event, saving the best eye candy for the biggest gun or the most powerful wizard in the closing phases of the game, or the impact can be lost. On a practical note, effects must never interfere with gameplay. Too many effects on top of one another obscure the action and distance the player from full immersion.

QUIETLY EFFECTIVE

Some of the best special effects make hardly any noise at all but contribute immeasurably to the atmosphere. While not strictly "special," atmospherics such as a dense fog rolling in from the sea, rippling heat haze, pools of mist in the morning, or dust in a shaft of sunlight heighten the sense of reality far more than the most accurately modeled car or perfectly painted texture.

1. Sleek and chic—it's Electronic Arts' **Need for Speed Underground**.
2. Maxis' **The Sims 2** continues to turn the mirror of interactivity on our own lives.

3, 4. A taste of the lifestyles of the extremely rich, provided by Nadeo's **Virtual Skipper 3**.

ARENAS & AMUSEMENT PARKS

LOCATIONS DESIGNED PURELY FOR PLAY

10

ALTHOUGH MANY GAMES AIM TO DELIVER A STORYLINE OR SET OUT TO GUIDE US THROUGH A CAREFULLY AUTHORED SEQUENCE OF EXPERIENCES, OTHERS REVEL IN SIMPLY PROVIDING THE FREEDOM TO PLAY. THIS ELEMENT EXISTS IN GAMES AS DIVERSE AS *GRAND THEFT AUTO*, *QUAKE*, AND *A TALE IN THE DESERT*.

Electronic Arts' **FIFA Football 2004**

A NICE PLACE TO VISIT

SOCIAL INTERACTION IS PART OF ALL OUR GAMES, BEGINNING IN THE PLAYGROUND: "HE SHOT YOU, SO YOU OUGHT TO FALL DOWN AND PLAY DEAD." ARE MASSIVELY MULTIPLAYER ONLINE GAMES—COMMONLY ABBREVIATED TO MMOGS—GOING TO NEED SOCIAL, LEGAL, AND POLITICAL FRAMEWORKS MORE THAN THEY NEED PHYSICS AND GAMEPLAY?

"It depends on the audience to which the MMOG is trying to appeal," says author and designer Ernest W. Adams. "Almost all such games require a justice system of some kind, especially if it is possible for players to treat each other badly in significant ways—particularly now that *Everquest* items have a real-world financial value! But I believe there will be some MMOGs that don't need much in the way of social and political frameworks, if their primary appeal is nonsocial—massive war games, for example."

"Yes, of course persistent worlds will raise questions of politics," says Dr. Richard Bartle of Muse, regarded by many as one of the fathers of massively multiplayer gaming. "Naturally, there is no guarantee that designers will be aware of this, nor that the politics they profess will be in any way consistent."

"Ultimately, yes," says Chris Bateman. "Sociopolitical organizations are essential in the long term, and these drive the most interesting play. Bells and whistles such as physics are nice, but the majority of players are held to the game by the community, and therefore structuring such organizations is actually more important in many ways than the core gameplay."

In persistent massively multiplayer game worlds, it's possible that a participant in the world might create an object that the hosts of the game wish to use—perhaps to duplicate, to make part of the "official" game reality, or even to sell in the real world. The last option is not as far-fetched as it seems. Characters in multiplayer role-playing games have changed hands on eBay.

We may ask: If the game contains rules of physics for creating and shaping the environment, and players exploit those rules to build themselves a world—as in the case of *Asheron's Call 2*—then who are the creators of that world?

The interesting question that is being debated among game designers right now is whether the hosts of the world should pay to use player-created artifacts. One argument is that such

1. Shootin' hoops in **NBA Live 2004** by Electronic Arts.
2. Lizards in space. **Dino Crisis 3** by Capcom.
3. **Bionicle: The Game** by Electronic Arts.

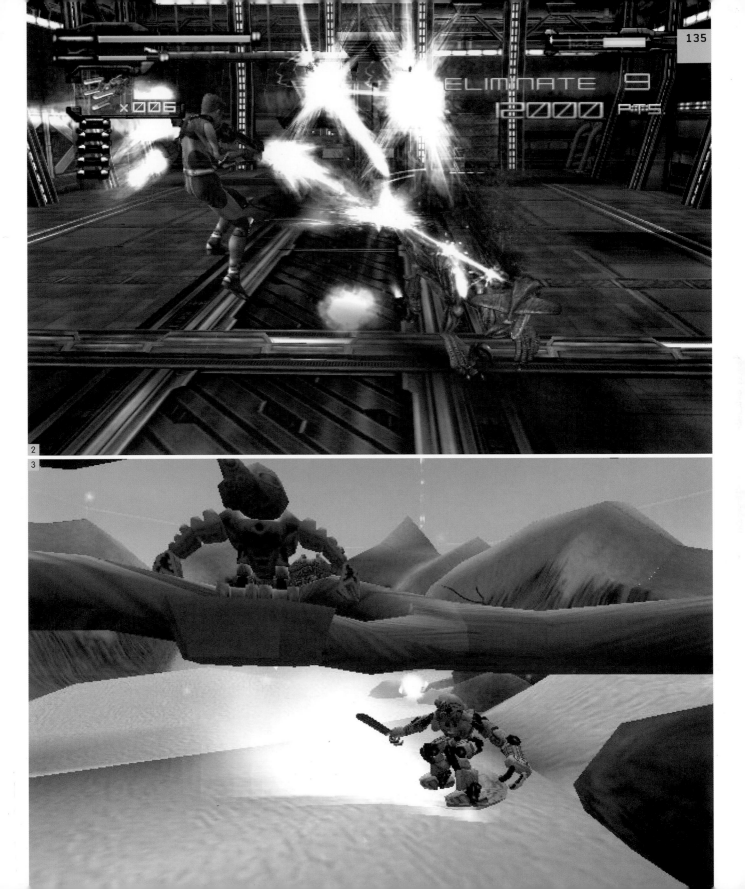

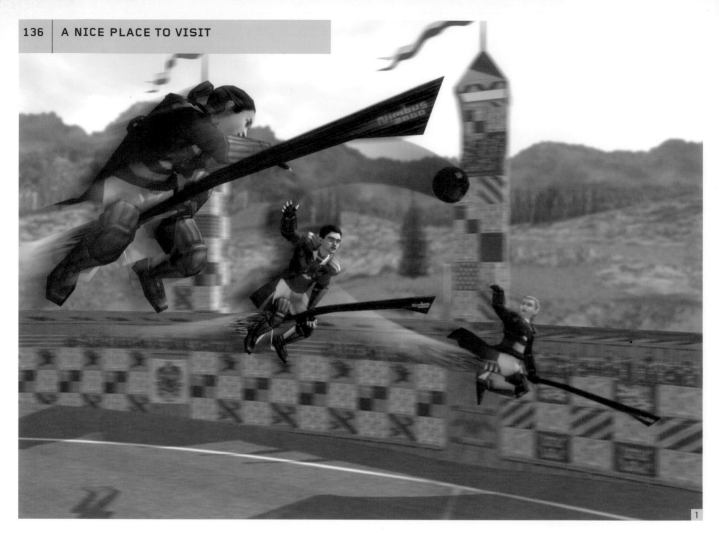

1

items, virtual though they may be, can be legitimately regarded as artworks to which the creator has moral rights. It remains to be seen, however, how such moral rights could be upheld in a user-defined environment.

"The owners of the host world can use the sidewalk artists' defense," says Dr. Bartle. "In the same way that sidewalk artists know when they chalk their masterpiece on the ground that it is impermanent, so do virtual artists accept that their virtual creations are, too. Sidewalk artists can't claim the sidewalk just because they drew on it, and virtual artists can't claim chunks of the virtual world, either. Whether they may assert copyright over a particular configuration of objects in someone else's database is more debatable, but if they can, then I foresee the Terms of Service agreements for such games including lines like 'not to be used for creating works of art.'

"Some designers are suggesting that because players have invested so much time and effort in a virtual world, they somehow have rights in that virtual world other than the right to leave. The right to assert real-world ownership of virtual-world

objects, for example, is not something players ought to be able to claim unless the developers let them—as have Linden Labs.

"If many people are interested in something, then yes, they're going to be upset and protest when things don't go their way. That doesn't mean anything needs to be changed to reflect their views, though, especially where there's an element of game involved."

The degree to which players of persistent game worlds feel legal entitlement of the world can be illustrated by the case of a MMOG that was switched off by its hosts in response to player insurrection. The ultimate sanction, one might think. But some players took the case to court, raising the possibility of an intriguing outcome: "I find the concept of the courts mandating that a game be turned back on to be absolutely fascinating," says Dr. Bartle.

1. Taking to the skies in **Harry Potter: Quidditch Word Cup** by Electronic Arts.
2–4. Return of the hero. **Mega Man X7** by Capcom.

5. Pausing for thought in **Sudeki** by Climax.
6–7. Breaking out of the stadium for **NFL Street** by Electronic Arts.

"It is demonstrative of some sort of disconnect with reality somewhere along the line. One of the big things we talk about as online-game developers is how these things are services, not products. So, what happens to the service when the servants refuse to run it? Or, worse, run it in such a way that guarantees players will be upset?"

It is clear that interesting questions are being raised by massively multiplayer virtual worlds. Whether intended for gameplay or not, these are virtual places that will inevitably evolve—or have imposed upon them—systems of etiquette, laws, and politics. Even if the world itself is devised purely for gameplay, the system includes all of the players and the interaction that they develop between them—just as, in our world, the rules of war extend far beyond the simple physics of firearms and the science of logistics.

Finally, if it is viable to create games that are purely environments for play—where there are no specific challenges set by the game designer, as we have come to expect in games—are other aspects of the gameplay experience also dispensable? What about stories, for example?

"Games don't need stories," points out Chris Bateman. "There are many great games with no story. However, when a game does need a story, it needs a good story. What it doesn't need is a hackneyed, clichéd narrative written by someone with no storytelling experience. It is becoming clear that a strong narrative is a selling point, however, so it will increasingly be the case that professional story construction becomes more and more significant for the mass market.

"There's room for both scripted and sandbox play within the same framework. Games are going to have an increasing need to support the play requirements for a diverse audience, and combining a playground environment with a story and mission structure—as in *Grand Theft Auto 3*—is a powerful approach to the problem."

All images from **Chaser** by Cauldron.

INSIDER SECRETS: SANDBOX PLAY

PAUL WRIGHT WAS LEAD DESIGNER ON *ROLLING* WHEN HE WORKED FOR RAGE.
HE IS NOW A SENIOR DESIGNER AT SCI. HERE HE TELLS US ABOUT USING A PLAYER'S WAYS OF
INTERACTING WITH THE VIRTUAL ENVIRONMENT TO CREATE EMERGENT GAMEPLAY—AND ABOUT
HOW DESIGNERS CAN USE THE "SANDBOX" AS A PHASE IN DEVELOPMENT:

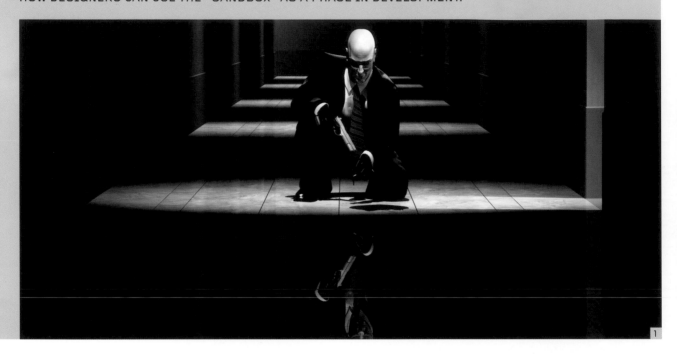

"Shigeru Miyamoto, creator of the legendary Mario games, once said that his idea of making an interesting game is to create toys, with boxes for them to play in. This is another way of saying, create great characters, and environments that utilize the abilities of those characters. This is the key to any successful game based around playground locations.

"When you were a child playing with your Evel Knievel bike, or your Barbie doll, as fascinated as you were by what you could do with the toy itself, it was nothing to what the toy did in different situations and environments. Add a ramp to the end of Evel's run and—bingo!—he pulled jumps. Stand Evel at the back of the bike and hit the ramp to get a backflip. Barbie can be manipulated so she can ride a horse and a car.

"To draw parallels with games, a character such as Mario is really interesting because he can jump off walls, swim, climb up fences, and so on. If he were to be placed in an environment where his ability to, say, swim was reduced to traveling from A to B, then it would be the environment that had failed to capitalize on that character ability. The player would probably then have a mediocre experience while they were underwater. Luckily, this is not the case with the Mario series of games. I believe that the reason for this is that the character was developed first, and then the levels were built. They created a sandbox for Mario that would permit rich use of his various abilities.

"When developing *Rolling*, early on in the design we used the sandbox methodology, where the character was developed in an area of standardized geometry. The environment contained all the basic building blocks of the game, and the character was developed to work with these blocks.

"This had several benefits. The level builders could construct first-pass environments using standardized geometry, with no waiting around for the artists to finish in game geometry.

1, 2. **Some games are more dangerous.**
Hitman Contracts from IO Interactive.
3. **P.N.03** from Capcom.
4. **Play ball in NFL Street** from
Electronic Arts.
5. Namco's **Soul Calibur 2.**

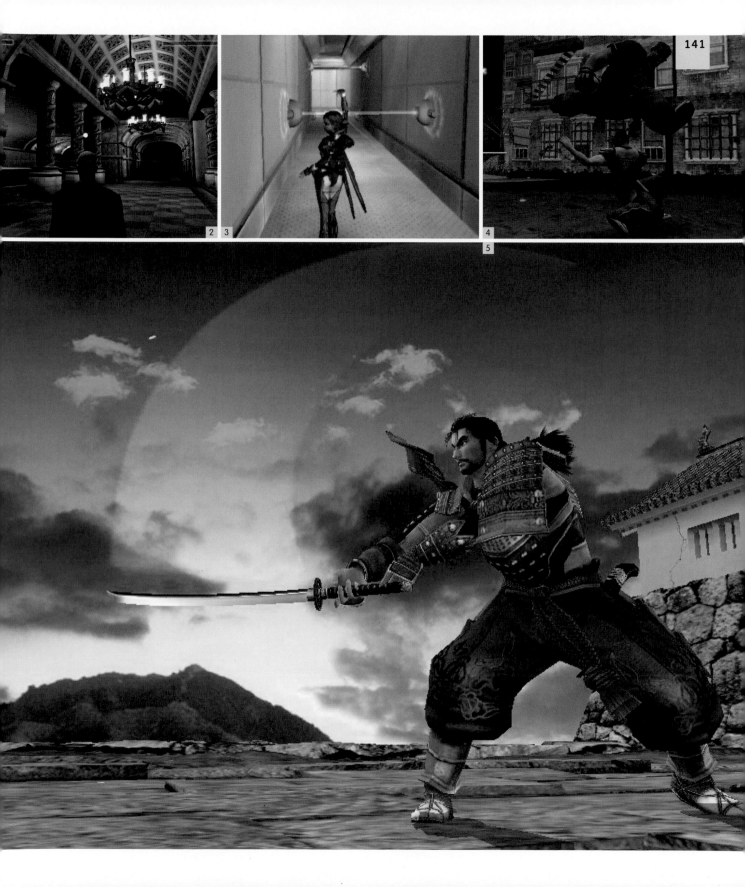

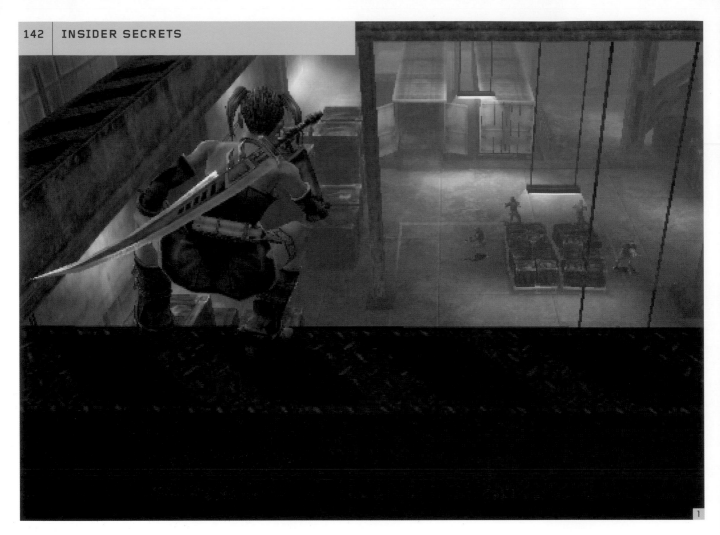

1

Programmers could concentrate more on physics and character handling in a closed environment without worrying too much about interaction with unique models. And basic gameplay principles could be tested well before the full level-building process took place.

"The end of the sandbox phase (or the first development phase) should be followed nicely and smoothly by the main development phase. This is where the artists and level designers get to take their sandboxes and make them into interesting environments for the character to explore and interact with. In the case of *Rolling*, the designers had two rules when creating the sandbox: challenge and choice. Now that the sandbox phase moves to the main development phase, the artists and level designers must incorporate esthetics into the environment. This can be a frustrating time for the artists, as the standardized geometry cannot be altered that much to make an environment look believable. A good team of programmers and artists will find a way to make a sandbox into a beautiful, unique-looking level, and consequently, this is where most of their time is spent in the main development phase.

"During the end phase and testing, you should have environments that look nothing like the first-pass sandboxes created in the initial development phase. But they should still play as well, if not better.

"There are problems with this methodology. It's hard to integrate new features after the sandbox has been developed, and valuable resources are sometimes used in getting these features implemented correctly. Sandboxing does produce bland environments at times, and sometimes it's difficult for the team to disguise that fact.

"To summarize: when creating a playground for your toy, make sure that the environment capitalizes on the toy's features, and provides ample choice to the player as to when and where to use the features. Behind every great game character lies an environment ripe with possibilities for the character to interact with."

1. Warehouse hijinks aplenty in High
Voltage Software's **Hunter: The
Reckoning – Redeemer.**
2, 3. Freedom to play in SCi's **Rolling.**

THE DARK SIDE

11

PLACES OF UNEASE AND HORROR

"LIKE ONE, THAT ON A LONESOME ROAD

DOTH WALK IN FEAR AND DREAD,

AND HAVING ONCE TURNED ROUND WALKS ON,

AND TURNS NO MORE HIS HEAD;

BECAUSE HE KNOWS A FRIGHTFUL FIEND

DOTH CLOSE BEHIND HIM TREAD."

SAMUEL COLERIDGE, *THE RIME OF THE ANCIENT MARINER*

WHETHER IT'S THE OUT AND OUT HORROR OF THE *RESIDENT EVIL* AND *SILENT HILL* SERIES, THE PSYCHOLOGICAL

TERROR OF *THE THING*, OR THE SIMPLE RADAR BLEEPS ECHOING IN THE DARK OF *ALIENS VS. PREDATOR*—THE

MACABRE HAS A LONG HISTORY IN GAMING.

GSC Gameworld's **S.T.A.L.K.E.R.: Shadow of Chernobyl**

BAD DREAMS

HOW CAN GAMES EVOKE HORROR AS EFFECTIVELY AS LITERATURE OR CINEMA?

The best horror involves playing on the viewer's (or reader's) fears—using hints, half-glimpsed secrets, shadows flitting at the edge of vision to plant seeds in the imagination. We fear what we cannot know. But how can that apply to fifty flesh-eating zombies and a sawn-off shotgun?

"Gore isn't scary," says designer Chris Bateman. "It does not evoke fear per se. There's a certain part of the audience that enjoys watching gore, but there is almost no one for whom this is the source of terror. In fact, gore may be more appropriate in an action setting than a horror setting. It's easy to do gore in games, but it's much more impressive when a game succeeds in evoking an atmosphere of terror."

Take Jacques Tourneur's spine-tingling classic *Night of the Demon*. Before extra shots were inserted by producer Hal E. Chester in postproduction, there would have been nothing to put this movie unequivocally in the arena of supernatural—as distinct from psychological—horror. The ambiguity (which remains by implication despite the additional scenes) makes for a far scarier experience than any number of schlock horror films.

Likewise, in Hideo Nakata's *Ringu*, a few brief visuals imply a whole backstory of horror that preys on our minds long after the movie has ended. In fact, even writing these words in a well-lit office I can feel a tingling at the back of my neck at the very thought of the film's final scenes. And in perhaps the greatest classic of cinema horror, Robert Wise's *The Haunting*, we see—nothing at all. And nothing could be more frightening.

1–2. George Stobbart was never one to mind getting his hands dirty in Revolution's **Broken Sword: The Sleeping Dragon**.

3–4. Medusae and fire imps from Rare's **Grabbed by the Ghoulies**.

11

1

**"THAT IS NOT DEAD WHICH CAN ETERNAL LIE,
AND WITH STRANGE AEONS EVEN DEATH MAY DIE."**

ABDUL AL-HAZRED, *THE NECRONOMICON*

Broadly, there have been two kinds of horror in the movies. The first cranks up the tension throughout with only a few carefully judged moments of horror before the climax—a film like Hideo Nakata's *Dark Water*, for example. The other type is a continuous roller coaster of terrifying events—a trend that started with films like *A Nightmare on Elm Street* and carried through to *Scream* and *Scary Movie*. Up to now, games have tended to take the easy option and emulated the latter, but times are changing.

Games face certain obstacles that make it hard to replicate the subtleties of these horror classics. Players are used to instant gratification. Who would have the patience for a game in which the horror didn't appear until the final level—if then? Also, familiarity breeds contempt. When you are entering that haunted bedroom for the umpteenth time, the shock effect of the monster crashing through the window is irritating at best.

Most importantly, games give us puppet avatars, not characters we completely believe in. When our puppets are under threat, the experience is more like a ride on a ghost train at the theme park than it is like a scary movie.

And yet—consider *Max Payne*. The horror implied in Max's dark subconscious is scarier than anything we actually see. The game's dream sequence delivers definite chills on a par with the best of movies or literature. When we can't trust our senses, it's time to be very afraid. Such narrative quality is not yet typical of games, but it's coming. *Max Payne* is a genuine landmark in the evolution of the medium.

1, 2, 4. **Confronting evil head-on in Capcom's Resident Evil 4.**
3. **Ghost Master by Sick Puppies.**

11

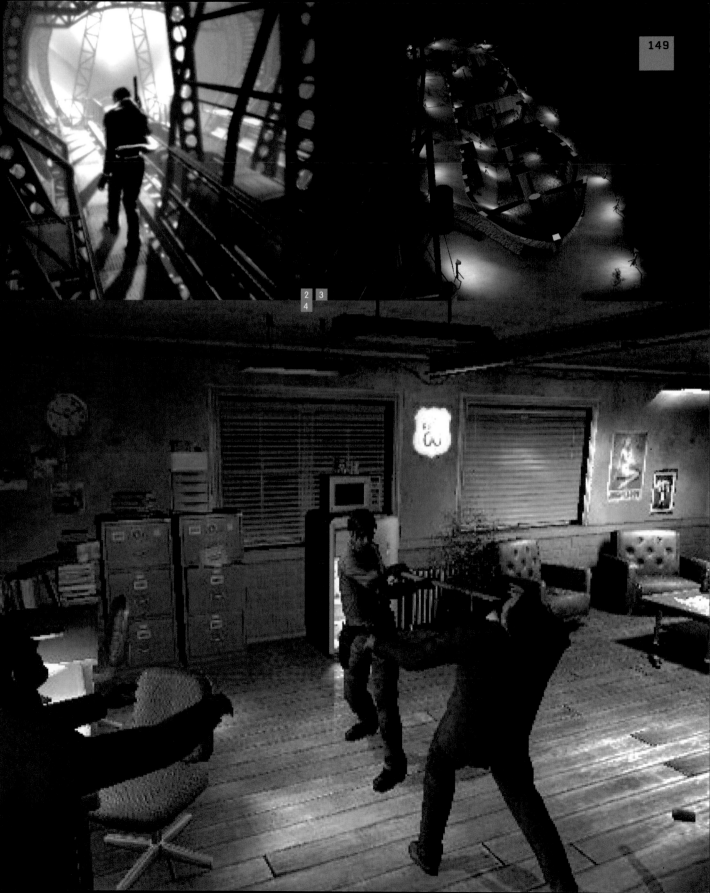

DON'T LOOK UNDER THE BED!

HORROR WORKS BY PREYING ON THE IMAGINATION, YET GAMES ARE ALL ABOUT EXPOSING THE UNKNOWN. INTERACTIVITY MEANS THAT YOU CAN FIND OUT EXACTLY WHAT IS RATTLING CHAINS DOWN IN THE CELLAR. CAN THE HORROR REMAIN WHEN THE MYSTERY IS GONE?

In fact, designer Ernest W. Adams disputes that games are all about exposing the unknown: "It's perfectly possible to make a game about being hunted by a mysterious Something that you can never see clearly—even up to the end of the game, in which you escape safely. Games don't have to be about exploration and conquest; they can also be about flight and survival."

This is a sentiment that Ian Lovett of Big Blue Box Studios agrees with wholeheartedly: "Games have so far managed to create fear very successfully, primarily because fear is often evoked because of an absence of things such as human companionship, light, and sound. It's much easier to create an unsettling atmosphere that relies on a few well-chosen, selective 'nothings' than it is to create a bustling, happy metropolis."

"Games can evoke horror more effectively than other media," says Chris Bateman of International Hobo, "because the player is right in the thick of the action. Just like a film, a game can make you jump. The difference is that in the cinema, you just go back to munching popcorn. In a game, you have to deal with the situation that gave you that shot of adrenaline! In terms of atmosphere, the remake of *Resident Evil* is as effective as any zombie film, and *Silent Hill* is as creepy as any episode of *Twin Peaks*. Better narrative design is the key to taking this further.

"Why should a game play all its cards? Indeed, games like *Silent Hill* with a low reality threshold are as mysterious at the end as when they began. The only unknown that a game inherently exposes is its environment, but mystery goes far beyond the physical space."

1–3. The triumphant return of the adventure game—Revolution's **Broken Sword: The Sleeping Dragon.**

11

Ernest W. Adams lists the important elements in evoking a sense of horror: "Loud, unexpected noises. Sudden movements. Being followed or stalked by something that you can sense but not clearly see. Blood and gore, especially when unanticipated. Inexplicable and/or hostile behavior of what should be inanimate objects. Wild or dangerous weather. Claustrophobia. Persons who appear to be mentally deranged—an unfortunate, but probably ineradicable, stereotype. Disfigured persons likewise. Reptiles and insects, especially if magnified to larger-than-life, or larger-than-human, sizes. Enemies who cannot be killed but continue to come after you despite receiving severe damage. Being attacked by people you believed were friends or allies."

"The right environment for horror is whatever will act as a canvas for the mind's fears," says Chris Bateman. "Lighting is very important, because shadows imply the unknown, and, as the film *Alien* taught us, what you do not see is often scarier than what you do. Another lesson from *Alien* is that music is a vital tool in building a scary atmosphere. Silence, used strategically, is more frightening than a constant soundtrack. The soundtracks to the *Silent Hill* games are great examples of this technique. Sound is integrated right into the gameplay, and silence is used to build tension very effectively."

"These mechanisms are just as effective in games as in movies," agrees Ernest W. Adams. "I even got scared playing *Colossal Cave* very late one night, in my university's dark, quiet computer center. The game was text-only, and at one point it printed: 'You hear footsteps in the darkness behind you.' I had been afraid of some kind of attack anyway, and this shocked me completely. I ran away, but the footsteps followed. Eventually they disappeared. I can still remember the feeling of fear."

The writer, M. R. James said that familiar, everyday settings are the most effective for horror. Most horror games favor dark, grimy environments. Could a game give us chills on a summer's day?

1. The grim reaper ponders an ageless question in Capcom's **Gregory Horror Show**.
2. Humorous horror in Rare's **Grabbed by the Ghoulies**.
3. Sega's terrifying **The House of the Dead**.

11

"Taking that which is mundane and comfortable to us and somehow twisting it to the terrifying is perhaps the most effective tool of modern horror," says Chad Kent of High Voltage Software. "I have to say that *Cujo* unnerved me far more than *The Howling*. If a horror story is going to contain an element of the supernatural, it's most effective if that unreal element appears in a very normal setting. *American Werewolf in London*, for example, was great for that. How many times have we walked through the subway, or through a park at night? The next time you're doing these things, let those scenes from the movie run through your mind and see if your pace doesn't quicken just a little bit.

"I think of the scene in Stephen King's *Dreamcatcher*, where the hunter stands on the porch of his cabin watching hordes of creatures flee the forest, all in the same direction. Normally the hunter would have to search very hard to find those animals, and now they're totally ignoring his presence. What are they running from? Wasn't he the biggest, baddest thing they had to fear? But the real scary part is, he stays! His friends aren't back with the car yet, and okay, so it's a little odd—but he's a grown man, he has a gun, and we all know that there is no such thing as the bogeyman, right? That's why it's scary. I probably would have stayed, too!"

Chris Bateman concludes: "The problem with most horror games is that they are focused on combat, and therefore an environment that supports a horde of foes is essential. When other media make a summer's day scary—as in Steven King's *It*, for instance—they do so by evoking a threat that is always just lurking under the surface. H. P. Lovecraft showed us that even the most trivial things, such as the corners of a room, can be made scary. I believe a game could easily make bright light scary, with the right narrative design."

11

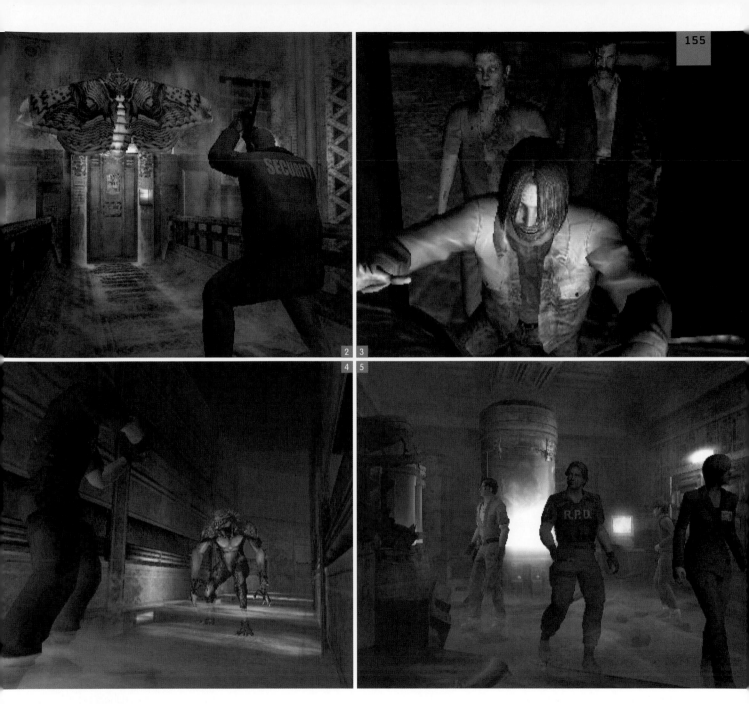

1. The unforgettably dark vision of Konami's **Silent Hill 2**.
2–5. Brilliantly disturbing imagery from Capcom's **Resident Evil 4**.

INSIDER SECRETS: SCARE TACTICS

CHAD KENT, PRODUCER OF *HUNTER: THE RECKONING – REDEEMER* AT HIGH VOLTAGE SOFTWARE, TALKS ABOUT THE NATURE OF HORROR IN GAMES:

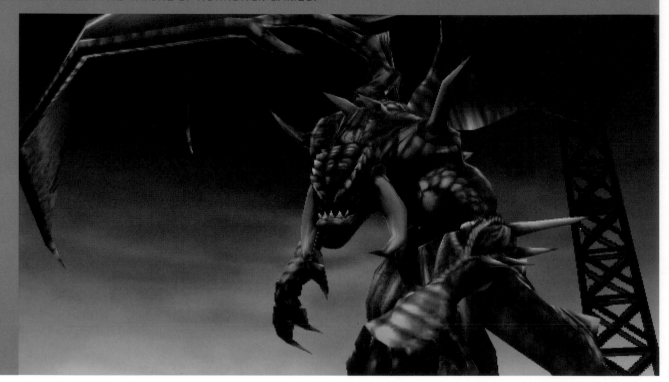

"Scaring people with film is considerably easier than with a video game. The path of the characters and the camera are totally in the control of the filmmaker. This allows the filmmaker to move us forward toward that ultimately scary moment at his whim. Setting people up for a good scare takes careful planning and well-timed execution. Video games by nature allow players control of their character, and therein lies the key difficulty in making a truly frightening game. Making a game truly frightening requires a careful design that lets the player feel in control while still ensuring that they must take the proper path to walk into all of your intricately scripted moments of terror. This is why most survival horror games are single player. Having to predict the actions of one player is hard enough without the added difficulty of having another player or two thrown into the mix.

"Games evoke horror, as films do, by moving the player from the land of the familiar into the realm of the unfamiliar. This transition should be enhanced with sound and visuals that evolve toward the disturbing. The transition will evoke a feeling of foreboding; once that feeling is achieved, your victim is ready for you to spring the terror trap.

"Currently games rely heavily on the visuals and sounds that we as humans have been told are scary: dank, dark places enhanced with the sounds of things going bump in the night, as seen in *Hunter: The Reckoning*. The first game utilized the scare tactic of taking something benign, even comforting, and warping that item into something terrifying. In the game, the little girl's teddy transforms from a child's comforting toy into a demonic being that slaughters her parents in front of her eyes.

All images from High Voltage Software's
Hunter: The Reckoning – Redeemer.

11

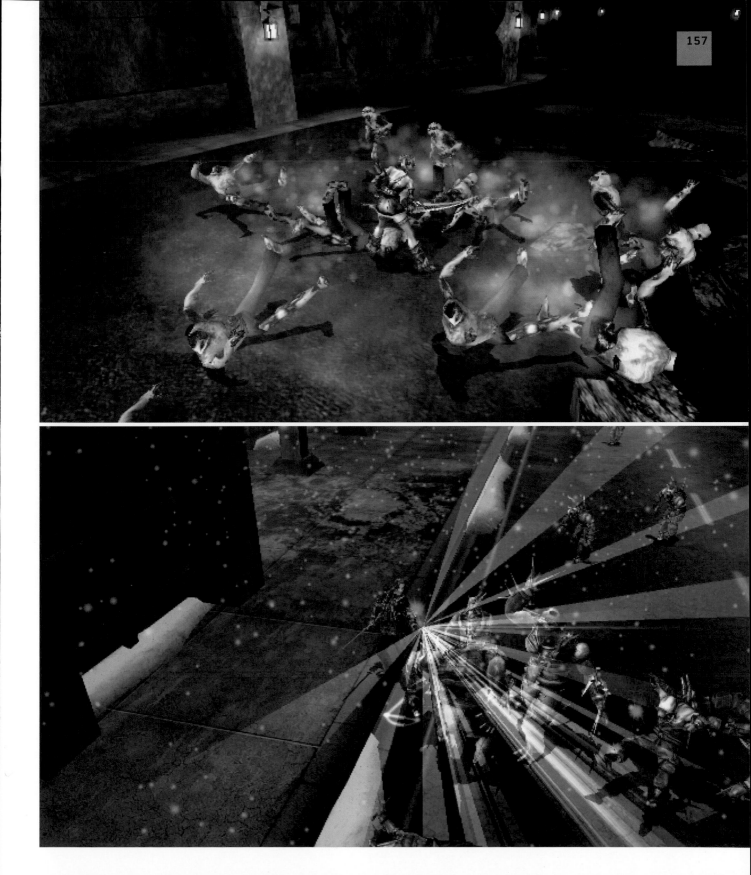

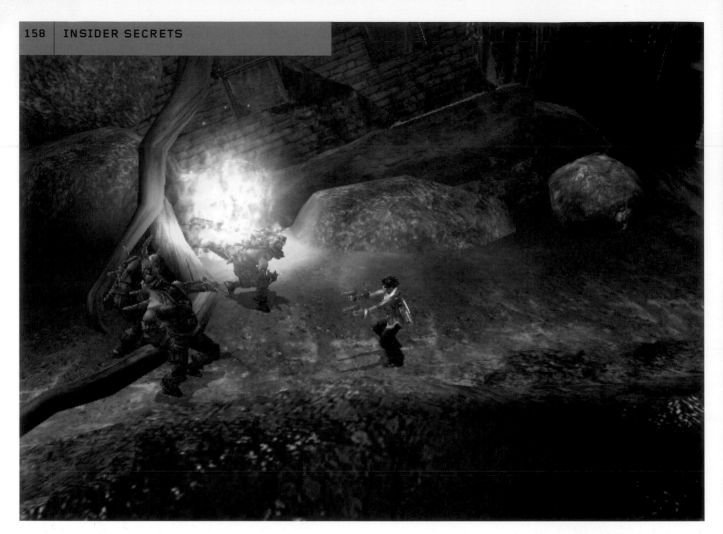

"In horror movies and games that have powerful main characters, like soldiers or crusaders armed to the teeth against evil, foreboding is achieved in a far different manner than 'teen babysitter alone in the house' horror. Your hero knows he can easily fell one or two monstrosities with his powerful weapons. Once he is comfortable in this feeling, that's when you begin your transition—for instance, by introducing hordes of zombies, rather than one or two at a time. Soon the thought will occur to him, 'How many of these things are coming, and will I have enough bullets to stop them?' With this realization, the sense of foreboding is achieved. Now he is ready for the scare. Introduce a new, more powerful enemy, in an even more disturbing environment, and make sure it emanates a series of sounds that would send a lion scampering for cover.

"What do we find scary? There are the things that have been embedded in us since youth: werewolves, vampires, and strange sounds in the dark. But do these things really scare us anymore? I think we see these in movies, game settings, and amusement parks, and we say to ourselves, 'This is supposed to be scary; okay, I'll play along.' The killer jumping out of the closet may make us jump, and the gore may even be enough to make us turn our heads and cringe; but in most cases, we still find ourselves just playing along. The experience is fun because we agree to buy in. As we get older, we are more afraid of contracting cancer than one day being cut down by a slobbering werewolf. What really scares the mature audience is the fear of having their personal norm interrupted. Unemployment, terminal illness, and social

All images from High Voltage Software's
Hunter: The Reckoning – Redeemer.

11

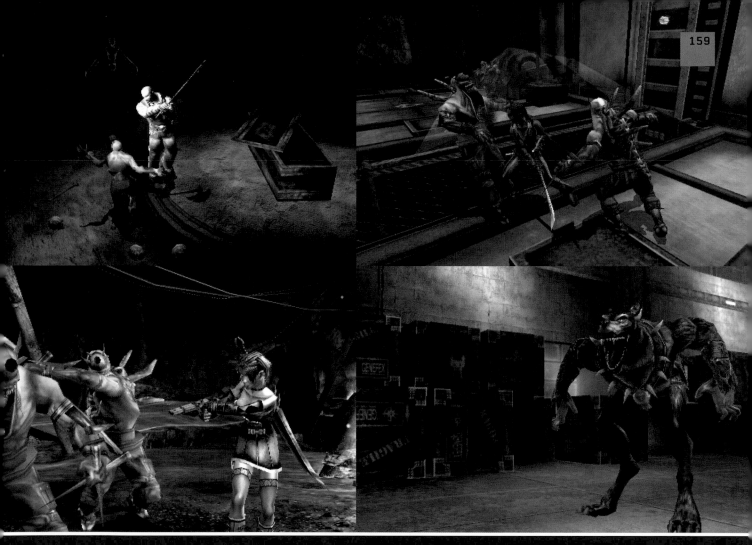

condemnation are our real fears. The mature audience can still be surprised by the fiend jumping out of the bushes and be scared, if only briefly. The real accomplishment is creating enough unease and foreboding to be able to get away with it again. I still love to play a game or see a movie when I consciously agree to suspend my disbelief, but the rare ones that disturb me and stick in my mind have to possess elements that make me wonder, 'What if that happened to me?'

"Both horror and terror are shocking and intense moments that occur at that second when our fears break through into reality. Games are great at these moments, but only under a few conditions. First we have to buy into the setting, and second, the game needs to return you to a sense of normality before attempting the scare again. It is a difficult thing to pull off. We may

wait through the initial half-hour of a horror film while the plot and characters are established before we get our first real scare. We accept this as part of the established process. Games, however, are different. The convention here is that it be fast paced. Action should occur very early on and is expected to increase in pace and intensity throughout the game. The convention for games does not really mesh well with good, mature horror—not that it can't, but it will take some real work. We could bring a whole new level of horror gaming to the public, unlike anything they have seen before. But it would require both a public interest in the new format and a publisher brave enough to invest in a product that doesn't conform to the industry norm of the typical horror game. The truth is that the cost of producing a Triple-A title is quite staggering, and innovation is a dangerous gamble."

FUNKY TOWN

12

ART, MUSIC, AND THE BIRTH OF COOL

HOW DO YOU DEFINE "COOL", WHEN EVEN THE TERM ITSELF SWINGS BACK AND FORTH INTO FASHION? WE CAN'T PUT IT INTO WORDS, BUT WE KNOW IT WHEN WE SEE OR HEAR IT. WHAT IS THE NATURE OF COOL, AND WHY DO CERTAIN GAMES HAVE IT IN THE EXTREME?

Climax's **Sudeki**

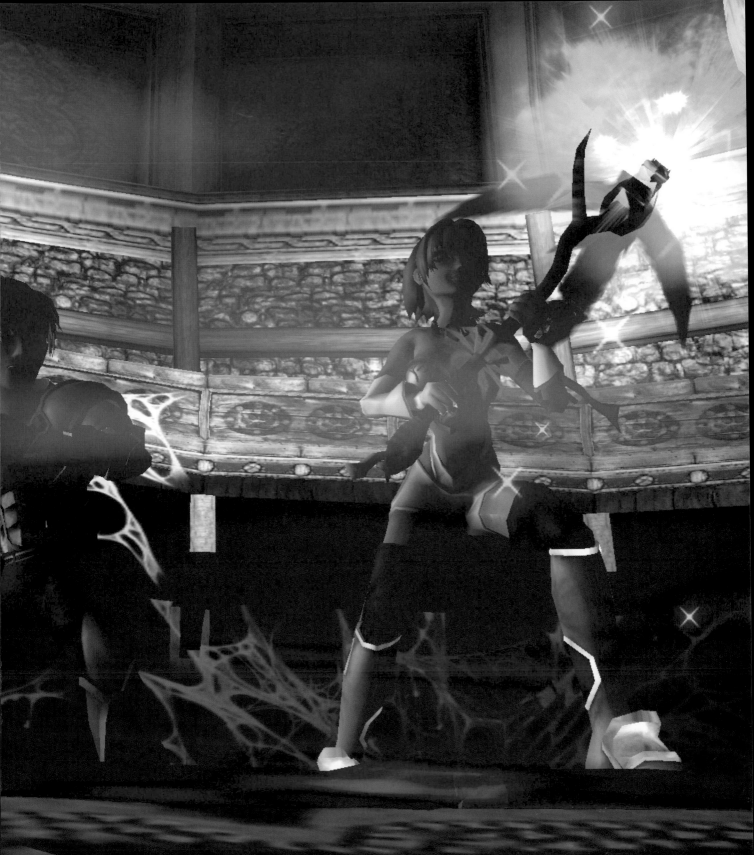

THE FOOD OF LOVE

WHY ISN'T THERE MORE USE OF CONTEMPORARY MUSIC IN GAMES, AS OPPOSED TO COOL BUT
RETRO STUFF? IS IT SIMPLY A COST ISSUE?

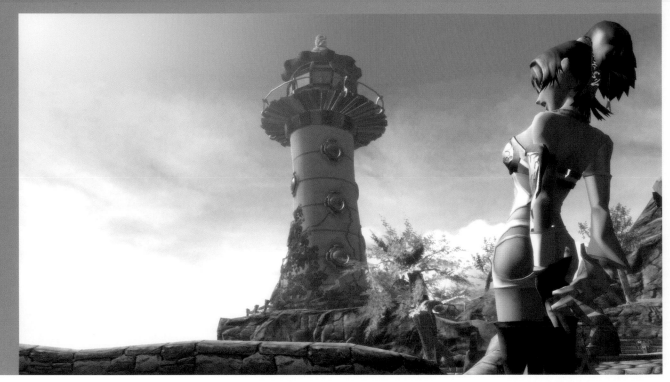

"It's because the vast majority of current pop music is either utter rubbish or irrelevant to games," says Ernest W. Adams. "Nobody who isn't disturbed would make a game about smackin' their 'ho' around; nor does anybody want to make a game about the plastic emotions that Britney Spears sings about. There was a brief trend a few years back to use music from people like the Chemical Brothers and Swervedriver, but now that games are big business, these groups are starting to demand significant royalties, and it's seldom worth the price. People don't buy games to hear the music in them."

"It is much more expensive to license current music," says Chris Bateman. "And it's not always a good idea. If you use music of a particular modern genre or style, you will turn off a portion of your audience, as the modern listener will like and dislike different aspects of the musical zeitgeist. If you use older music, it inherits 'retro chic,' and people are less likely to have heard it ad nauseam already. Of course, when the game gives the player the choice of what to listen to—as with *Dance Dance Revolution* and *Vice City* and so on—you have much more freedom to use whatever music you please."

12

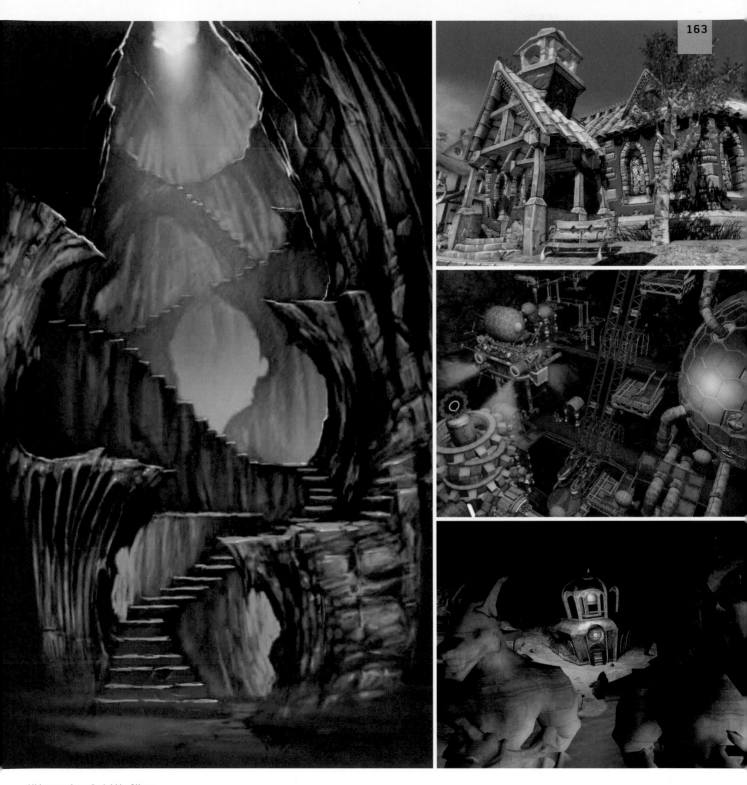

All images from **Sudeki** by Climax.

INSIDER SECRETS: UNLIMITED SAGA

YUSUKE NAORA, ART DIRECTOR ON SQUARE ENIX'S *UNLIMITED SAGA*, KINDLY TOOK TIME FROM A BUSY SCHEDULE TO ANSWER OUR QUESTIONS:

Please tell us about what inspires you when creating a game.

I don't get one clear-cut idea from one source. I tend to draw points from various everyday sources, which then become ideas. The game design process then begins in earnest, shaped by these simple initial ideas.

Are there any other factors that play an important role for you in the creation of a gameworld? For example, do you try to be inspired to create places where you would like to live, or just visit?

There are other factors, yes. There's nothing more important to me than broad experience, and drawing information from as many sources as possible. For example, I thought up the layout of the city of Midgar in *Final Fantasy VII* while eating a pizza at home.

What are the basic concepts that you take into consideration when creating a game?

Such things as landscape, light, and color are just the surface details of the world. I think that it is important to ask yourself, "How surprised will the user be?"

Do you have any comments about game art in general, or about the game art in *Unlimited Saga*?

I have mostly had experience with fantasy games and I have always worked with my staff to be as particular as possible about expressing new ideas to as great a degree of detail as the resources available to us would allow. We will be challenging various new frontiers in the future, so watch this space!

Square Enix's **Unlimited Saga** features a system called Sketch Motion— created in cooperation with Adobe Systems—which uses hand-drawn and hand-painted artistic graphics.

12

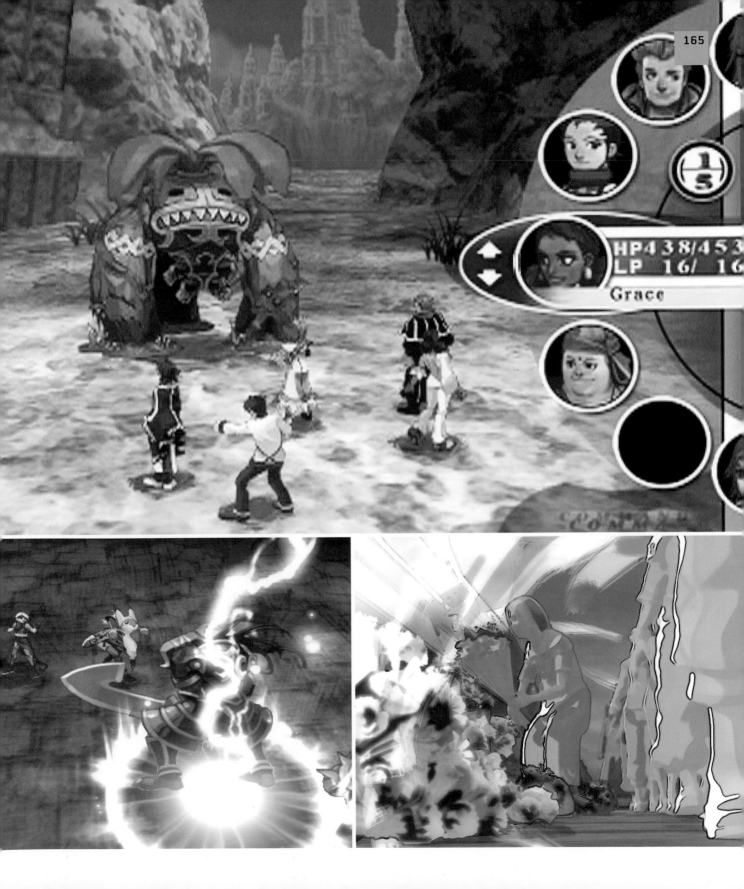

SONOROUS EXPEDITIONS

PAUL WEIR, DIRECTOR OF SOUND-DESIGN COMPANY EARCOM, TALKS ABOUT AN OFTEN-OVERLOOKED ASPECT OF GAMEWORLD CREATION:

"From the start, Nolan Bushnell wanted his game to feature roaring crowds and realistic sound effects. What he got was one hollow staccato sound that inspired the name of the world's first commercially successful video game: *Pong*.

"From Bushnell to the orchestral palettes of Harry Potter, from the 'wakka-wakka-wakka' of *Pac Man* to the sinister sounds of *Silent Hill*, the technology responsible for creating those evocative sound worlds has undergone a series of not-so-quiet revolutions.

"The audio for early arcade games like *Pong* and *Space Invaders* was built from analog circuitry, more a job for an engineer than a sound designer. Yet the struggle against the limitations of the time led to many innovations.

"Atari's *Asteroids* (1979) was arguably the first game to feature sound consciously designed with a gameplay dimension. At the height of *Star Wars* fever, *Asteroids'* monophonic sounds were the closest attempt at transplanting the cinematic audio experience to the arcade. The game was also unusual in featuring a dynamic audio accompaniment through its characteristic pulsating sound, which sped up over time. The ominous background sound paralleled the sound of a heartbeat and helped to generate a sense of urgency as the game progressed—so tension was raised through a corresponding increase in the speed of the beat.

"Just one year later, the arcades were being rocked by Atari's Pokey sound chip. At a time when synthesizers were costing thousands of dollars, the Pokey was a standardized chip capable of four simultaneous voices with a wide range of timbres, allowing for the clear reproduction of both music and sound effects. Designers were quick to push the technology. *Tempest*, also released in 1980, employed two Pokey chips for a huge eight-voice soundtrack.

1. Imagine the roaring engine from this '49 Coupe from **Ford Racing 2** by Razorworks.
2–4. Stylized action requires stylized sound in Capcom's superstylish **Killer7**.
5. The swoosh of ice, the blare of traffic, and the vociferous adulation of the crowd—it's Electronic Arts' **SSX 3**.

12

1

"As audio duties were liberated from the engineer, the role of the game sound designer emerged. *Marble Madness* in 1984 was Atari's first released game to use an audio chip similar to the classic Yamaha DX-7 synthesizer, and the first to have a recognizably musical score. The music is full of character, creating an identity unique to the game and, with the music being created in real time, interactive elements were also incorporated. Games continued to swallow up new music technologies, spitting them out in cost-reduced and scaled-down form.

"Magical Sound Shower from Sega's 1986 game *Out Run* has become the stuff of legend. It wasn't just that the game was louder than anything else at the time, or the addictiveness of the tunes. It was the sheer appropriateness of the music for the game: the audio uniting the speeding Ferrari, the cool blonde at your side, and the exotic locations into an overall gaming experience of ferocious intensity.

"With the advent of the CD-ROM, restrictions on audio quality were lifted. The technology is the same whether what's being reproduced is a symphony orchestra or the latest dance act, and it can all be delivered in surround.

"The limits set by early games meant that the information describing the musical instruments had to be stored within small amounts of memory rather than on a hard drive or CD. The music was therefore played back live as the game rolled, enabling any element of the sound to be adapted in an instant. Altering the tempo, changing the key, bringing in new voices were a matter of simply changing numbers. Game music was, for better or for worse, recognizable. It was in a genre of its own."

12

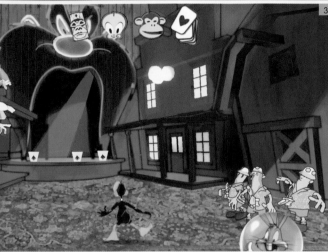

"Game music may now only be limited by the quality of the composer, or in the case of sound effects, the imagination of the sound designer, but with the passing of 'chip music' a new challenge has emerged, a challenge of identity. With the freedom afforded by the CD or DVD, game music is struggling to deal with the interactive nature of games, often borrowing heavily from the film music tradition, a model rooted in linearity.

"The next big change will therefore not be one of technology, but of style. The change will be slow, almost imperceptible, but as sure as the blonde returns for yet another ride in the red Ferrari, however bad the driving, game music will again create a genre all of its own, combining interactivity with the very latest in music technology."

1. Creaking floorboards in Capcom's **Gregory Horror Show.**

2, 3. You can almost hear the cartoon sound effects in Warthog's **Looney Tunes Back in Action.**

4. The screech of hot tires on wet roads in **Need for Speed Underground** by Electronic Arts.

5, 6. The perfect comic book depiction of sound in Ubisoft's **XIII.**

OUTLANDS

13

THE WEIRD,
THE WACKY, AND
THE DOWNRIGHT SURREAL

"HUGE AND MIGHTY FORMS, THAT DO NOT LIVE

LIKE LIVING MEN, MOVED SLOWLY THROUGH THE MIND

BY DAY, AND WERE A TROUBLE TO MY DREAMS."

WILLIAM WORDSWORTH, *THE PRELUDE*

FROM THE VERY FIRST DAYS OF COMPUTER GAMING, THE ODD WAS THE NORM. YOU COULDN'T RENDER A PHOTOREAL CHARACTER ON A MAGNAVOX ODYSSEY—HECK, IT WAS DIFFICULT TO MAKE SOMETHING RECOGNIZABLY HUMAN AT ALL. SINCE THEN, THE ABILITY OF GAMES TO EMULATE THE REAL WORLD HAS GROWN AND GROWN, BUT SOME GAMES JUST RESOLUTELY REFUSE TO BE REAL.

Beep Industries' **Voodoo Vince**

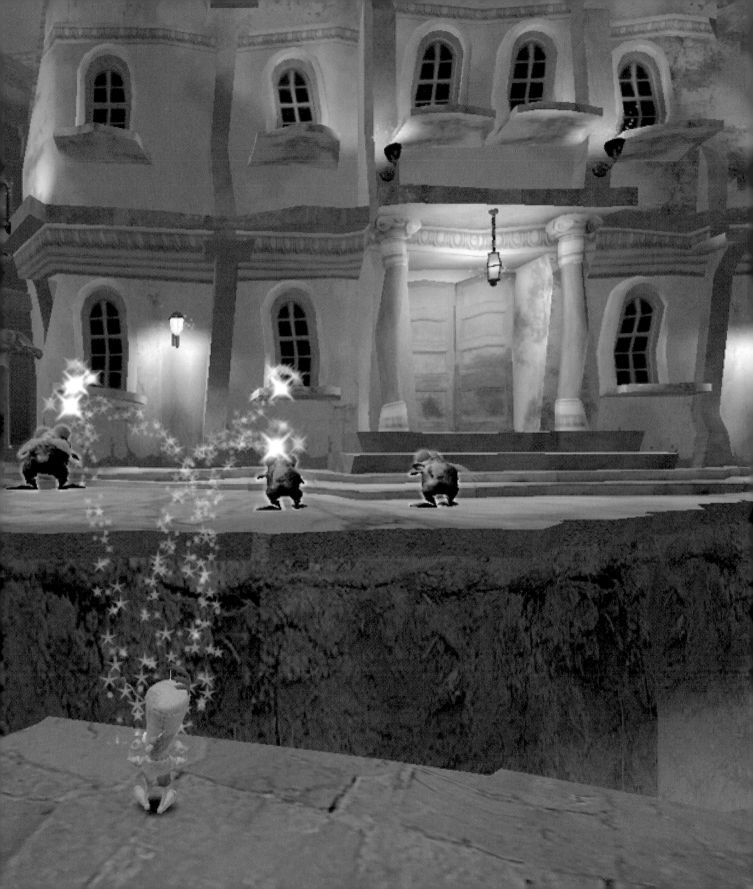

WAY-OUT WORLDS

IT IS SOMETIMES SAID THAT REPRESENTATIONAL PAINTING DIED WITH THE BIRTH OF PHOTOGRAPHY.
COULD THE SAME THING BE TRUE IN GAMES AS GRAPHICS GROW EVER CLOSER TO PHOTOREALISM?

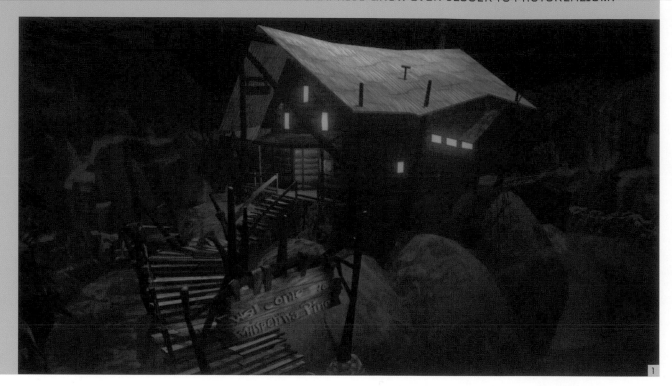

In the era of Kodak, there was hardly any point in an artist slaving for days to capture an exact likeness of a bowl of apples. Instead, artists started to take an interest in the impression of a scene. "I paint objects as I think them, not as I see them," said Picasso.

Some game designers believe that, now that it's getting so easy to deliver realism in games, the only direction to go with game art is stylization. "There will always be a place for realism, particularly in games set in real-world environments, like flight simulators," says designer and author Ernest W. Adams. "But it's time for us to start to explore additional styles. Two-dimensional games have done this for years—consider the *Monkey Island* series, or *Planescape: Torment*, which had a very strong visual style. Stylization in 3D games is overdue."

Chris Bateman of International Hobo takes a different view: "Certainly photorealism is now not much of a selling point in itself, but that doesn't force art into stylization. This is one area where we can learn from films. Every live-action film is shot to a photorealistic standard by definition, but the cinematographer creates different effects with the use of light, lenses, and angles to suit the purpose

of the narrative. Games should be able to expand this artistic creativity to an extent that we cannot yet fully appreciate."

An especially promising new title in the stylized genre is *Psychonauts*, developed by Double Fine Productions for Microsoft. Players take the role of a trainee psychic who experiences a succession of bizarre worlds by traveling into the minds of other characters. Because many of these characters are insane, their neuroses and desires take on strange lives of their own, and the laws of physics are distorted and filtered through the particular subconscious perspective being explored.

Psychonauts is described as "twisted, colorful, fun, and scary." An inkling of its imaginative style may be deduced from the creative involvement of Tim Schafer—who was project lead on LucasArts' extraordinary adventure game *Grim Fandango*.

1. Double Fine Productions' **Psychonauts**.
2. **Voodoo Vince** by Beep Industries.
3. **Elder Scrolls III: Morrowind** by Bethesda Softworks.
4. **The Lord of the Creatures** by Arvirago.
5. Ubisoft's **Beyond Good & Evil**.

HANDS ON: FEATS OF CLAY

INDEPENDENT GAMES DEVELOPER **ANTHONY FLACK**, CREATOR OF SUCH QUIRKY
MASTERPIECES AS *PLATYPUS* AND *BERT THE BARBARIAN*, REVEALS HIS UNIQUE
PERSPECTIVE ON THE ART OF GAMEWORLDS:

"I love animation, all kinds of animation—computer-generated animation, cel-animated cartoons, stop-motion animation, Terry Gilliam–style cutouts, those strange amorphous animations produced by painstakingly painting onto the same piece of glass over and over, and any other technique or combination of techniques that it's possible for creative minds to devise.

"All these diverse styles of image-making have one thing in common—they have the power to transport the viewer into fantastical otherworlds where the normal rules don't necessarily apply. It's like being offered a direct window into their creator's imagination. And in the case of computer games, it gets even more interesting because the audience actually has the opportunity to climb through the window and interact with this strange new world.

"Unfortunately, the world of computer-game animation is not, for the most part, as rich and varied as what you would see in a collection of animated shorts at a film festival. These days, computer games are almost all made entirely with a single technique: computer-generated 3D models.

"This is not surprising in itself. Out of all the various styles I mentioned, CG is the one that most naturally lends itself to an interactive environment, because the images can be generated on the fly by the computer, rather than having to be prerendered by an artist. What is most disappointing to me is that, even within the context of CG animation, most computer-game artists do not try to create a unique style or experiment with unorthodox techniques. In fact, more often than not, the expressed aim is simply to make the animation look as much like real life as possible. It seems to

▶▶

1. **Bert the Barbarian** from
Squashy Software.
2–3. Water water everywhere—
AquaNox 2: Revelation by Massive
Development.

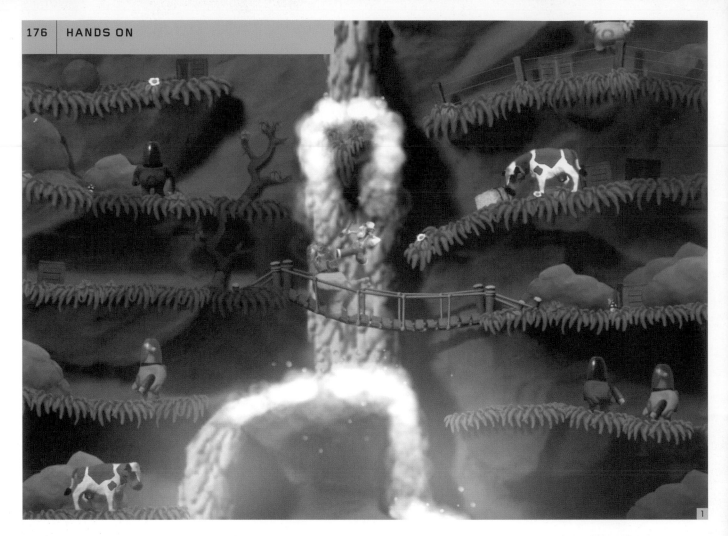

1

me like such a waste to be given the chance of creating whole new worlds, and then to make them look just the same as the world that you already live in.

"What I really set out to do was to try to bring more of the other kinds of animation to the computer screen, for the sake of variety, if nothing else!

"As an animator, my particular focus over the last few years has been stop-motion animation, and particularly clay animation. To me, stop-motion animation has a unique appeal because the models and sets are real, physical objects. They offer a vision of another world, but you know, and can clearly see, that they also exist in our world. It makes that imaginary place all the more tangible. And when you see those little models start to move,

well, then it's just like magic—the animator truly breathing life into lumps of clay.

"That magic is something that a CG model will never be able to replace because, no matter how realistic they get, CG models will never be physically real. Somehow they always give off a sort of clinical, surreal vibe, which is totally different from the stop-motion vibe. CG can be cool, but what I really want to do with my games is climb through the window into that clay world. That's why I decided to make computer games in the stop-motion style. I really wanted to see it done, and done well.

"Technically, this offers a unique set of challenges since stop-motion animation does not lend itself to interactivity the way CG animation does. Unfortunately you have to use a bit of trickery.

1–4. Putty in your hands—it's **Cletus Clay** from Squashy Software.

5–7. **Platypus** by Squashy Software. The vapor trails, clouds, and explosions are all animated in clay. Even the lettering and score counters adhere to the hand-modeled style.

13

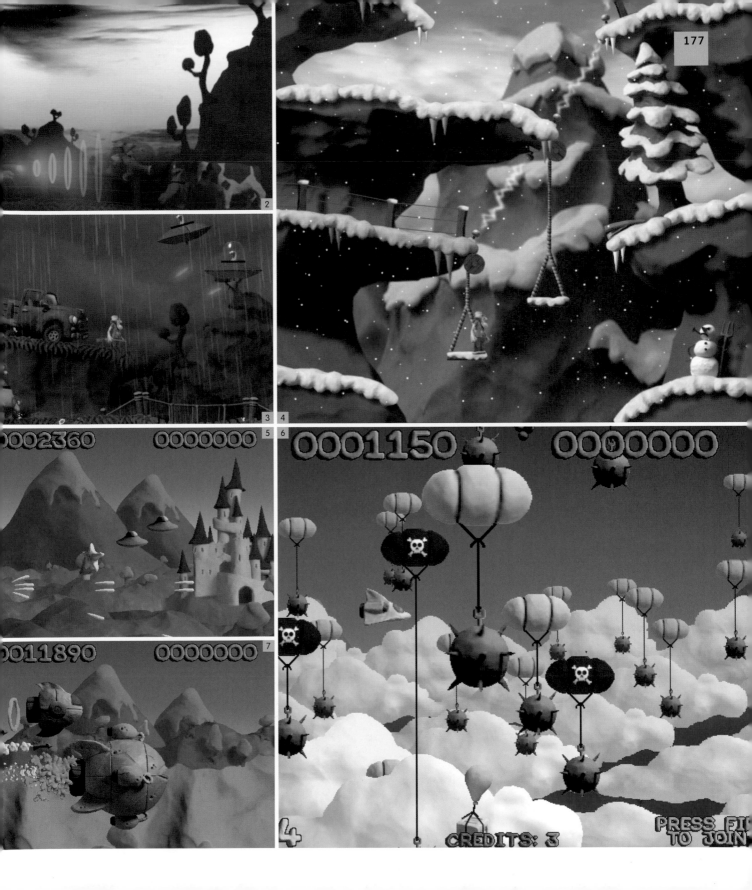

"Of all the different kinds of animation, stop-motion is probably the most difficult to fake convincingly. The tricks I've been using up till now have been pretty simple. For the most part it's just a matter of animating and photographing each model separately, and then compositing them all together with the background as seamlessly as possible to create the final image.

"Recently I've managed to achieve pretty good results with this technique alone, but ultimately it's still not enough. That's the thing about making stop-motion animated computer games—your tricks really need to be completely convincing and photorealistic. And currently, try as I might, they're not. They look nice, but they don't quite look real.

"But that's all part of the fun—thinking up new tricks and techniques to try. If I were a CG artist, most of the effects I'd use would already have a fairly well-established precedent. But in my work, I'm always having to think up new ways to achieve particular effects. Every game I've made to date has been a huge improvement, both technically and graphically, over the one before. And I have a whole lot of other untested ideas for more ambitious future projects that I'm dying to try out. By combining stop-motion compositing, full-screen video, and, yes, a little CG as well, I'm hoping that one day I will finally be able to open a window into that clay world. And if not, I'm pretty sure it will at least look interesting, and a little different from what everyone else is doing."

1, 2. Dream visuals from Capcom's **Dead Phoenix**.
3. A quirky and interesting game look—**Neighbors from Hell** by JoWood.

4, 6. Conceptional and in-game art from Beep Industries' **Voodoo Vince** showing the model-like look that's possible with modern 3D engines.

5. Watch your step in the highly stylized **Gregory Horror Show** by Capcom.
7. Rare's **Grabbed by the Ghoulies** showcases a comic book clay look.

INSIDER SECRETS: REAL STYLE

AJIBAYO "SIKU" AKINSIKU, VISUAL DIRECTOR AT ELIXIR STUDIOS, OFFERS AN IMPASSIONED AND PERSONAL VIEW OF THE DEBATE BETWEEN REALISM VERSUS STYLIZATION. WE HAVE BEEN ASKED TO POINT OUT THAT THESE ARE SIKU'S OWN VIEWS: THEY DO NOT NECESSARILY EXPRESS THE CORPORATE PHILOSOPHY HELD BY ELIXIR.

"As with every media genre, every sphere of discipline is a captive to its legacy. As science fiction tried to shake off its B-movie clothes in the early '70s, there was a time where no respectable A-list star would be caught dead in a sci-fi film. The essence of sci-fi, though, is in its heritage. The exponents of the craft were not merely moviemakers, but individuals who shared a passion for fantasy and for dreaming of the myriad possibilities for the future. Thoroughly humanist in their outlook, they sought to use science fiction as a vehicle for advancement, and they shared this passion with the devout. Since Mary Shelley's *Frankenstein*—which is credited as gothic fiction, though in reality it was the very first science fiction on record—the fans and creators of science fiction have shared a common bond. What sci-fi fans today consider as kitsch, but historically valid, in titles such as *It Came from Outer Space*, the general public can be forgiven for smirking at mockingly. However, sci-fi has since grown up. From the cultish confines of science fiction fans to mass-market appeal, compromises have been embraced—and it is this sort of compromise that will eventually engulf the world of game development.

"The similarities between the two disciplines of sci-fi and games are illuminating. The traditions of game development grew out of the bedrooms of acne-infested adolescents, and there was the general understanding that the message was overwhelmingly superior to all else. In fact, the question of graphics was redundant. The culture of development is therefore rooted in its legacy: each hardcore gamer inevitably becoming a developer, and then as a developer, making games that appeal to the hardcore.

"Clichéd, kitsch sci-fi in its infancy was not a prelude to how things would be, but rather evidence of what sci-fi creators had to fix.

A world of ethereal beauty in Ubisoft's
Beyond Good & Evil.

13

"We debate realism versus stylization because we ought to. We ought to fix it because we know that we are only approaching adolescence as far as maturity is concerned. As primitive science fiction was acceptable to a persistent few, gamers (in this case hardcore, or, as some might express it, PC gamers) esteem the message above the delivery. Every purist (and they tend to be designers) would proclaim evangelically of the purity of design above all else, and hardcore gamers follow in their wake. Yet, as with moviegoers, the mass-market gaming crowd will not follow in that wake. And it is this demand for maturity that will force the art and design development in games to grow up.

"The question posed here—'Is realism so easy that the only way to go now with game art is into stylization?'—argues my case. We see a dichotomy where none exists, and we see stylization as peripheral and cosmetic. After all, the legacy of game development lay with programmers and designers. The mundane application of art solutions to design questions has created a culture where realism is the default answer, while stylization is simply an indulgence.

"In effect, stylization has been forced upon us. The question demands two approaches: the practical and the esthetic. The assumption is that realism is more practical. This is wrong. The second flaw that has become tradition is the belief that stylization is purely esthetic.

"Realism and stylization are simply answers to questions. For example, if a designer were to approach an artist with a strategy war game based on the First World War, realism would be a the sensible option. A Disneyesque solution would leave the potential audience laughing in ridicule. However, here is where the false dichotomy is revealed. Stylization isn't only about form or volume but can also be expressed in tone and texture, and in the case of a war game that would be a viable option.

1. Who says disco is dead? A typically incandescent image from Climax's **Sudeki**.
2. Wide-eyed and footloose—Capcom's **Chaos Legion**.
3. The convincing evocation of another world characterizes Level 5's **True Fantasy Live Online**.

2

3

"On the flip side, a game based on a rabbit endowed with superpowers is laughable in realism, and in this case, stylization is not merely an esthetic choice but a practicality.

"So the issue isn't a realism versus stylization debate but why developers in the West are restrained or are not as creative stylewise as their Eastern counterparts. The Japanese have shown no resistance to stylization and have seamlessly adopted stylistic traditions from every sphere of the visual arts.

"While historic legacy is one reason, market forces are another. The general game-buying public in the West still has the Warhammer-figure art mentality, impressed with detail to the exclusion of form—and where there is a successful experimentation with style (as with *Jet Grind Radio*), others copy the same cel-animation style—completely missing the point! Stylization is about providing solutions to design questions. Its cosmetic capacity, while undiminished by practicality, is merely secondary.

THE PROBLEM WITH REALISM

"A clear case for practicality is that most of the time, absolute realism in game development is absurd. Low polygon count, limited texture space, finite technical specifications, and 'realist' animation can leave the senses bewildered. At best it is naïve; at worst, just plain bad art decisions—a cauldron of overcooked, over-the-top applications with little or no lateral thinking. Superdetailed textures on low polygon structures are naïve and quite silly and, worst of all, because we know nature so well, we know instantly that it's wrong.

"The devotees may not quibble about this minor detail. After all, gameplay is king—rightly so if you are a purist. But the mass market, when she arrives, will not think so.

Imaginative concept art and finished visuals from Double Fine Productions' **Psychonauts.**

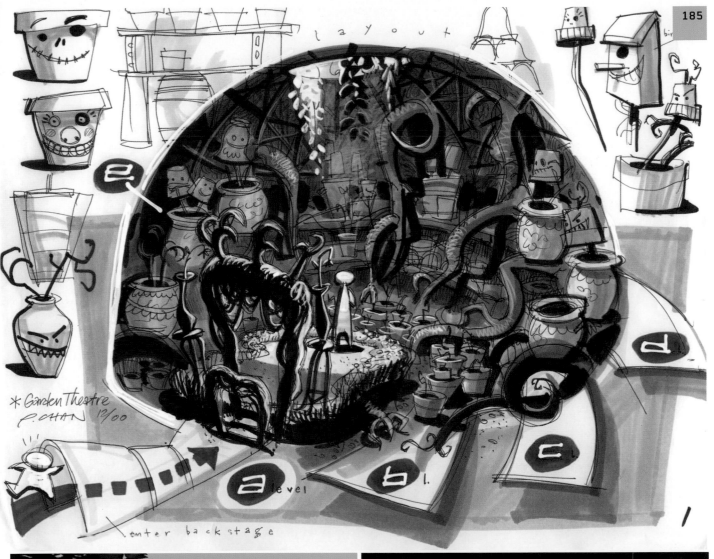

layout

* Garden Theatre
P. CHAN 12/00

enter backstage

a level

b.

c.

d.

e

bir

"What do I proclaim, then? That realism is a dead duck? No. *Grand Theft Auto* demonstrates a little lesson in solutions: we need to adapt to the limitations of our tools, weeding out naïveté for flair, which *GTA* amply possesses.

"*GTA* is realism-based while adapting to low-spec calls. It is seen in design, form, volume, palette, and lighting: realism with a little touch of styling. *Resident Evil* goes a little further with realism, adopting prerendered scenes with high-poly characters. Yet the texturing is sympathetic to the form. There are too many games where the lack of symmetry between form and texture exists, where there is no sympathy shared between the two but, rather, the twain going in opposite directions.

THE FUTURE OF STYLIZATION

"Some have simply copied *Jet Grind Radio*, perpetuating style for style's sake. Yet *Jet Grind Radio* itself is not style for style's sake. Its graphic style is the embodiment of graffiti styling, each character and scene furniture personifying graffiti font characteristics. *Jet Grind Radio's* styling is concept-led, a pure example of solution provision.

"Stylization is not art for art's sake, but rather a solution-based endeavor. Stylization is what makes games like *Viewtiful Joe* or *Jet Grind Radio* visually and conceptually compelling.

"While one might be hard-pressed to see stylization (in its pure form) work in a war-game context, it provides the designer with options and plausibility. It is that very plausibility that makes *Viewtiful Joe* work. I see style as an embedded essence rather than as cosmetic. It facilitates gameplay design. Cosmetic application will only lead to more *Jet Grind Radio* wannabes while a 'solutions provision'–based approach will unearth strange and curious beasts. The public will be educated, as in every medium before ours and after ours. They will become game-graphics literate, and they will demand stylization because some bright people will offer it, consistently, eventually."

You do that hoodoo so well—fabulous fantasy scenes from **Voodoo Vince** by Beep Industries.

INDEX

Alpha Blending
Allows two objects to be blended together. This is primarily used for atmospheric and environmental effects. It allows such things as "fogging," where an image is rendered behind a "translucent" image, which creates the effect of looking though fog or looking down through a pool and seeing the bottom. It also allows Depth Cueing, which is the lowering of the intensity of lighting to make an object appear farther away.

Anti-Aliasing
This is a method used to smooth the jagged edges of objects. This is most noticeable when dealing with curves, such as circles. For example, if you look at a circle drawn in a simple paint program at a low resolution, you can see the "steps" taken to make the circle. If you raise the resolution you'll notice the "steps" much less. If you use anti-aliasing, different shades of the circle's color are used to "fill in" the gaps caused by low resolution.

Cel shading
A type of 3D rendering that gives the image a stylized, cartoon-like appearance, as seen in games such as *Jet Set Radio Future*.

CGI (Computer-Generated Imagery)
While this can refer to any computer-generated image, it usually refers to pre-rendered 3D stills or animation sequences, such as a cut-scene.

DirectX
A set of APIs created by Microsoft that allow programmers to access more directly sound and graphics capabilities of the computer allowing for, among other things, great games.

Engine
A computer program that performs a set of routine tasks. For example, a physics engine models the mass, velocity, and other physical attributes of objects, while a graphics engine renders images on screen.

First-person shooter
A popular form of 3D action game, typified by titles such as *Doom*, *Halo*, and *Time Splitters*, where the player fights through complex 3D levels from a first-person point of view.

FMV (Full-motion video)
A non-interactive video sequence used for a cut-scene. While these are usually CGI animations, they can also be live action or even a mixture of the two.

Middleware
A specialist form of software, which may include technical tools, 3D graphics engines, physics engines, and/or sound engines, sold to development teams to provide the backbone of a game and free up resources for more creative tasks.

Model
A digital representation of a person, creature, building, or any other object in 3D space.

Motion capture
A technique used to record a person's movements precisely in three dimensions so that the data can be used to animate a 3D character model.

OpenGL (Open Graphics Language)
This is a 3D graphics language developed by Silicon Graphics. OpenGL support is built into most modern operating systems.

Platform game
One of the oldest game formats, the platform game has the player in control of a character who has to climb and leap around a dangerous environment in pursuit of certain objectives. Originally 2D, the platform game moved to 3D with the launch of Nintendo's *Super Mario 64* and the original *Tomb Raider*.

Polygons
3D objects consist of hundreds or thousands of polygons (usually triangles) joined together into a 3D model.

Pre-rendered
CGI images or animations that are calculated from 3D data and stored as complete frames or animations ready for use in a cut-scene or film.

Realtime
Graphics that are rendered as required, as opposed to being pre-rendered. In-game graphics are usually realtime, as they need to change rapidly to reflect the actions of the player. By contrast, while cut-scenes can be produced in realtime they are more often pre-rendered.

RTS (Real Time Strategy)
The dominant variant of the basic strategy game. Older strategy games and wargames had players and a computer player taking turns to move units or build facilities, but in real time strategy it all happens at once, in real time.

Rendering
The process by which images are taken from the 3D virtual environment and presented to the viewer. Rendering can be realtime or pre-rendered.

RPG (Role-Playing Game)
A type of game that takes its name from the old *Dungeons and Dragons* style of tabletop game. Players take on the role of a character or group of characters in a large game world, taking on quests, attacking monsters and gathering treasure and experience. These games traditionally have a fantasy or science-fiction setting.

Simulation
A game that re-creates a particular activity with the emphasis on giving an impression of realism. Driving games and flight simulators are perfect examples, but simulations can also cover more fantastic subjects, such as space combat. The approach matters more than the subject matter.

Texture map
A bitmap image that is wrapped around a 3D object to give it the appearance of having a material or texture, or to add surface detail.

Vector graphics
A method of storing and displaying graphics within a computer. All that the computer needs to store are single points in a mathematical space, joining them with lines to create 3D images.

Wireframe
A 3D model consists of hundreds or thousands of polygons connected together into a mesh. When no texture or surface has been applied, it is referred to as a wireframe. Early 3D graphics, as in *Battlezone* or the *Star Wars* arcade game, consisted entirely of basic wireframes.

We would like to thank everyone from the games industry who has been so generous with their help including:

Adrian Arnese *Empire Interactive*
Anthony and Millie Flack *Squashy Software*
Antony Christoulakis *Neon Studios*
Becca Green *Starrydog*
Bernd Beyreuther *Radon Labs*
Brian Woodhouse *Bizarre Creations*
Cathy Campos *Lionhead*
Charles Cecil and Steve Gallagher *Revolution*
Chris Bateman *International Hobo Ltd*
Clayton Kauzlaric *Beep Industries*
Darren Thompson *Firefly Studios Ltd*
David Swofford *NC Soft*
Dawn Beasley *Climax*
Diana Calilhanna and Pete Hines *Bethesda Softworks*
Eyal and Limor Shani *Majorem*
Gabor Feher *Digital Reality*
Hanna Gehrke-Rosiecka *Techland*
Íñigo Vinós *Pyro Studios*
Jamie Thomson *Black Cactus Games*
Jason Gee *Brat Designs*
Jason Fitzgerald and Mark Green *Sony Computer Entertainment Europe*
John Beardon *Ashleigh Consulting*
Jon Beltran de Heredia *Arvirago*
Kevin Sheller and Josh VanVeld *High Voltage Software*
Lance Hoke *Ensemble Studios*
Lidia Stojanovic *Ubisoft*
Line Bundgaard *IO Interactive*
Marc Holmes, Mike Sheidow, and Jason Wonacott *Turbine Entertainment*
Mark Chapman *Rebellion*
Neena Patel, Richard Williams, and Greg Jones *THQ*
Paul Weir *Earcom*
Poppy Reeve-Tucker and Peter Gilbert *Elixir Studios*
Simon Callaghan *Atari*
Stephanie Journau *Square Enix Europe*
Stephanie Malham *Digital Jesters*
Todd Sheridan *Glyphx*

Picture Acknowledgments
All games and images are copyright of the original developers and publishers and no challenge is intended to trademarks.